QUEEN
OF THE
SAVOY

QUEEN
OF THE
SAVOY

The Extraordinary Life of
Helen D'Oyly Carte 1852–1913

An Exceptional Talent
for Managing Chaos

ELISABETH KEHOE

UNICORN

For EBA

Published in 2022 by Unicorn, an imprint of
Unicorn Publishing Group LLP
Charleston Studio,
Meadow Business Centre,
Ringmer,
Lewes BN8 5RW

www.unicornpublishing.org

Text © Elisabeth Kehoe
Images © see page 216

ISBN 978-1-914414-18-3
10 9 8 7 6 5 4 3 2 1

Designed by Anna Hopwood
Printed by Fine Tone Ltd.

Table of Contents

Introduction

'A Woman of Extraordinary Magnetism', 'A Famous Theatrical Manager', and 'A Loss to Opera' were just a few of the accolades for the world's most famous businesswoman in May 1913. She had 'Wonderful Business Ability'. She was a 'Remarkable Woman', the 'Organising Genius' and the 'Great Organiser of the Savoy'. She was the remarkable Helen D'Oyly Carte.[1]

HELEN LENOIR, born in 1852, was known on both sides of the Atlantic as the most successful businesswoman of her time, but her name has been eclipsed by that of her male partners, Richard D'Oyly Carte, William S. Gilbert and Arthur Sullivan. Helen D'Oyly Carte (as she became) was, however, readily acknowledged by those three partners as the real power behind the massive Savoy franchise. It was thanks to her that D'Oyly Carte's larger than life personality and vision were shaped into one of the most profitable and powerful forces ever known in the British worlds of theatre and hotels – and that Gilbert & Sullivan's pieces achieved global celebrity as the famous Savoy operas. Her legacy lives on in the Savoy and Claridge's Hotels, the Savoy Theatre and, of course, the many, many ongoing productions of the Gilbert & Sullivan operas.

Both Arthur Sullivan and William Gilbert – whose notoriously rocky partnership lurched from one falling out to another – relied on Helen to keep progress on track, smooth over many mishaps, and negotiate and enforce iron-clad contracts. They and D'Oyly Carte relied on her, too, to manage the Savoy Theatre with ruthless precision – accompanied by the charm and thoughtfulness needed to motivate and manage a company of demanding divas and aspiring

chorus members, to say nothing of the dozens of crew and company employees who reported to her during her 12-hour office days.

While Richard D'Oyly Carte – known always as 'D'Oyly', to distinguish him from his father, also named Richard – was an extraordinarily talented visionary, his implementation skills relied more on his notorious charisma (earning him early on in his career the soubriquet 'Oily Carte') than on his administrative skills. A man who liked to have a finger in every pie, he relied on Helen's phenomenal memory, business acuity and meticulous follow-through to avoid floundering in a mass of detail. Although he was an extremely able negotiator, it was Helen who delivered, producing on demand highly detailed operating statements, budgets and work contracts and conditions.

She was also the one who kept the money-making duo Gilbert & Sullivan on reasonable terms and, as important, on schedule. Gilbert was a focused writer, who with military precision delivered his libretti on time. Sullivan, on the other hand, was less reliable. He avoided work, preferring his society friends and pastimes, and penned his brilliant scores with an alarming tendency to last-minute delivery after all-night composing sessions. Keeping the two men – whose vastly different personalities resulted in a working relationship devoid of friendship – on an even keel was a challenge for which Helen seemed admirably suited. It was her tact that revived the creative process time and again, and indeed, it was due to her intervention that the famous 'Carpet Quarrel' of 1890 – which temporarily ended the Gilbert & Sullivan partnership – was resolved.

Unlike D'Oyly, whose showmanship was undeniable – and in fact an asset to the Savoy brand – Helen was most at ease in the background, leaving the limelight to those who craved it. It gave her genuine satisfaction to run a well-oiled machine, and she was never happier than when solving problems, whether suing a rogue theatre manager for breach of copyright, renegotiating a contract with an errant actor or consoling a heartbroken member of the cast. Her advice was sought by her three partners as much as by the company and administrative staff. Further, Helen's ideas were the stuff of legend: it was her initiative to model the new Savoy Hotel on the great American hotels, which

she knew well after working there for many years, and to bring the first elevators to a public building in Britain. She instituted a queueing system for the pit and gallery seats and brought in advertising to the theatre programmes distributed free of charge. Always mindful of the full visitor experience, she arranged for tea and other refreshments to be provided to long queues of theatre-goers as well as to her theatre company. Bringing together the best ideas and best practice was what made the Savoy brand unique.

Feminine qualities of sweet submissiveness, uncomplaining suffering and coy helplessness were deeply inculcated in Helen's world, expounded by the press, and revered in literature from poets such as Keats and writers such as Thackeray. Subjecting herself to a man's will was a profoundly ingrained message that was articulated and cultivated from a girl's earliest years, and was reinforced by the law governing her rights and property. A woman's principal function was to marry, transitioning from the stewardship of her father to that of her husband. From a very early age, however, Helen chose to challenge her mind and set her sights high.

Her story is more than that of a singularly talented individual. At a pivotal moment in British history, when fundamental shifts were taking place – many driven by the vast changes engineered by technological innovations in the worlds of industry, commerce, art, photography, fashion and dining – Helen was at the forefront of the brand-new enterprise of expertly managed showbusiness. At the turn of the century, London was the epicentre of global transformations in travel, culture and social reforms, as well as commercial explosions. Society, having broken free of the constraints of an ever-dour Queen Victoria, found its tightly guarded walls successfully assailed by the pals of Edward, the Prince of Wales (known as Bertie) – many of them outsiders: foreign, homosexual, Jewish or, heaven forfend, American. They were talented, beautiful or wealthy, or all three. However it was money, the vast riches brought in by trade, industry and foreign ventures, that ruptured the ramparts of aristocratic froideur and allowed entry to those outside their caste.

Although snooty sneering might – and did – take place, there was no denying the appeal of luxury, comforts and entertainments now

available to not just the upper classes but to socio-economic groups previously denied such treats. The democratisation of high-quality entertainment was the greatest legacy of Helen's work, and of the Savoy brand. It opened up a wealth of experience and joy to thousands – and later, millions – of enthusiastic consumers of all social classes, united in their delight of music, fun and the joys and glamour of showbusiness at its best.

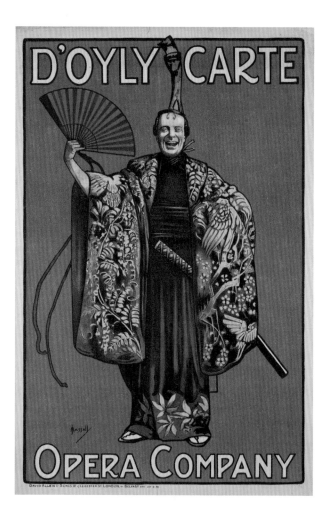

High artistic standards, beautiful costumes – with travels to foreign lands – characterised the Savoy operas.

Chapter I

A Scholar

1852–74

A HUNDRED OR SO MILES SOUTH of Glasgow, in the Galloway county of Wigtownshire, sits the small, out-of-the-way border town of Wigtown. Situated on a western peninsula of southern Scotland, washed by the wild Atlantic Ocean, Wigtown is fortuitously located on the banks of a tidal river. Although the town was remote – some 110 miles from Edinburgh – Helen Black's birth, in May 1852, took place when the impact of steam meant that Britain's economic and industrial landscape was undergoing enormous change. Rural communities such as Wigtown, hitherto linked mainly by water, became steadily more accessible. The boom of railway mania meant that in the decade of Helen's birth the first direct trains from Glasgow to London were able to complete the 400-mile journey in a day (a long, uncomfortable, and expensive 12 hours). Such industrial transformations were to have an enormous impact on Helen's life.

Both Helen's parents came from interesting backgrounds. On her father's side, the Coupers had originated as established tenant farmers, and their prosperous family fortunes had resulted in upward social mobility: Helen's great-uncle, Sir George Couper, was knighted for his service to Wellington in the Peninsular War and made a Comptroller of the Household of Queen Victoria's mother, the Duchess of Kent. Traces of the Black family can be found in the annals of ancient Scottish bards, and there are records going back to the 14th century in Scotland. Helen's grandfather, John Black, described himself as a writer, but was employed as a manager by the British Linen Bank in its newly opened Wigtown branch.[2]

*Described as the quaintest county town in Scotland, Wigtown – once home
to a thriving smuggling business – sits in Galloway on the magnificent
Machars peninsula.*

Such was the family's financial comfort that his son, Helen's father
George Couper Black, attended the University of Edinburgh, still
the preserve of the privileged few. George completed his education
by travels, and, while in Devon, stayed with the Foster Barhams,
an unusual family who lived near the coast. Dr Thomas Foster
Barham was a very clever doctor and innovative thinker, practising
in Penzance and Exeter, and a firm proponent of education. All 13
of his children – boys and girls – were well studied and expected to
speak classical Greek at the table. An advocate of progressive ideas
and a pronounced eccentric, the physician walked about in warm
weather clad in a Greek tunic. He supported radical change, such
as land reform to favour yeomen and peasants, as had been done in
revolutionary France.[3]

In 1850 George married Foster Barham's daughter Ellen, who
came to live with him in Wigtown. This would have been a dramatic
change on many levels, the first being the adjustment from the mild
south-western climes of her home – where figs grew on the garden
wall – to the cold, windswept northern town. Far from her family,

Ellen was not deprived of social contact, however, as Wigtown, for its scale, was a busy place, having been for years a centre for coastal trade, fairs and markets, as well as birthplace of the famed Baldnoch distillery. George Black occupied a place of social importance as the bank manager and the procurator fiscal (the Scottish equivalent of a coroner). His mother lived in a large house in the town, and there was family nearby.

Children arrived soon: Mathilda in January 1851, followed by Helen (although christened Susan, she and her family used her middle name) in 1852, John in 1855 and the youngest, Alfred, in 1858. The Blacks lived in comfort, large fish in a small pond, residing at Bank House, a handsome residence tied to the Wigtown branch of the Linen Bank of Scotland. There were three domestic servants in addition to an English governess. The family travelled regularly to the south, where they stayed with Ellen's family – another network of aunts and uncles.

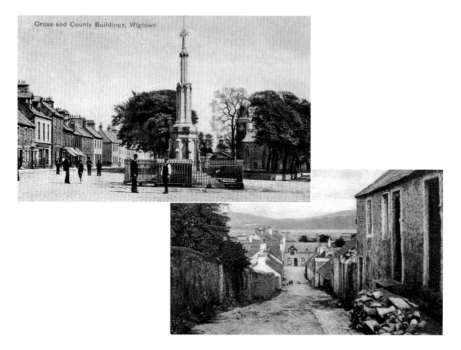

Wigtown Square and Wigtown Street: big fish in a small town, the Black family lived comfortably in Bank House until the death of George Black at the age of 44, when Helen was 11.

Thus Helen was exposed from an early age to the striking contrast between the limited community life of a remote Scottish town and the bustling, more populous south-west, where her grandparents were important members of a prosperous society.

Education was a priority, and the 1861 census records that the three eldest children were all categorised as 'scholars'. The family members were not in any way isolated: in addition to the relatives in Wigtown, there were visits from Ellen's own family. In his memoirs, Helen's brother John recollected regular outings and meals with kindly aunts and uncles. The family was Presbyterian, learned, but not in any way dour. Helen recalled walking in the garden with her father and chatting away in Latin or Greek. There were frequent attendances at theatrical and musical performances and a genuine love of intellectual pursuits and culture.

Tragedy struck, however, when George Black died of illness at the age of 44, leaving his widow with four young children, Helen aged 11. To add to their sorrows, the family had to leave their home, and settled in a house on one side of the main square, with George's mother on the opposite side. Helen's family remained financially afloat, although less comfortable. There was sufficient income for the children to continue their education. There would not, however, be sufficient to support the adult children, who would all have to earn a living. Mathilda (known as Hilda) and Helen would be expected to marry men who could provide for them. Education remained a central part of the children's life, including that of the two girls. When Ellen decided to move to Edinburgh, in 1866, John attended Edinburgh Academy, and Helen, Hilda and Alfred attended private schools.

In yet more upheaval, however, Ellen decided, in 1869, after her own father's death, to move her family to the Clifton area of Bristol, close to the Barham family home. It does not seem to have been her intention to remain in Scotland and, upon receiving the financial means to do so, she relocated to her home area. This inevitably made for unsettling experiences for the children. In the six years following the unexpected death of their father, they had left their home, then moved to an unfamiliar city, and then once more moved to a new location, in another part of the country. Although by the sea and

surrounded by lovely countryside, the conurbation was a busy one: the building of the famous suspension bridge, originally designed by Isambard Kingdom Brunel, had caused a sensation at its grand opening in 1864.[4] This icon of Victorian engineering symbolised the dynamism of the city and its industrial drive. It had always been an important seaport, and was home to a prosperous high-quality shipbuilding industry (hence the expression 'shipshape and Bristol fashion').

Much of the city's prosperity had been built on the profits of an ignominious and highly profitable slave trade. Although Helen lived in Bristol 60 years after the abolition of this trade, the legacy remained ingrained in the city's commercial heritage, where prominent slave traders continued to be honoured. These were complex and very new customs, values and ideas for the youngsters from Wigtown to absorb. And it was indeed an environment far removed from that of their distant home town. In addition to the busy seafaring import and tourist trade, Bristol was home to a number of factories, including the famed Fry's chocolate manufacturer. Merchants and manufacturers formed the backbone of the city's economic elite, and the world of upward mobility and financial independence was on view.

A constant, though, was the continuance of learning: John, a very talented scholar, was sent to the Church of England School at Taunton and Alfred attended Bristol Grammar School, while now the two girls were taught at home. Helen's aptitude for learning and obvious brilliance were recognised, encouraged and materially aided. While the family lived at Hampton Park in Clifton, Helen was tutored by two masters from the Bristol Grammar School. Such a step was crucial because, in the main, education for girls was not at this point 'intended to produce emancipated females competing with men for careers'. Instead, better education would 'allow middle-class women, freed from household duties by labour-saving devices and more servants, to develop intellectual and personal attributes enabling them to fulfil their traditional roles as wives and mothers more effectively'.[5] Indeed, the clever scholar Mary Hughes recalled in her memoirs that in 1881 she was nearly refused admission to the country's finest school for girls, the North London Collegiate,

when – after successful examinations – she was unable to 'make a buttonhole'. (After a week's practice with her mother, she returned and completed the task.)[6]

The role of Ellen Black cannot be underestimated. It is only through her sole parent's support that Helen was given the opportunity to develop her intellectual brilliance. She then undertook a very ambitious next step. Although university education was not available to women, she decided to sit, along with a small number of other women, the University of London's matriculation exam. Eleven women were successful and on 17 May 1871 the *Western Daily Press* was 'pleased to find that in the class lists issued by the University of London the name of Helen Susan Black … stands at the head of the Honour List'.[7] After this impressive achievement, Helen continued to study, and went on to take a Special Certificate in Mathematics and Mechanical Philosophy in 1873, followed by another in Logic and Moral Philosophy in 1874. She was at the head of the examination list. (To put this performance into context: it predated by 16 years the later achievement of Philippa Fawcett as the first woman to achieve a top score in 1890 in the Cambridge Mathematics Tripos.)

Not only was Helen successful, she was successful in subjects that were considered to belong exclusively to the male preserve. Victorian women – the prevailing mores dictated – were strangers to logic, because of their anatomy and primary function of childrearing. The 'gentler sex' was not expected to be in any way capable of study, let alone of mathematical study. While Helen clearly benefited from her mother's support, her drive and her hunger to learn are evidence of a strong, motivated personality. Sitting an exam such as this did not mean simply turning up. Special measures had to be undertaken, including providing a female chaperone and ensuring that the young women were supervised at all times.[8] Arrangements would be made to provide safe, supervised accommodation and dining facilities. No allowance was made for separate sex provision, so examinations had to be scheduled when the male students were not present. Female invigilators had to be hired. It was a novel and cumbersome business: young women needed iron will to succeed, where their efforts were considered strange and, by many, disruptive and challenging to the established order.

THE THEATRE OF THE NEW LONDON UNIVERSITY BUILDINGS—THE OPENING CEREMONY

University of London: although opened by a woman – Queen Victoria, in 1870 – the University of London did not allow women to graduate until 1878.

Helen was a pioneer in pursuing her education to this level. Girton, the first all-female college at Cambridge, had opened only in 1869, Lady Margaret Hall at Oxford not until 1878. Somerville (1879) and St Hilda's, also at Oxford, did not open until 1893. Art schools such as Kensington and Heatherley had been early to admit women, as had the Slade, which had accepted women students (with restrictions) since its foundation in 1871. Yet these options were mostly seen as 'safe' outlets for creative middle-class women, rather than ones leading to significant career possibilities. Indeed, much was done to pacify 'virulent opposition among commentators'. There were those who 'argued that education would disrupt menstruation and cause dysfunction of the reproductive system; others feared that educated women would be introduced to sexual licentiousness through classical literature, that spinster teachers might peddle "oblique and distorted conceptions of love" or that women's widespread employment might

presage an apocalyptic war between the sexes, culminating in the ultimate extinction of the race'.[9]

So, despite Helen's obvious ability, application and independence of spirit, the options open to her after her brilliant academic success remained few. She could either marry a man with sufficient income to support a family, or she could find remunerated employment that would not lower her social status. Professional opportunities available to women in 1870s Britain were scant, and most well-educated women who needed to support themselves looked to teaching as a respectable – if not especially remunerative – profession. For decades, teaching girls was considered a 'safe' choice for women like Helen, and opportunities grew more numerous as education generally, and education for girls specifically, expanded throughout the century. More teachers were needed, and these instructors needed to be well trained and educated to at least as high a standard as that of their pupils.[10]

While Helen focused on her studies, family life had become more fragmented. In 1872, John left to attend a commercial school in Germany for three years. On his return in 1875 he joined the family in Bristol where he began work at a soap manufacturer as a clerk, but soon decided to leave for Scotland, to take up a position in the Edinburgh branch of his father's old bank. There he lived in cheap lodgings and struggled to manage on a small salary. This was sufficiently uncongenial that by 1876 he had rejoined his mother, who had moved yet again, to a flat off Queen Victoria Street in London. Throughout these changes, Hilda was slipping through the cracks, as she struggled with depression. She was not a scholar, and took the unusual decision to convert to Roman Catholicism, considering whether to take up holy orders. Alfred, who like the rest of his siblings had to earn his living, began studying engineering at Crystal Palace in London.

Chapter II

Hitting the Boards

1874–76

T HE NEED FOR TEACHERS was growing: in 1861, about 80,000 women held teaching positions in England and Wales, and by 1901, the numbers had more than doubled.[11] Teaching might have been a popular, if predictable, career path for intelligent, well-educated women, but for many it was dull and unsatisfying. Living with her mother and siblings in London, Helen teamed up with a friend, the Russian *émigrée* Alice Gruner, to tutor daughters of wealthy families. Unlike Gruner, who thrived on promoting education for women, Helen did not like teaching. Her brother John recorded, however, that she travelled up to Birkenhead to join Gruner to teach three young women in a household there, in August 1876. Gruner was thrilled to be in Britain, where she felt that opportunities for education abounded. She was not only clever but thrived in a studious atmosphere. She was motivated by ambitions that were professional and scholarly, and she worked hard to save enough money to attend Girton College for two years, and to bring her younger sister to England, where they ran a boarding school. For the talented Gruners, teaching represented a fulfilling future and independence. Not so for Helen. As she later explained, she found the work 'very tiresome'.[12]

Once again, she manifested strong will and individuality, deciding to take up a career on the stage. Within months, John recorded the astonishing news that Helen was in Dublin, where she had secured a part in a pantomime at the Theatre Royal. The theatre was owned by the enterprising brothers John and Michael Gunn – who were soon to become partners with the English impresario Richard D'Oyly Carte. This small debut was therefore to play an enormous part in

Helen's major life pivot. Taking the part was a big decision: Helen re-invented herself as 'Helen Lenoir' (the French for 'Black'), which she used as her formal and not merely stage name. At some point – before the 1891 census – she shaved six years off her age.

Training to be a stage actress was a really surprising decision. In 1876, the stage was absolutely not seen as a suitable place for a middle-class, educated woman – although as 'respectable' performances became more highbrow and generally more accepted by the clergy and the general public, the profession cried out for women of education and social sophistication who could convincingly replicate women of the upper classes. It is possible that Helen's original intention was to take lessons in elocution and acting, perhaps in order to overcome her reputed shyness, and she may have discovered an appetite for performing, leading her to dancing and singing lessons. She took private tuition offered by Mr Coe, the Stage Director of the Theatre Royal Haymarket.

It was an especially unusual career move, as most actresses at the time came from theatrical families and had experience growing up close to the profession.[13] Typically, performers from a middle-class background might have demonstrated singing talent at an early age, and been allowed to pursue the genteel path of concerts and carefully vetted performances in select venues, so as to be clearly differentiated from the music hall culture. And up to the 1890s the concept of the career-actress 'was still not wholly acceptable in middle-class circles'.[14] The young actress, Alma Ellerslie,[15] recorded the travails of life in the theatre. She herself was well educated and from a middle-class background. She wrote in 1857 that her own sister did 'not wish to be brought down to my level, or to hold any communication except by letter. She has even told me that men might not like to marry her girls when they grow up, if they thought they had an aunt who was an actress.'[16]

So it is critical to bear in mind when looking at Helen's decisions – both to sit the University of London exams, and to pursue a career as an actress – that young women of her background were expected to conform to societal norms that protected their marriageability – and she was quite clearly rejecting these norms. Further, the life

of an actress was a very, very difficult one. Actors had to pay for advertisements, visit agencies and audition for roles. The reality of an actor's existence was one of weeks with no work, living in boarding houses and running out of money. Alma Ellerslie wrote in 1875 of how eight weeks had gone by since the end of her last engagement and lamented: 'All this dreary time I have been writing and advertising, and hoping and despairing.'[17]

Ellen Black's small pension and inheritance would not support four adult children. When their mother decided to give up the London flat and travel to visit friends, John and Alfred had to move into cheap lodgings. Hilda joined a convent. This unusually unstable and peripatetic existence, the death of her father at a young age and her mother's increasing ill-health combined to create an opportunity in 1876 for 24-year-old Helen to make her own decisions in a way that few young women of the period could. Ellen was clearly a strong-minded individual whose moves marked her out as someone prepared to take chances. She was also, clearly, a supporter of education and, as later became obvious, especially in the case of her sons, was ambitious for her children and determined to help them succeed. It can be imagined that Ellen and Helen, both strong women, did not see eye to eye, and that Helen was determined to make her own way in life.

For while the Black family had a keen appreciation of the theatre – as evidenced by frequent entries in John's diaries of outings to plays and other performances – it was a very big step to go from enjoyment of the stage to actually being on it. To put this in context, Helen's decision occurred very close in time to the publication in 1880 of the French author Émile Zola's scandalous novel *Nana*, a best-selling narrative whose protagonist is a prostitute turned actress turned man-destroying courtesan. French novels of this 'naturalist' school reinforced the perception of actresses being, in the main, of the demi-monde and not respectable. In Britain, although theatre owners sought to differentiate their pieces from the music hall productions catering to a rather more rowdy and bawdy crowd, there remained a stigma attached to women on the stage.

As we have seen, Helen's acting efforts bore fruit in November 1876 when she was cast in Dublin in the pantomime *Aladdin* as Prince

Piccadilly (with a small chorus part as well), ending on 24 February 1877. It is perhaps no coincidence that her bid for employment occurred at the same time that her mother put in place a plan to emigrate to Australia. It is hard to know what Ellen Black was looking for. As we have seen, there was little stability after the death of her husband. Her plans gradually grew more radical: from Wigtown to Edinburgh to Taunton to London, and now exploring the idea of moving to Australia. Some years previously, she had considered an Antipodean move, and John was also eager to start a new life there. Ellen's sister-in-law, Isabelle, had farmed in Australia with her husband John McHaffie and their family for many years.

When advised by her doctor to seek a change of climate in 1876, Ellen pursued the Australia prospect more vigorously. The McHaffies, although they had done well there, did not recommend Queensland, and Ellen settled on moving to South Australia. It was quite an unusual decision for the 54-year-old, who could so easily have settled in her home town. Further, she was determined that the family move there together, including Hilda, who had abandoned her idea of joining a convent in Paris. To this end, Ellen sold some of her shares so that she and her children could invest in a new life. This was a risky move, for she was dipping into precious income-generating capital to invest in the complete unknown.

Adelaide was an interesting choice, and a favoured destination of emigrants from the southeast of England. At the foot of the Mount Lofty Ranges, close to the eastern shore of the Gulf of St Vincent, with a Mediterranean climate of hot summers and mild winters, the location was promising. The capital of South Australia was a planned city; after the Adelaide plain had been colonised by the gradual and inexorable removal of the indigenous nomadic Kaurna tribe, the governing authorities had implemented a deliberate immigration scheme. Adelaide's population would be made up of settlers willing to purchase land. Immigrants were soon successful by virtue of the cultivation of wheat and grapes (used to make wine), and by the late 1870s the 100,000 dwellers of the city and its prosperous suburbs benefited from beautiful parklands, gas street-lighting, a university and a bank, as well as the advantages of a water reservoir and a deep

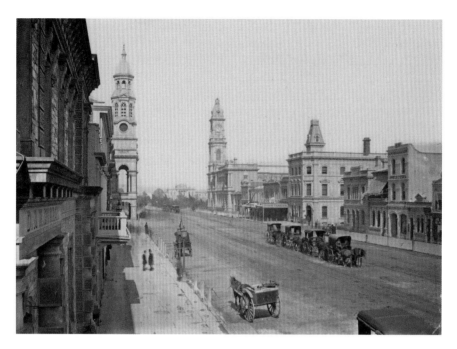

Adelaide: its pleasant climate of hot summers and mild winters made it a destination of choice for many emigrants from the southeast of England.

sewer system. Buildings lined the grid-formation streets and the wealthy elite built majestic homes in the northern residential area – although the poor crowded into the city centre.

Armed with letters of introduction to various notables, the family left England on 28 June 1877 on the maiden voyage of the Orient Line, travelling aboard the *Lusitania*. They would be joining the 90,000 or so British emigrants to Australia that year, where, after waves of forced emigration of convicts (1788–1868) followed by the arrival of free settlers – including a frenzied gold rush in the 1850s – the growing nation was encouraging solvent, hard-working individuals and families to contribute to the economy by working on the land. The majority of residents of Adelaide and the surrounding areas hailed from Britain, with large numbers, too, from Germany. The senior positions – those of leading lawyers, bankers and businessmen – were held by men English by birth and they, along with the 'squatters' who occupied land, formed the socio-economic elite. Earlier settlers

from the British Isles, however, had claimed the most fertile land by the 1870s, and later arrivals such as Helen's brother John had to make do with the dry, marginal territories. Although John had originally hoped to obtain a good post in banking, there was plenty of competition for few posts in the developing economy, and he turned instead to farming. Helen was expected to follow the family soon after, by a later ship arriving on 20 September. She told them that she could not leave London, as she had been cast in a second minor role in *The Great Divorce Case*, set to run for a 12-week tour beginning in Liverpool.

Chapter III

D'Oyly Carte

1878

THE IMPRESARIO RICHARD D'OYLY CARTE, however, had other ideas after meeting Helen. 'Well do I recall,' reminisced the editor of *The Era* magazine, Frank Desprez, 'the slight figure, the large, dreamy, depthful eyes of the little lady in a fur-lined cloak who came to D'Oyly Carte's agency offices in Craig's Court to get work of some kind'.[18] Richard D'Oyly Carte – known always as D'Oyly to his intimates, and Mr Carte more formally – was an ambitious impresario, with music and theatre in his blood. He was the product of unusually open-minded parents. His father, Richard, was a talented flautist of note, and partner of a very successful flute-manufacturing firm. He had also built up a concert agency, and a highly profitable music publishing company. D'Oyly's mother, Eliza, was a strong proponent of education that included foreign languages as well as literature and music. D'Oyly started composing musical pieces at a young age, and, an inveterate extrovert, enjoyed performing them before family and friends.

The eldest of six children, from a warm and very loving family, D'Oyly had from an early age a love of music 'so intense'[19] that he seriously considered adopting it as his profession. He attended the liberal University College School and, interestingly, sat, some ten years before Helen, the 1861 matriculation examination at the University of London. Although he achieved a first-class pass, he declined the opportunity to study, in order to enter his father's business.[20] The following few years as an apprentice concert agent taught him all the skills needed to excel in the music business. He

negotiated agreements between promoters and music artists, and was in charge of the ensuing administration: bookings, contracts, travel and accommodation, all while managing the all-important accounts.

In 1870, he married the 17-year-old daughter of one of his father's partners.[21] Blanche Prowse moved with D'Oyly to lodgings not far from the Carte family offices in Charing Cross. D'Oyly does not seem to have shed his workaholic tendencies, working at the office all day, travelling with his artists and still composing musical pieces in his spare time. His great passion was for opera and, specifically, for the genre of the lighter *opéra bouffe* and comic opera, on which he was becoming an authority. To this end, he opened a small offshoot office a short walk from Charing Cross, in Craig's Court. There is little known about Blanche, who remains a shadowy figure suffering from ill health. Two sons were born, Lucas in 1872 and Rupert in 1876, but Blanche is rarely present, possibly because of illness.

At D'Oyly's invitation, Helen left the touring company and joined the office in Craig's Court in April 1877. The manager was hard at work on his passion, his project to produce an English genre of comic opera. He was convinced that the composer Arthur Sullivan and the playwright William Gilbert could form a winning collaborative duo, with the right managerial support. To this end, he had formed, in November 1876, the Comedy Opera Company, with nine shareholders and a capital sum of just over £3,000.[22] It was a project only, for D'Oyly was long on ideas and short on cash. Until more capital was raised, things were in the air. Further, it was not until June 1877 that terms with Sullivan and Gilbert were discussed (there had also been delays because of the tragic and unexpected death of Sullivan's brother, Frederic). In addition to various royalties and rights, the composer and author required a pre-production advance payment of 200 guineas. D'Oyly was eventually able to pay this, and he moved to a new, larger office in the Strand. The Company took a lease on the nearby Opéra Comique.

The whole enterprise – with some shareholders wholly ignorant of the music business – was fraught with risk. Helen was nevertheless inspired by the entrepreneur's vision and ambition. A new life beckoned, one that promised hard, interesting work, risk and reward,

never knowing what each day would bring. She knew right from the start that it was a precarious undertaking; John received a letter from her dated 22 August, in which she confided that 'there was no money in the office'.[23] Carte did not have the cash to offer her a job, but Helen had no intention of going to Australia. Instead, she signed up as a 'ballet lady' with a touring theatre company travelling out to Calcutta, for a salary of £6 a week. By September, however, Carte had raised enough money to pay Helen a salary and she cancelled her contract[24] and took up his offer for the far lesser sum of 30 shillings weekly.

The family was left in the dark. With no telegraph line between England and Australia, they had to wait for her arrival or a letter. In November 1877, John recorded that Helen had not arrived in Australia as anticipated and that they had had no letter of explanation. The only news received was a communication from a 'Mrs Browne' who wrote that Helen was 'happy' with her 'present work' and that 'it was not worthwhile for her to leave'.[25] It was a matter of great concern for Ellen and the rest of the family, but communications took such a long time that it was impossible to understand what was happening.

It was not until 4 December that two letters (one of which had been mislaid for two weeks) from Helen arrived. In these, Helen explained that she was not able to leave her employment with Mr Carte. Furthermore, she had rented a house in Buckingham Palace Road for £70 a year, and, contrary to her expectations, Alice Gruner and her sister, who had arrived from Russia, would not be sharing the house with her. John recorded the 'worry and upset' to their 'poor mother' but there was nothing they could do. Ellen believed that Helen was being 'obstinate' because she did not get along with Hilda, whose depressive illness made life 'unbearable' for those around her.[26] It was perhaps easier to believe this rather than another possibility, which was that Helen had found an exciting job and a new life. She worked in an office located just off the Strand, in the heart of 'the dreadful, delightful city'.[27] The West End of the capital had by the 1870s become synonymous with the pleasure district – a dazzling 'constellation of theatres, restaurants, billboard hoardings, music-

halls, concert venues, pubs, galleries, and grand hotels'.[28]

D'Oyly's plan was to capitalise on the appetite of an increasingly prosperous middle class for dignified yet adventurous and amusing theatrical entertainment. He had observed the expansion and gentrification of the West End theatre district, which had benefited from the mid-century economic upturn. The old theatres of the 1860s had been for the most part 'badly built, badly lighted, badly seated, with inconvenient entrances, narrow winding passages, and the most ineffective sanitary arrangements. They smelt of escaped gas, orange peel, tom-cats, and mephitic vapours.'[29] D'Oyly was determined to change all that, and he found in Helen a fellow enthusiast and work addict. Notorious for their 12-hour days, the two entrepreneurs thrived on intensive labour and big ideas. Helen absolutely loved going in to work, and rapidly became a part of the bustling, brightly lit metropolis – where fashion, art, shopping, eating and entertaining came together in a noisy, glamorous assault on the senses.

Working on the Strand was an experience about as remote as one could get from the rural charms of Wigtown. 'So far as I can, I avoid that channel of all that is unloveliest in London, the Strand,' wrote the drama critic Max Beerbohm, famed for his essays and caricatures. It was a crowded and busy street where 'Anxiety, poverty and bedragglement' met, there were 'drivers cursing one another in the blocked traffic; hoarse hucksters on the curb, and debauchees lolling before the drinking bars'.[30] Some believed that the notorious London fogs, 'a turbid yellowish-brown vapour' that could go on 'for three days and nights at a stretch', were 'nowhere denser than in the Strand, which remained 'very much of an eighteenth-century thoroughfare'.[31] Instants away were the filthy, overcrowded slums of the West End, running from today's Soho as far as Oxford Street. The area was crowded with prostitutes who openly promenaded the Strand as soon as the theatres were let out. Obscene literature was available steps away from Helen's workplace, but she remained so unflustered that she was rapidly promoted to manage the office.

Essential to D'Oyly's bold business plan was a collaboration with the composer Arthur Sullivan, a close friend. A musical prodigy who by the age of eight had mastered all the instruments in his father's

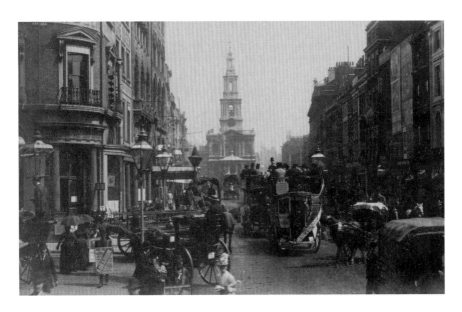

The Strand: 'that channel of all that is unloveliest in London...'
(Max Beerbohm)

band at Sandhurst, Arthur Sullivan came from a cosmopolitan yet very poor household. It may have been a struggling home, but it was a loving one. His Italian mother was a strong influence, and Sullivan, an inveterate womaniser who never married, remained devoted to her.[32] He and D'Oyly shared a love of music and an appreciation of culture and the good things in life. In 1871, D'Oyly had seen Sullivan's short piece, *Thespis*, with libretto supplied by William Gilbert, at the Gaiety Theatre, under the manager John Hollingshead. The piece had limited success, and Hollingshead did not retain the pair. D'Oyly, however, recognised the potential of a partnership of musician and writer – if they had a manager.

Sullivan was already a celebrated composer, a favourite of the musical establishment and darling of the royal family, for whom he had become an unofficial laureate. His musical talent and composing genius had gained him fame and fortune. He was, furthermore, enormously popular. As a fellow student at the Conservatoire noted: 'It was part of his nature to ingratiate himself. He always wanted to make an impression and, what is more, he always succeeded in doing

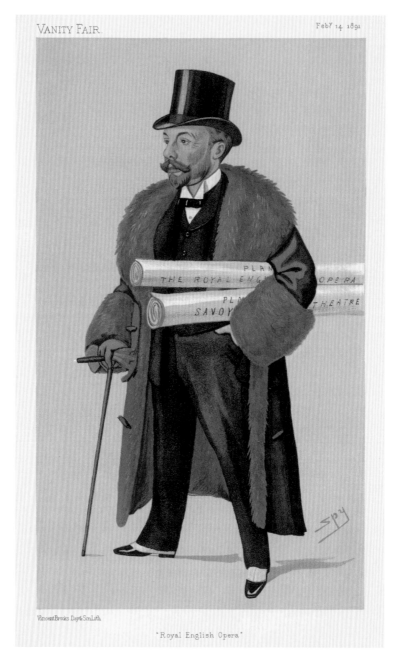

VANITY FAIR.

Feb᷑ 14 1891

Vincent Brooks Day & Son Lith.

"Royal English Opera."

Richard D'Oyly Carte: 'Oily' Carte was a great talker and hugely talented visionary, whose unerring eye on the big picture sometimes led him to overlook the everyday details of work.

it.' He was able, therefore, to get 'into personal touch with most of the celebrities', and was 'a natural courtier'. These characteristics did not, however, veer into obsequiousness or prevent Sullivan 'from being a very loveable person'.[33] Sullivan's easy, relaxed charm gained him friends from all walks of life, despite his unabashed lifelong gravitation to high society.

In the course of managing his thriving agency and becoming a serious player in the West End, D'Oyly had also come across the professional playwright William Schwenck Gilbert. A tall, handsome man of erect bearing with a tendency to take himself very seriously, Gilbert, unlike Sullivan, had been brought up in conventional, comfortable middle-class prosperity. He did not, however, benefit from the same warmth at home, and his relationship with his mother – who persisted in addressing him as 'Schwenck' despite his loathing of the name – was fraught. It had, furthermore, been difficult for him to find his professional footing. He had joined the militia by 1859 and this was not an unqualified success, despite his enjoyment of the part-time experience of masculine barracks and outdoor life. After four unhappy years as a civil servant, followed by four unsuccessful years as a barrister, he turned to his passion for writing, running from comic verse (the famous 'Bab Ballads') to short stories and theatrical criticism published in a series of magazines and periodicals. During the 1860s, Gilbert had also become an extremely successful, well-paid playwright, whose works included burlesques, farces and comedies, as well as a series of 'lightly satirical plays with incorporated songs'.[34]

Both Gilbert and Sullivan were thus each very successful in their own right, but of highly differing backgrounds and personality. Where the small, chubby Sullivan exuded bonhomie and carefree friendliness, Gilbert was touchy, prickly and sensitive to any perceived insult or disregard. He had a lifelong passion for litigation, which he indulged to its utmost. Although loyal friends – most often attractive young women he had helped – praised his kind heart and generosity, to the wider world he was a difficult character, quick to take offence and to dish out pithy critical comments. Quarrels, reconciliations and petty hostilities featured permanently on his personal landscape, and his strong work ethic and determination to control everything around

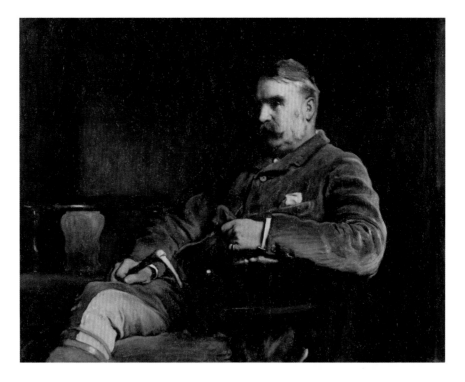

*William Schwenck Gilbert: clever, good-looking and affable to those he liked,
the former military man and barrister relished conflict when seeking to
impose his impeccably high standards.*

him made it difficult for his partners to truly relax in his presence.

Both men were keen socialisers, and Gilbert, despite his sensitivities, was in fact a gregarious and warm-hearted man, who loved social occasions and entertaining, both in his home and at his clubs. His was an upper middle-class circle, whereas Sullivan favoured the glittering royal milieu and its fringes. Both Gilbert and Sullivan, though, had an enormous capacity for work. Despite different styles, they were each perfectionists, paying huge attention to detail. D'Oyly was convinced that a partnership between the successful writer and the famed composer would prove immensely popular and profitable. While managing the Royalty Theatre for one of his clients in 1871, he tested the waters by asking Gilbert to write a brief one-act play as a curtain-raiser, to which he would invite Sullivan to set the music.

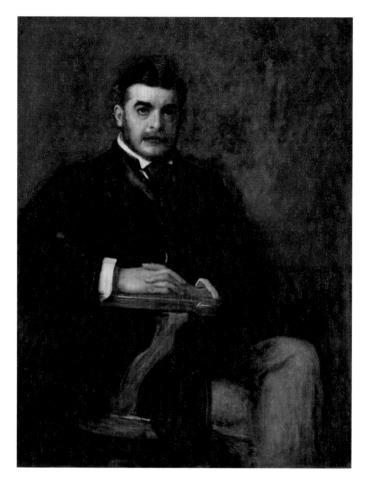

Arthur Seymour Sullivan: brilliant, handsome and debonair, the composer's charming exterior hid a nervous nature, prone to stress and overwork.

Gilbert had, in his usual disciplined and well-organised fashion, written the piece straight away, *Trial by Jury* (1875), for which Sullivan composed the score. It proved hugely popular and both writer and composer were open to the possibility of another collaboration. Much encouraged by its success, the following year D'Oyly put in place the first stage of his dream of an English opera company. The Comedy Opera Company was designed to manage the Gilbert & Sullivan partnership, and to produce their light opera pieces on a regular basis. The music lover was one step closer to making his

vision of an innovative, creative and entirely new concept of a night at the theatre a reality.

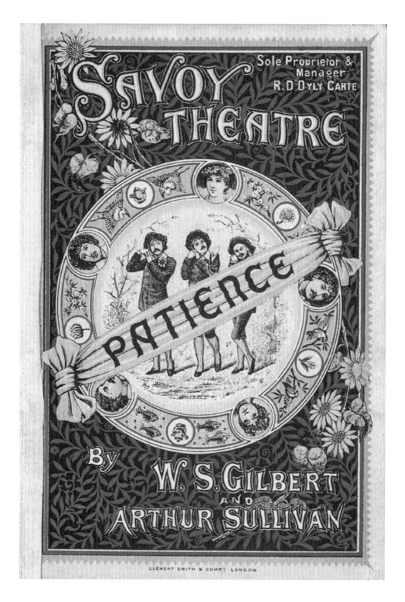

Advertising the G & S pieces became a prominent feature of the franchise, broadening access to a variety of avid playgoers.

Chapter IV

Selling Gilbert & Sullivan

1878–79

The premise of D'Oyly's venture was that making entertainment 'respectable' would open up a large market of middle-class theatre-goers who would be prepared to pay handsomely for tickets, food and beverages – and merchandise. The key to achieving this was to provide a pleasurable and safe customer experience, from the moment of booking till exiting the theatre.[35] And, indeed, the production of attractive theatre programmes had already begun some years before, and included advertisements that targeted the wealthy. Middle-class theatrical entrepreneurs such as Madame Vestris and the Bancrofts had paved the way for changes in the theatre-going habits of the well-heeled, but D'Oyly Carte was the first to look upon the partnership he wanted to engender with Gilbert and Sullivan as itself part of the business venture. His vision incorporated an integration of the supply chain, as it were, into the production itself, by tying down the producers of his material and giving them an equal share in the business. He wished, further, ultimately to control his own venue as well, and his dream was to build a theatre of his own as soon as finances would allow.

Another important plank upon which he based his vision was to promote English authors, composers, singers and actors. D'Oyly firmly believed that there was a demand for home-produced drama, rather than the usual foreign pieces – predominantly French. He was, furthermore, convinced that the public would appreciate a high-quality, hand-picked company cast, carefully selected and carefully trained. What is important to understand is that all these plans were

ideas only. Both Gilbert and Sullivan were very successful artists who had plenty of other opportunities, both as individuals and as a writing team. At one point during the period when D'Oyly sought to raise capital, Gilbert lost patience, writing in March 1876 that with the chance of working in a good theatre, he and Sullivan would 'work like Trojans'. They could not, however, hold themselves at his disposal 'whenever you want us'.[36]

D'Oyly, in the process of building this empire, proved his business acumen by quickly recognising that in Helen he had a jewel of an assistant. By October she confirmed to her brother that she was receiving a regular salary.[37] The writer Frank Desprez (author of the famous poem *Lasca*[38]) was already helping D'Oyly as his secretary. He recalled how quickly Helen had taken over running the busy office. She soon proved pivotal, too, in assisting in the casting. As Desprez observed, his friend D'Oyly was 'a man of ideas and impulses, of violent fits of work and ardent periods of enjoyment'.[39] The steady, clever young woman brought much-needed stability and order to the chaotic company. Although D'Oyly's attention to detail was legendary, no sooner had one production opened than he was engaged in organising a provincial tour for it, or launching the following piece. He was also still running his busy agency, with hundreds of artists on his books.

Helen and Desprez bonded in those early pioneer days. Desprez was just one year older and had attended Bristol Grammar School (where he might well have encountered her brother, John). He too had chosen to avoid the beaten path: after serving an apprenticeship with an engraving firm, he had set out as a young man to Texas, to work as a rancher. After a few years, he returned to open a riding school in London, in Chalk Farm. His real passion, though, was for poetry and drama and while working as a private secretary for Carte, he wrote many extremely well-received one-act plays, which accompanied the operas, as well as acclaimed poems.

With people such as Desprez, who became a friend as well as a colleague, Helen began to create a new 'family', and for this the world of the stage was a perfect environment. Actors were of course constantly reinventing themselves, and librettists and composers

flowed with creativity. D'Oyly was a man fizzing with enthusiasm, passions and ideas. In such an enterprise, Helen discovered a capacity for organisation and getting on with people that made her a huge asset to the young enterprise. It is hard to imagine a better fit: Carte had vision and Helen was the clever, dependable partner, who made the deliverables happen, and coached individuals and teams around her to pull together harmoniously. She was the dream manager – and she had found not just a career in which to thrive, but a circle of friends who understood and valued her: no more second-rate citizenry as a teacher to daughters of the wealthy or the drudge of the classroom with long hours and poor pay.

An exciting world beckoning, Helen laid plans for her future, and it was one that did not include living in Australia. Never one to value material possessions or to care overmuch about her personal comforts, she settled down to days of work that ran from ten in the morning till midnight, often later. Her meals would have been taken with the senior team, who often dined together. Michael Gunn, his cousin George Edward(e)s,[40] Richard Barker, François Cellier (usually called Frank), Frank Desprez – all became trusted friends. The artist Walter Sickert became a close personal friend of both Helen and D'Oyly (his well-known painting of her, known now as *The Acting Manager*, was famously exhibited in London in the winter of 1886–87 as *Rehearsal: The End of the Act*). Helen was warmly welcomed as a valued colleague by D'Oyly's family, and began a friendly correspondence with his father and sisters, keeping them in touch with the business.[41] The company members were equally fond of her: at a company dinner in 1887 for the opera *H.M.S. Pinafore* in Bournemouth, the health of Miss Helen Lenoir was proposed, greeted 'most heartily', and 'followed by three cheers'.[42]

The team was hard at work to launch the Gilbert & Sullivan opera *The Sorcerer*, which opened to great acclaim on 17 November 1877. Because it was a new format, and the risk-averse investors were cautious, the company directors (but not D'Oyly) prepared to close the theatre at short notice at the first sign of waning sales. There was no cause for alarm, however, as the piece gained in popularity and ran to 178 performances with great profitability. Carte was

encouraged by the success to develop his strategy of multiple income streams, sending the touring company out in March 1878. The tour lasted 22 weeks, covering such major conurbations as Manchester, Birmingham, Leeds and Liverpool.[43]

Timelines were tight, to promote cost-effectiveness, and *H.M.S. Pinafore*, Gilbert & Sullivan's next opera, opened the day following *The Sorcerer*'s last night. On 25 May 1878, the new piece had a magnificent opening night. What began to stand out was a D'Oyly Carte signature style of great production values. Helen was intricately involved in guaranteeing the perfection of the sets, the props and the costumes, and in maintaining overall supervision of the long weeks of smoothly run rehearsals. She was also in charge of salaries and budgets, keeping an eye on the expenses, and making sure that bills and wages were paid on time. There was always a huge amount of work in the preparation of a new piece: the actress Violet Vanbrugh, working at the nearby Lyceum Theatre, marvelled at the effort required. 'I wonder how often the public,' she mused, 'as it watches a production smoothly unfolding itself on the stage, realises the work, the thought, the energy, the time, the care that have been expended on it; how many clever brains have worked and planned the detail that makes up the seemingly inevitable whole.' And she had astutely observed how often the performers forget, when their 'own little bit is done', that the manager 'cannot go home as we can' and rest, but must continue to bear 'the burden and the anxiety of the whole enterprise'.[44]

In addition to setting in place house values that prioritised courtesy, consistency and hard work, Helen and D'Oyly also worked on streamlining and improving the customer experience. The detested free-for-all was abandoned in favour of a queuing system. The intrusive tipping requests were abolished, and tickets were printed with a seating plan on the stub, with the location of that particular seat clearly indicated.

A successful theatre ran on great material, excellent organisation – and capital. As evidenced by Sullivan and Gilbert's demand for up-front payment, a manager/owner had to have access to enough cash to pay for the theatre lease or financing costs, as well as enough

in hand to meet the costs of running the current production and rehearsing the next one. The trick was to judge the run as accurately as possible. When the numbers of attendance began to drop, stimulation of demand was often possible through advertising. But at some point, the market demand would be saturated, and the spend on advertising a lost cause. The second important task was to minimise as much as possible any 'dead' time in the theatre. Rehearsals for the following production had to take place on an empty stage, with the full company as needed, and, eventually, the full orchestra. Timing was thus of the essence, for all these people needed to be paid, as well as the set designers, carpenters, costume designers and others. Advertising for the new piece had to be placed and paid for, but not too soon, or assumptions might be made that the current piece was losing popularity.

Reviews for *Pinafore* were gratifyingly positive, and the opera was immediately popular, a real audience-pleaser. Across the Atlantic, copycat productions abounded and *Pinafore* mania grew – both in Britain and abroad. Unfortunately, the vexing problem of summer weather raised its head. In London, the directors looked at the dropping receipts in horror: audiences fell as a draining May heatwave worsened and, by the end of June, exhausted the city inhabitants. The Opéra Comique theatre, dark and poorly ventilated, experienced dramatic falls in ticket sales, as theatre-goers avoided a hot and uncomfortable experience. The four principal investors, led by 'Watercart' Bailey (so-called because he had made his money through ownership of the carts that sprinkled the London streets with water), demanded that D'Oyly close the production, thus temporarily laying off staff and avoiding royalty payments to Gilbert and Sullivan. This would have caused tremendous hardship not only to the singers and senior staff, but to the lower-paid theatre personnel and backstage workers – 'dressers, seamstresses, call boys, stagehands, property masters, machinists – people who worked long hours for very little pay'.[45]

D'Oyly was confident that he could ride out the storm, insisting that the piece would recover as the weather cooled down. The difficulties with the investors grew more pronounced, however, and there ensued a rather farcical dispute that culminated in an aborted attempt by the

directors to have the stage sets and props for *Pinafore* seized during a performance. The stagehands fought back in an undignified tussle and there were injuries. The understanding between D'Oyly and the directors was at breaking point, and he hoped to sever the connection by the end of July 1879 in order to establish an independent company with Gilbert and Sullivan. Part of his new scheme would be to diversify income so that he could maximise profits of a success and spread the risk of a slower-performing show, and Helen embraced the challenge with enthusiasm.

As her talents became ever more obvious, additional opportunities beckoned. Both D'Oyly and the writing duo had become extremely concerned when pirate copycats began producing *Pinafore* in the United States. Bereft of copyright protection, they could only watch in dismay as one American company after another (some estimates are that there were as many as 100 productions running at one time) put on poorly produced performances that were lamentable imitations of the original – especially with regard to Sullivan's score, which was unpublished. This infuriated them not only because of the loss of potential revenues, but for the harm inflicted to the developing brand – which, through great efforts by all concerned, was meant to be all about quality.

D'Oyly, Sullivan and Gilbert agreed a strategy for America, signing a 'Memorandum of Agreement' for the American tour on 12 June 1879, after which D'Oyly sailed for New York. He felt sufficiently confident to leave Helen and Michael Gunn in charge. In July 1879, he wrote back that local performances in the US were 'atrocious'.[46] He found negotiating for a theatre difficult, though, as the American managers demanded a large share of any profits. Nevertheless, when he returned at the end of August, he had successfully negotiated 'splendid terms' in a number of the larger cities.[47]

Chapter V

Living in America

1879–80

HELEN HAD ALREADY BEGUN managing and expanding the lecture tours that D'Oyly had initiated, as well as running the touring company. She was managing an important and profitable part of the business, and one that required great independence. It was quite an undertaking for a 27-year-old single woman of her era to take responsibility for an entire company out on the road, touring for weeks. Such was her success that as the number of touring companies grew to four, she managed them all, in addition to running the office. These touring companies performing at the provincial theatres provided a backbone of steady income and profit streams that were an essential part of the successful D'Oyly Carte business model. The regional theatres, which had originally been started in the 18th century to provide entertainment for the wealthy, had dropped in popularity before reviving and expanding to market themselves for middle-class audiences in the growing, newer industrial towns.

D'Oyly was quick to promote Helen to first lieutenant. Thus liberated from much of the day-to-day management of his growing enterprise, he planned his next move, which was to conquer the American market. To put in place his strategy, he needed trusted managerial talent on both sides of the Atlantic. The plan was to produce an authentic version of *Pinafore* in America, with a properly trained and rehearsed cast, supervised in person by Gilbert and Sullivan – with D'Oyly masterminding the production. This would show the American audiences a high-quality performance of the piece as it was meant to be produced. It was hoped that the public

there would then always want the real thing rather than imitations. An entire cast was brought over, and this 'authentic' *Pinafore* received rave reviews when it opened in New York on 1 December 1879. This success set in train the execution of the strategy to beat the pirates, in which Helen would play a pivotal role.

D'Oyly had decided to pre-empt further piracy by producing the newest Gilbert & Sullivan piece almost simultaneously in Britain and America, in unannounced performances. It was an unusual departure from tradition, in Britain especially, where a new piece would be expected to be produced by a first-string cast, supervised in person by the composer and librettist. In a cleverly planned move, D'Oyly arranged for Helen, who was leading the touring company performing *Pinafore* in Torquay, to produce a one-off performance of the brand-new Gilbert & Sullivan opera, *The Pirates of Penzance*, in a small, privately owned theatre in the nearby resort of Paignton. Despite the lack of time (there was only time for one evening rehearsal), Helen and the cast rose to the occasion – to rapturous applause. This performance secured the copyright in Britain, and across the Atlantic, Gilbert and Sullivan opened *Pirates* with the star cast and orchestra in New York the following day, 31 December 1879 – to wild acclaim. Each night the score had to be locked away in a safe, as once the music was published anyone could perform it, because of the lack of copyright protection.

Henceforth, the company would establish an American base, to create and promote their own brand and take on the plagiarists. This would, they hoped, crack this lucrative market. Sullivan wrote to his mother that in order to 'get all the profit we can' from the new opera, they were 'sending out three companies to other towns in America'. All these companies were hand-picked, and had to be organised and rehearsed.[48] Helen travelled by herself to the United States at the end of February 1880 to take charge. Travelling alone was highly unusual: middle- and upper-middle-class women of the Victorian era did not travel by themselves and their experience of the world was 'severely limited by the bounds of propriety'.[49] When the legendary actress, Ellen Terry, travelled for the first time to the United States in 1883, at the age of 35 and already a huge success, she recalled

her absolute terror of getting aboard ship, 'with the fixed conviction that I should never, never return'. It took all her courage 'to face the unknown dangers of the Atlantic and of a strange, barbarous land', one where 'women wore red flannel shirts and carried Bowie knives' and where she might be 'sandbagged in the street!'[50]

From the earliest days, Helen travelled first class. This made a huge difference in what was always an uncomfortable journey across the Atlantic. Unlike the unfortunate souls in steerage – third class – crammed into small spaces and providing their own food, she was provided with luxury and privacy. Actors, unless they were very successful, travelled in second class, where cabins were shared. This could be less than ideal: the American traveller, Mary Krout, wrote of a voyage in 'a cabin shared with three persons, each of whom was more impossible than the other'.[51] Still, the voyage across the ocean was always a daunting one. Most passengers suffered terribly from seasickness, and it was a long journey approached with much trepidation. The star of *opéra bouffe* Emily Soldene (who for a time managed her own touring company) wrote of how she and the rest of the cast had 'made our wills, increased our life insurance, and sunk no end of capital in the travel insurance' before embarking on the White Star Line's steamship *Celtic* in 1874.[52]

As she arrived in New York, Helen was, like Terry, confronted with the strange and magnificent 'vast, sparkling Hudson with its busy multitude of steamboats, and ferryboats, its wharf upon wharf, and its tall statue of Liberty dominating all the racket and bustle of the sea traffic of the world!'[53] D'Oyly, Gilbert and Sullivan prepared to leave, while Helen was to remain on her own to run the four companies – that of New York and the three touring casts. She was also to run the office which managed various lecture tours, including that of budding playwright Oscar Wilde. The city was a cacophony of foreign sights, sounds and smells, with a large and growing immigrant population that brought its own customs, food and culture to the metropolis. German beer gardens abounded, catering to entire communities and their families. Huge indoor and outdoor beer gardens could hold 3,000 or 4,000 people, and many provided entertainments for both children and adults. The Atlantic Garden, the largest of these halls,

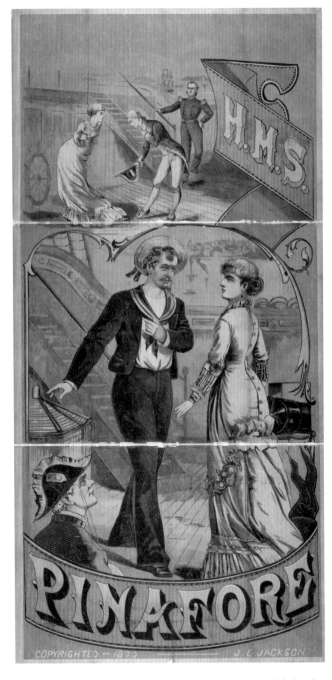

*Beautiful illustrations captivated the market, and helped
to create the illustrious Savoy brand.*

featured 'an immense room with a lofty curved ceiling, handsomely frescoed and lighted by numerous chandeliers and by brackets along the walls'. In addition to a restaurant, it contained 'several bars, a shooting gallery, billiard tables, bowling alleys, and an orchestra'. One enthusiast noted that there were 'dense clouds of tobacco-smoke, and hurry of waiters, and banging of glasses, and calling for beer, but no rowdyism'.[54]

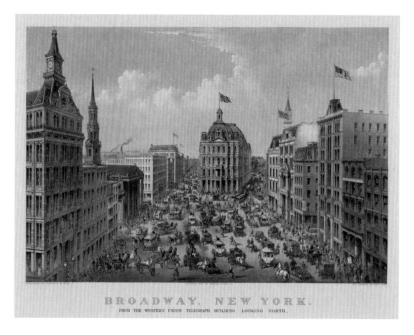

*New York City: a churning, marvellous melting pot of cultures,
nationalities and languages.*

In 1871 Helen could not sit a matriculation exam without special supervision for women. Now, she had travelled across the world by herself and was running a theatrical agency, with responsibility for four theatre companies – cast, crew and orchestras. She had to manage her life, selecting a respectable hotel as a *pied-à-terre* while putting in her usual endless hours at the office. When required, she travelled to cities across America and Canada to check on productions and sort out problems. She was in charge of dealing with the tough American theatre managers, renowned for their negotiating skills

and at times bare-knuckle interpretations of business etiquette and 'fair' play. Through all of this, she did not turn a hair. Report after report chronicled progress in the United States, where Helen got on famously with her counterparts.

She was in one of the most dynamic places in the world, and in no time, the young manager became D'Oyly's 'American brain' – as Matthew Arnold called her. Clearly unfazed by the electric atmosphere of New York, bright lights included (the stretch of Broadway between Union Square and Madison Square was stunningly illuminated by the revolutionary Brush arc electric lamps), she ran the business at considerable profit. The city represented a great opportunity for D'Oyly's commercial ideas. New York was undergoing rapid industrialisation and huge wealth creation – underpinned by cheap labour and thousands of immigrants arriving daily. It was a city of contrasts: as moguls such as Morgan, Carnegie and Rockefeller amassed eye-watering fortunes and built palaces, the poor huddled in overcrowded, disease-ridden tenements where they faced starvation, exploitation and the ever-present danger of fire. As the rich moved uptown and along Fifth Avenue, they increasingly drew up socio-geographic barricades and protected their economic and privileged social position.

These contrasts were part and parcel of the New York experience. As immigrant communities lived cheek-by-jowl in the bustling port areas and the Lower East Side, vibrant entertainment industries thrived. Cheap music hall productions were hugely popular and at the same time the theatre business on Broadway grew exponentially. The delights of storytelling and entertainments were universal, however, and transcended class and culture. The wealthy eagerly sought new opportunities to be entertained – and were accommodated in 'safe' areas where they would be insulated and protected from the poor, who might steal from them, or, even worse, envy them and cause social unrest. Luxurious theatre houses attracted the social elite who delighted in more occasions to demonstrate their wealth with fancy frocks and sparkling jewels. Self-made men accompanied by their status-hungry families could rub shoulders with snobby elitists in safety and comfort, all the while being diverted by productions of a

high standard. In a town built on money-making, the rich flaunted their wealth to excess. The Polish journalist – and later Nobel laureate – Henryk Sienkiewicz observed drily in 1876 that in New York

> you will find only merchants. Business, business, business, from morning to night, that is all you all see, hear, read…. Wealth is the chief criterion by which men are measured, and even the idiom of the language reflects this sentiment. Here people do not say a man *has* a certain amount of money, but that he is *worth* so many thousands.[55]

How many of the city's glittering socialites truly enjoyed the traditional opera productions such as those shown at the newly constructed Metropolitan Opera House, which opened to great fanfare in 1883? Perhaps what really mattered to the *nouveaux-riches* was proclaiming to the world at large that they could afford to own an expensive box. Indeed, the fabulously wealthy financier/politician August Belmont lamented to his European agent that he struggled to attract audiences to the highbrow operatic and musical offerings of the Academy of Music, although 'our people will rush to pay liberally for celebrities'. The 'music-loving & enthusiastic audience' was 'not yet of sufficient culture to do without the additional stimulant of some European celebrity or some native phenomenon'.[56]

There was another theatrical entertainment market, however, which was the one that mattered most to D'Oyly Carte. Plenty of prosperous middle-class Americans, reassured and gratified by the patronage of the very wealthy, were prepared to spend money on high-quality entertainment. In New York, as in London, they flocked to a salubrious environment, in theatres which were located not too far from the safer areas of the metropolis. The Gilbert & Sullivan productions, with their witty – yet never vulgar or improper – libretti and light, happy music, were perfect fare. Further, they catered to a taste among the affluent for all things English. Following the hugely popular visit of the Prince of Wales in 1860, Anglophilia reigned, as upper-class New Yorkers devoured English literature and commissioned architects to recreate features of English stately homes

along the eastern bank of the Hudson River or in rural New Jersey.

In such a propitious commercial environment, Helen, together with the locally hired agent Colonel Morse, developed the growing Carte business, running lecture tours as well as the light opera productions. She soon turned her tremendous intellectual firepower to challenging the vexing legal problem of protecting the Gilbert & Sullivan copyright. As the duo continued to produce new pieces in line with their agreement with D'Oyly Carte, the problem of protecting their work became ever more important. Over the six winters that Helen spent in America, she became an acknowledged expert in American copyright law for imported drama and music. This was crucial to the overarching ambition of growing the D'Oyly Carte brand. Helen fully understood the importance of protecting the integrity of the performance offer. The music (both as written and performed), the lyrics (again as written and performed) and the artistic elements of the production – the sets, props, the costumes as well as the integrity of cast selection and training – were all part and parcel of the high-quality product.

Copyright law extends to the creator of a work and control over how this work is used, and when pirate productions took place in America, this not only deprived the authors of their deserved profit, but also diluted and in many instances traduced the brand. In Britain, the rights of authors, artists and other creatives had been protected in various ways since 1710, and the law had evolved as markets expanded, in order to protect the rights of creators of original material. In America, however, protection was far more sketchy, performance was only protected under statutory law, and no protection at all existed for nationals of foreign countries before 1886.[57] Helen Lenoir, as the acknowledged 'primary American business representative' for the Savoy,[58] threw herself into the debate, and enlisted the help of lawyers Causten and Alexander P. Browne, who specialised in intellectual property law, to help argue the cases in court.[59] These arguments were particularly complex because the piracy was so varied and geographically diverse – each case had to be fought in state court, and the outcomes depended on the view of the sitting judge. Helen also took on litigation over the enforcement of contracts – it is no surprise that she acquired skills over this period that

led to legal experts such as Gilbert to comment on her formidable legal mind. It is clear, too, that her foundation in logic acquired during her studies proved a huge asset.

Patience, in 1881, was the next eagerly awaited operatic collaboration, and proved an immediate success – Sullivan took eight encores on the first night. D'Oyly determined that in future every Gilbert & Sullivan play was to launch as simultaneously as possible across the Atlantic. He initially worried that *Patience*, based on the Aesthetic Movement craze in England (as exemplified most famously by Oscar Wilde), might not translate to the American market. The promoter made use of Wilde's American lecture tour (organised by the D'Oyly Carte company) to cunningly advertise the piece – by asking the author to prominently attend a performance of the opera in New York. He had suggested to Wilde, he wrote to Helen, 'that it would be a good boom for him if he were to go one evening to see *Patience* and we were to let it be known beforehand and he would probably be recognised'. Wilde, having initially objected to being referred to in the press as D'Oyly's 'sandwich man' advertising the production, was happy with this, D'Oyly having taken the trouble to drop the idea 'incidentally in the course of telling him that he must not mind my using a little bunkum to push him in America'.[60]

The success of *Patience* was yet more evidence of the ability of the Savoy partnership to tap into the cultural and social trends of the day. The Gilbert & Sullivan formula succeeded because it recognised and gently ridiculed modern life, but it did not seek to radicalise or to lead. Yet the collaborations of artist, composer, designer, lyricist and manager brought together the fascinating blend of later Victorian culture which, in London, produced a fusion of ideas and innovations. The participation of the talented artist Percy Anderson was a good illustration of how the Savoy harnessed the very best of skills. A known but discreet homosexual, Anderson was the lover of the author Hugh Walpole, and a close companion of men such as the journalist William Morton Fullerton (famously involved in a passionate affair with the celebrated American author Edith Wharton). Lord Ronald Gower was another intimate, as was the artist Frederic Leighton (President of the Royal Academy). A coterie of artistic, wealthy homosexuals

were pivotal players in the cultural, military, political and social life of the nation. Until the arrest of Oscar Wilde in 1895 for homosexual activity – which, famously, was illegal – many of these men led what they imagined to be very private lives.

Although the law was draconian, there was an acceptance of homosexuality, as long as any frank reference to sodomy was avoided. Lord Kitchener, General Gordon, Cecil Rhodes and authors such as Edmund Gosse and Henry James were suspected of homosexual inclinations, but these matters were not discussed. What is important is that contributions by Anderson and Wilde were welcomed by the Savoy team. Indeed, Anderson was an important member of the franchise, designing all the D'Oyly Carte costumes, beginning with *Yeomen of the Guard* in 1888, and including the revivals of the early 20th century. Social occasions that included artists and artistic men of homosexual inclination were not avoided. Indeed, as the later legal persecutions of Wilde demonstrated, the overlap between the worlds of theatre and a thriving culture of homosexual artists, designers and authors was hugely significant. Helen may have chosen to shut her eyes to the bohemian habits of some of the men with whom she worked, but she was certainly aware, as were most sophisticated members of theatrical circles, of their 'outsider' status.

When looking back on the Gilbert & Sullivan phenomenon, it is tempting to assume that the two collaborators, having experienced such huge success and very high incomes from the offset, would have wished to continue their lucrative partnership. Certainly D'Oyly was enormously keen to develop and promote the duo, whose divergent backgrounds and skills combined to produce such fortuitous outcomes, writing to Sullivan as early as May 1881 that he looked 'upon the operas by you and Gilbert as my mainstay'.[61] Audiences couldn't get enough of the performances, the sheet music was hugely successful, and the future seemed paved with gold. Despite this success, and to D'Oyly's mounting frustration, the two creatives were often at odds, and refused – each of them independently – to put all their eggs in one basket. Sullivan, still fêted by the classical music establishment, yearned to create a serious opera that he felt would befit his musical status and legitimacy. Gilbert, meanwhile, continued to be in

demand for his writing, and was perpetually suspicious of D'Oyly, downplaying the impresario's contribution to their success.

Gilbert felt from the early days that he himself had perfectly good management skills, and didn't really need D'Oyly. Unlike Sullivan, who was not only a close personal friend of the impresario but an admirer of his business ability, the librettist constantly found fault with him, frequently complaining about the accounts. There has been much written about the quarrels instigated by Gilbert, and there were some catastrophic results, as we shall see. I think that it is important to recognise that Gilbert had excellent organisational skills, and just enough business aptitude to convince himself that if he didn't have to spend all his time writing, he could easily do D'Oyly's job. Sullivan had no such illusions and his inability to manage his own life without chronic debt left him in no doubt that it was in great part due to D'Oyly's and Helen's managerial abilities that he made so much money and, as important, was spared the worries and anxieties of running an increasingly complex business empire.

Gilbert was a confrontational character who didn't hesitate to criticise D'Oyly at any opportunity. Unlike Sullivan, who loathed conflict, Gilbert was, although a warm-hearted man, always on the look-out for perceived slights or cheating. 'I am sorry that you are dissatisfied with the manner in which the accounts are kept,' wrote D'Oyly to him at the end of 1880. Although he personally didn't believe that 'an error of £50 or so on transactions extending over about nine months and involving the turning over of about £30,000 is very out of the way' he had 'little doubt' that they would trace the full amount. The auditor he employed was the same professional accountant who worked on the Comedy Opera accounts, and he invited Gilbert to appoint his own auditor to go through the books.[62] One can readily sympathise with both sides in such an instance: with D'Oyly, because 0.17%, on an international turnover of an infant business with huge amounts of small transactions of income and expenses, was not very unreasonable, but with Gilbert too, because (especially for a military man) sloppiness in any detail was an indication of slipping standards.

The reason this is important is because the latent mistrust on

Gilbert's part set the tone for his relationship with D'Oyly – and this lack of confidence exacerbated the difference in the quality of relations between D'Oyly – and Helen – and the two creatives. Where Sullivan became an ever-closer intimate, Gilbert remained apart. In the years to follow, he often felt that he was outvoted by the composer and promoter, and Helen increasingly stepped up as peacemaker. As the years progressed, her role took on ever more importance, and there were times when Gilbert would refuse to deal with anyone but Helen – not simply because she was agreeable, but because her clear, logical brain matched his own, and he was amenable to her calm, rational explanations of how bridges had been broken, and could be mended.

Chapter VI

The Savoy Theatre
1881

HELEN'S WORK IN AMERICA gave D'Oyly the freedom to implement the next stage of the strategy, which was to build a theatre. Together with his close collaborator, Michael Gunn, he arranged for the purchase of a piece of land in the Strand that sloped down to the Thames Embankment. The new theatre was to be called the Savoy, in honour of the ancient Savoy Palace nearby. The site opened in October 1881, and D'Oyly wrote to Helen in New York with all the details. It was 'a colossal success, the loveliest theatre in the World all the critics say and everyone', he wrote excitedly. He raved about the 'marvellous' acoustics, declaring 'in the top gallery every whisper is heard'. The beautiful new building, exquisitely decorated in white, pale yellow and gold, could accommodate 1,292 people, with 18 private boxes and a gallery that could seat 400. This was D'Oyly's dream come true, and the new Savoy Theatre was the first building in the world to be lit throughout by electricity. It was especially popular for the Gilbert & Sullivan performances because audiences purchased copies of the libretti (from the start, an important source of income for the partners), which they used to follow as the show progressed, with the auditorium lights left on.

The business thus flourished in London, and was doing well in America, too. This is where Helen earned her stripes, as she learned the business inside out. D'Oyly had given her full discretion in management, and she ran two main business lines: in the first instance she managed to arrange for the productions that were showing in London to run in America simultaneously. Her preference was for

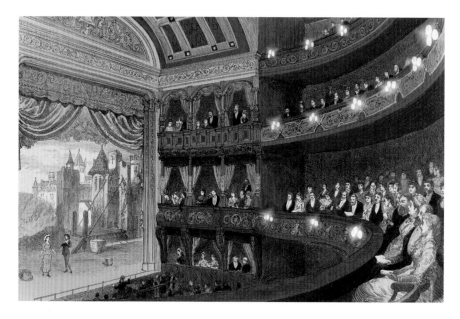

*The Savoy Theatre: the loveliest theatre in all the world, according to D'Oyly,
it was fully lit by electric lamps and exquisitely furnished in white,
pale yellow and gold.*

the London team to send out experienced cast members, which she supplemented with American talent, explaining to D'Oyly that 'it is not very good business to bring out here novices however good their voices, because they are rarely in use, except for chorus for several months, and it would of course be cheaper to keep them in England during the time they are learning'.[63] She also ran the touring companies, and although each company had its own manager, she was in overall charge, and travelled regularly all over the country – and Canada – to spot-check performances and to solve inevitable problems that had cropped up. Travelling across the United States in the 1880s was adventurous, and full of surprises. In rural areas, local laws and customs ruled.

Emily Soldene wrote of her shock in 1890 when a young boy was found to have smallpox, while they were travelling by train across the Great Plains. The train car was locked – with all its passengers inside – and left behind some 50 miles outside Denver, where city

authorities refused to let the car cross city lines. As the incandescent male passengers climbed out of the windows, one of them shooting at the departing train, the conductor explained to her that food would be sent out every day, and provisions would be set out at a distance. A doctor would visit, but the passengers would remain quarantined for two to three weeks until he ascertained that they were safe (if alive). Thereupon, 'everything in the car will be burned, the car and the people fumigated, disinfected, and the passengers, supplied with fresh clothing, will resume their journey'.[64] On arrival in Denver, 'alive with excitement', she marvelled at the giant billboards: 'The Small-Pox Clamouring At Our Gates'; 'The Small-Pox Fiend Is Abroad'; 'Deadly, Disgusting Disease'; 'Death In The Desert'.[65]

The brash modernity of the new nation appealed enormously to Helen, who of course was herself the product of a society at a turning point in its history, moving away from Victorian norms to changes driven by technology and innovation – changes that were reflected in the social, economic and cultural trends of the 1890s and the turn of the century. America was, however, a very different country from the one Helen had left behind. Forcible smallpox vaccinations, for example, were taking place – a shock to the D'Oyly Carte players (Britons had been compulsorily vaccinated since 1853). Lindsay Harman, a Savoy actor for 12 years, was horrified to witness a sudden raid by police and doctors on a crowded beer garden in New York late one evening, where the guests and artists were examined. 'Two girls, who were performing there,' he recorded, 'had their arms bandaged the next day and told us they had been forcibly vaccinated.'[66]

With full independence in making decisions for the theatres and companies, there was no hint of shyness or undue deference in Helen's letters to D'Oyly: in one instance she wrote urging him to 'not forget what I wrote to you the other day in regard to your purchasing the American publishing rights. I am anxious that you should do so.'[67] It is striking to observe the readiness of D'Oyly Carte not only to bestow his complete confidence in the novice manager, but also his encouragement of the young woman – at a time when the pervasive belief was in separate roles for the sexes. As the activist and writer Mary Kathleen Lyttelton so memorably wrote, 'great patience' was

needed to change these ideas:

> Many men and many women believe in all sincerity that the greater independence and power of women will injure the race, because it will destroy that protecting, chivalrous instinct which teaches the man that the highest use of his strength is to protect and care for women as weaker than himself.[68]

There was simply no hint of any patronising protectionism from D'Oyly to his young manager. Correspondence between the two could take up to two weeks to arrive, and the pair devised a code to use in telegraphs. It was cloak and dagger stuff, which clearly thrilled them both. In a cowboy world, they felt themselves to be the sheriffs trying to outwit the desperadoes. This was life on the frontier, and it was exciting, frustrating and, to D'Oyly and Helen, a great deal of fun. When reference is made to Helen's extraordinary work habits, it is important to note that she loved her job and thrived on it. On the one hand, she had meetings with high-powered lawyers, absorbing their knowledge like a sponge, helping to put together arguments for legal attacks on the unscrupulous pirates. On the other, she and D'Oyly devised ways to trick would-be copycats by communicating in code, using all kinds of red herrings by referring to fictitious titles, made-up opera pieces and projects – bits of misdirection that were rapidly picked up in the gossipy world of Broadway. Clearly Helen had not entirely left her acting days behind her.

She shared her operational challenges with D'Oyly, but she solved them herself. She had been 'unable to keep the English girls together', she informed him in September 1882, having had to divide them 'into the "fast" set and the "quiet"'. Some of the actresses were coming home 'at all hours' and the landlady had insisted on their removal, which had 'upset our contract'. She had solved the problem by sending off the fast set with $10 apiece for board and had kept 'the good and quiet six' together.[69] Despite her youth, an important part of Helen's job was to keep the cast safe. In New York, as in London, this meant keeping the actresses from exploitation and harm. As stage star Ruby Miller recalled, 'flocks of admirers' crashed the stage door

after every London performance: 'Resplendent in their tails, opera hats and cloaks lined with satin, carrying tall ebony canes with gold or silver knobs, and with the eternal gardenia in their buttonhole, they represented the "man-about-town"' and in many cases were the sons of the nobility. Members of the 'most exclusive clubs', these gentlemen of leisure would divide 'their time between these Corinthian-pillared edifices, their family stately homes and town houses'.[70] At the stage door, the 'mashers', as they were known, would send notes, flowers and gifts to their favourites, hoping for favours in return. A strict policy was in place in the D'Oyly Carte theatres, and rigidly enforced. Despite this, there were plenty of mishaps, and cast replacements were a regular headache in Helen's life.

Further, a crash course in the American market enabled her to advise D'Oyly on how to manage the business strategy there, as she explained:

The season here is not all the year round as in England. The best of the season is before Xmas. After that time every day postponed is a day lost. If a G. and S. opera were produced here on (or rather before) Xmas it ought to run into May – but every day you postpone it beyond Xmas, is a distinct, clear and irretrievable loss. You cannot make up for it by running on into May (...) So much depends on the success of 'M.N.' and 'Rip' [two Carte productions she was managing, *Manteaux Noirs* and *Rip Van Winkle*], which a very few weeks will decide.

I am afraid about 'Rip' rather, but I may be quite wrong. Still, as I say, I consider the G. and S. opera as a certainty, and I consider every day it is postponed a day lost for it (after a certain time). Remember it is only this season you can make a cent out of it here – and it will probably make all the difference to the financial results of this season. I am anxious to make all I can for you here this year – and wind up.[71]

Helen had rapidly developed an understanding of the differences in doing business on the other side of the Atlantic, noting wryly to D'Oyly that people in the United States were 'so accustomed to

"blowing" that it is very difficult to convince them that you are telling them the truth'.[72] Helen Lenoir, however, had a sterling reputation for honesty and trustworthiness. And although she was compassionate and resilient in dealing with the inevitable operational challenges that dogged all activities in the theatre business, she was no pushover, as theatre manager McCaull learned. 'I have delayed writing you before in regard to the little matter between us,' she wrote, 'as I supposed you wished to get your season well launched before paying what you did not consider as most pressing matters.' Now that she could see that 'the dollars are raining in' she would 'be glad to receive the small amount for which I hold your cheque ... You can hardly say I have not waited in the most patient manner.'[73]

The more brash, commercial Americans did not intimidate this small-statured but self-possessed woman of quiet confidence. Already by January 1882, the press had taken notice: 'We are gradually becoming familiarised with the idea of ladies entering professions,' reported the *Hendon & Finchley Times*, 'but America gives us the first theatrical manageress, who is the business head of Mr D'Oyly Carte's "Patience" company.' Indeed, the article continued, Helen Lenoir 'attended to all the details, singers, assistants, wardrobe, orchestra, advertising, etc., yet is only 25 or 26 years of age'.[74] The New York of the 1880s clearly had elements of the wild frontier in its business dealings, but Helen was equal to the task of dealing with her male manager counterparts with collected efficiency, informing E.E. Rice that, with 'regard to the territory outside of New York Brooklyn, Philadelphia and New England', she was:

> willing to arrange with you for such places as you desire on the same percentage as New England on the understanding that you will bring me – on or before next Thursday (November 9) a list of the cities which you visit, and will show me that you have secured the [illegible; probably contract on a theatre rental] in the cities. You to pay me a deposit of one thousand dollars on account of said percentage on November 9th. It is understood that if you complete the agreement you will form a second company to play the cities outside of New England.[75]

Many of the managers were speculators, seeking to make money quickly, with little regard for the artistic standards so dear to the Savoy company. Helen had to watch them like a hawk. At a full-dress rehearsal of *Utopia*, John Stetson, manager of a number of theatrical companies, interrupted the overture and pointed to some members of the orchestra: 'Say … what are those men doing? I've been watching them and they're not attempting to play.' When told that they had 'so many bars' rest', the irascible Stetson replied: 'Oh have they though? Just you write something in for them then. *I don't pay nobody to rest here.*'[76] Nothing daunted Helen, and by 1882 she was such a mainstay of the growing business that D'Oyly offered to give her a £1,000-a-year salary and a profit share. To put this salary in context, a teacher might have been earning £120 a year. The value Helen was adding to the business venture was reflected in the proposed salary, D'Oyly insisted. He and Gunn were particularly keen to give her a profit share that would not, however, expose her to any risk. Helen had become so integral to the success of the D'Oyly Carte enterprise that by the end of October he wrote that he needed her to return to London:

> Now there are two alternatives before me and I cabled you as to what the receipts were and as to when you could close up business and return (which I very much wish you could do at once as your presence here would be most desirable; in fact the word 'desirable' is altogether ludicrously inadequate to express the situation). Your presence would be invaluable.[77]

D'Oyly was quick to promote Helen, and she was equally rapid in repaying his confidence. It was always difficult to manage the crop of talented singers, actors, musicians and stagehands, and Helen never shirked from keeping standards high as well as an iron control over hundreds of employees on contract. She ran a tight ship and didn't hesitate to act when necessary. When Augusta Roche (real name Mary Augusta Darvell), who was playing the role of Queen of the Fairies in the new American Gilbert & Sullivan production of

Iolanthe, did not turn up for work in January 1883, Helen promptly sacked her:

> I was extremely surprised on sending to your house this afternoon to enquire if you were ill to find that you were out, and (as stated to my messenger) had gone to a matinee. In my experience of five years with a number of opera companies I have never till now had an artist fail to appear in his or her part before the public in order to go and see another entertainment, without permission. It is a gross insult to Mr Carte – and still more to the public. I was convinced there must be some mistake until informed by Mr White this evening that you had yourself told him it was true.
>
> You have, of course, forfeited your engagement under clause 3 of your contract, and I shall not therefore require your services after to-day.[78]

Miss Roche did not appear in a (sanctioned) Gilbert & Sullivan production until 1885.

Chapter VII

Running the Show
1883–85

THE LAUNCH OF THE OPERA *Iolanthe* in 1882, followed closely by *Princess Ida*[79] in January 1884, cemented the reputation of Gilbert & Sullivan, but did little for their friendship. It was still an uneasy partnership. Sullivan suffered continually from ill health, exacerbated by periodic bouts of depression and anxiety about his role in Britain's music landscape. His work at the Royal College of Music earned him a knighthood in 1883, which filled him with joy, although the honour also opened the door to his critics who questioned the suitability of his continuing to compose light opera. Financial worries exacerbated by his gambling addiction did little to help. These woes did not, however, result in poor professional performance. On the contrary, his music scores continued to win great applause, even when Gilbert's libretti were found wanting. Gilbert was less prone to agonising over his purpose, and quite delighted by the success of the venture, which gave him the financial freedom to buy a new yacht and a new house. His main complaint was about the role of D'Oyly Carte and he continued to be suspicious of the accounts.

The success of the pieces, however, was enormous. A packed house greeted the premiere of the political satire *Iolanthe*, and politicians 'roared their ribs to aching pitch' as they heard 'the Sentry's hilarious views and sentiments on the House of Commons'. Indeed, 'patricians and plebeians' alike were in fits, as each 'pungent point of satire and ridicule was the signal for a volley of laughter'.[80] It was widely agreed that the partnership was reaching new heights, and the exquisite productions were a must-see for theatre-goers.

What delighted, united and fortified the D'Oyly Carte/Gilbert & Sullivan partnership was the ability to harness the awesome technological advances being made during the period. Both Helen and D'Oyly travelled incessantly, and both Sullivan and Gilbert spent much time on the Continent, where they relied on spas to restore their weariness and poor health (Gilbert increasingly suffered from gout as he aged). The increasing reliability and rapidity of the cross-Atlantic journeys had of course helped their American business, as had the telegraph (the first permanent transatlantic cable was operating in 1866). The British Post Office had taken over private telegraphing in 1868, and in 1885 reduced by nearly half the price for internal telegraphs to sixpence for 12 words.[81] Electric lighting had made the Savoy Theatre a wonder to use and behold. Now, the invention of the telephone would further transform experiences. Great was the excitement when on 14 January 1878 Queen Victoria had used Bell equipment to make the first telephone call in Britain.

D'Oyly was one of the first in England to jump in and had a telephone installed at the theatre in 1883. On 13 May a thrilling birthday treat was organised for Sullivan when the telephone was linked up to 36 receivers in his home, allowing his guests – who included the Prince of Wales and the Duke of Edinburgh – to listen to a late-night performance of *Iolanthe* by a specially assembled cast. And Gilbert, never slow to optimise new means of scrutinising expenditures and profits, immediately put in place a system where the box office clerk at the theatre was instructed to telephone the day's takings to Gilbert's home every evening.

Allied to the embrace of modern technology, the partners insisted on maintaining the highest standards of production values. Frank Cellier observed approvingly that for *Princess Ida* everything that Carte could do in terms of 'care, liberal expenditure, and consummate taste' was done and 'marked the last phase of perfection'. The costumes were, as ever, a priority – and they were 'rich in texture, exquisite in colour and design'. Expensive silver-gilt armour had been 'specially designed and manufactured in Paris by the famed firm of Le Grange et Cie.', and 'excelled in brilliancy of the sort ever seen at Drury Lane'.[82] Despite periodic setbacks where either Sullivan fretted over

the sublimation of his musical talent to Gilbert's libretti, or Gilbert objected to management decisions and costs, the pair continued their successful collaboration, and Helen's presence, whether in person or by letter, helped enormously. Gilbert wrote to her in November 1883 that he was 'quite distressed' to have 'referred so lightly to the remarkable letter' he had received from her.

Indeed, he continued, he didn't 'believe there is another woman alive who could have stated so complicated a case in such a masterly manner'. One of Helen's greatest strengths, honed over the years since taking her certificate in logic, was her ability to recall and summarise a series of events and decisions with perfect clarity. To someone of Gilbert's intelligence and high degree of sensitivity, her clear and calm and utterly irrefutable explanations were like a soothing balm that made sense, without in any way wounding his vanity. In addition, she was more than his intellectual equal, as he – somewhat surprisingly – acknowledged, declaring that his confidence in her 'brain-faculty & acute judgement' made him amenable to trust any of her recommendations implicitly.[83] For Sullivan, Helen's cleverness, kindness and warmth increased his motivation to continue with the Savoy productions – despite his frequent frustration with both the format and his writing partner.

Helen took the time and made huge efforts to soothe Gilbert, always so quick to take offence. Another quarrel had arisen between him and D'Oyly in 1883, culminating in a letter from the author to the impresario, threatening that unless he changed a plan to launch a revival, 'all friendly relations between us are at a definite end, & no consideration whatever will induce me to set foot in the Savoy Theatre again'.[84] This was patched up by Helen.[85] However, the argument was one in a seemingly never-ending series that exhausted all parties. Keeping Sullivan solvent and motivated and Gilbert on an even keel and relatively resentment-free was practically a full-time job in and of itself. Happily, the opening of the new opera, *The Mikado*, in March 1885 proved an immediate and tremendous success. The composer and librettist were lauded, and Carte hugely admired for his achievement. The mania for the piece soon reached epic proportions and the blockbuster placed Gilbert & Sullivan, and

the Savoy Theatre, very firmly on the superstar map.

D'Oyly frequently drew attention to the invaluable role played by Helen. In an interview published in the *Sunday Times* in May 1885, he volunteered that his system of management was simply that of applying business sense to an enterprise which had 'too often been conducted in a careless, "happy-go-lucky" style'. No 'account of my administrative work would be complete', he insisted, 'without reference to Miss Helen Lenoir', who had the 'entire direction of the provincial and American business'. She had begun by helping him with correspondence, but he had 'soon discovered in her a remarkable business aptitude – an aptitude which, so far as my experience goes, is unprecedented in a woman'. His partner had 'wonderful perception, energy and administrative ability, and, to crown all, the power to govern others'.[86] Other senior managers agreed: in his recollections, dedicated to 'Dea ex Machina' Helen Lenoir, Frank Cellier paid tribute to 'a kind, gentle, ever-watchful spirit in the form of a woman – a woman whose wisdom, tact, and energy did more to enhance the fortunes of the Savoy than the greater world can ever realize'. He 'humbly' dedicated his reminiscences to a manager who had filled her post 'with such extraordinary skill and ability'.[87]

D'Oyly claimed, furthermore, that on 'international copyright and dramatic rights she is probably one of the best living authorities'. He had years of business experience, and for him, Helen's 'industry and determination' were 'at times appalling to weaker mortals'.[88] She achieved this reputation while remaining extremely well-liked. Festive gatherings by the repertory companies invariably included toasts to the health of D'Oyly Carte, followed by one to Helen – which featured cheers as well. Before one of her long journeys, members of the company presented her with a bracelet, 'as a small token of esteem and respect'.[89]

Helen had a seemingly insatiable appetite for work. In America, she instigated a legal campaign to clarify existing law with regard to a combined dramatic and musical performance. Protecting the authors and the integrity of the performance was extremely difficult, as music in particular was not recognised within a musical drama as a legal entity entitled to protection. With her legal team, Helen

spearheaded case after case to push for clarification and modification of the law, which had simply not kept up with developments in the entertainment industry. It was dispiriting to see pirate performances take place in unsuitable venues. *Mikado* opened in the Museum [*sic*] in Chicago on 29 June 1885, for example, 'competing with a 21-inch tall Mexican woman and a two-headed cow for the public's affections at that theatre'. The tale gets worse for the D'Oyly Carte carefully curated brand: the *New York Times* reported years later that

> the manager of the double-headed cow became upset at the amount of business being done by 'The Mikado,' ... and tried to claim a breach of contract. He used to take the cow to the door of the theatre, and then he claimed that it was the cow and not 'The Mikado' which drew the crowds into the Auditorium. Finally, there had to be a compromise with the cow manager.[90]

Helen crossed the ocean over a dozen times. She simply lived for her job, and it was clear that she and D'Oyly shared a warm, respectful relationship. It is apparent, too, that D'Oyly saw little of his wife Blanche, who suffered increasingly from illness. By 1881, when the census listed D'Oyly in Kentish Town at his father's address with both of his boys, Lucas and Rupert, with no sign of their mother, it would seem that the couple were estranged. The boys were sent to live with D'Oyly's sister, Eliza, as their mother's health (and mental wellbeing?) faltered, and in the summer of 1885, Blanche was living at St Albans Bank in a rented home, where she died, apparently of bronchitis, according to newspaper reports, on 31 August. D'Oyly was in New York with the *Mikado* company, and his wife died with her father William beside her. Tellingly, she was buried in Highgate in the Prowse family plot.[91]

There is little known of Blanche, and no mention of her in the many memoirs written by those associated with the Savoy. What can be ascertained is that she and D'Oyly had been leading separate lives for some time before her death. In the gossipy, close-knit theatre world, and within the Savoy company, there was nevertheless no indication of anything other than a friendly and trusting working

relationship between D'Oyly and Helen. Indeed, they were most frequently on separate continents. It is hard to avoid concluding, however, that Helen and the impresario had found in one another a kindred spirit, and that this fired D'Oyly's entrepreneurial enthusiasm when his mood inevitably flagged with setbacks.

Helen and D'Oyly delighted in mutual friends, and moved in interesting and vibrant social circles – mostly made up of professionals who had become intimates. The clever celebrity solicitor George Lewis (later Sir George), of a Sephardic Jewish family long settled in England, had acted for D'Oyly and befriended him and Helen. Together with his talented and beautiful German second wife Elizabeth, Lewis – a favourite of the Prince of Wales – regularly hosted parties for artists, actors, musicians, intellectuals, financiers and politicians, forming a locus of both 'establishment' and bohemian society of which Helen and D'Oyly were a part. To be invited to these parties was a mark of having 'arrived', as Elizabeth had become a famous society hostess – and the fact that Helen, known as 'the theatre manager', clearly held her own at these events is clearly an indicator of her poise and confidence.

George and Elizabeth Lewis were avid first-nighters, as attendees of theatre's opening nights were known, 'indispensable figures at every important premiere'[92] – and very close to Sullivan. Elizabeth was a great supporter of the arts, and regularly adopted protégés in the literary and artistic worlds. One such was a young Oscar Wilde, and it was she who suggested to D'Oyly that the young author undertake an American tour,[93] which Helen herself famously managed. Another of the Lewises' friends and protégés, the painter James (always 'Jimmy' to his friends) McNeill Whistler – who referred to himself in the third person as 'The Butterfly' – also befriended Helen. In 1881, she began attending the artist's famous 'Sunday breakfasts', which were gatherings hosted by Whistler for artists and patrons, as well as literary and theatrical figures.[94] She joined artists such as the successful feminist Louise Jopling, who ran a 'celebrity' salon, which helped her to find much-needed commissions among the glitterati of the day. Celebrities such as the stunning actress (and royal paramour), Lillie Langtry, fondly remembered tasting the American's 'delicious

buckwheat cakes, pop-overs, corn muffins and other cereals that make breakfast such a tempting meal'.[95] It was a social honour to be included, and another sign of having 'arrived'. The breakfast – really more of a brunch, served at noon – was always attended by interesting and influential guests, and Whistler's dining room was beautiful, decorated with Japanese *objets d'art*. Helen shared corn muffins with luminaries such as the architect Edward Godwin – famous for his leading role in the English Aesthetic Movement – and the well-known journalist George Smalley.

Helen was so at home with artists, writers, actors and others in the public eye that Whistler insisted that she manage his lecture tours, begun in 1885. She had already organised a very successful (although, as was usual for him, derided by the critics) lecture series, the 'Ten O'Clock', where he spoke fluently on the challenges facing art. The artist frequently visited Helen in the evenings at her office and wrote to her, seeking advice on his business affairs and chronic difficulty with finances. He called in at the theatre, where she was hard at work preparing to open *The Mikado*. He 'delighted in her office, a tiny room lit by one lamp on her desk, with the effects of light and shadow'.[96] Inspired by this, he produced the etching *Miss Lenoir*.

Such was Whistler's trust in the theatre manager that one of the reasons for which his American campaign (a lecture tour such as that undertaken by Wilde) did not take place was because Helen was not available to travel to the US to run it for him: the artist told D'Oyly that he was 'quite dispirited' about the campaign, without Helen's 'sympathy and joyous sense of things in managing the affairs'.[97] The bond between them was strong, and The Butterfly later produced a beautiful portrait of Helen, *The Fur Tippet*. One of Whistler's talented followers, the artist Walter Sickert, also befriended Helen, regularly dropping into her office at the theatre, and he too produced a beautiful etching – and then a painting[98] – of her 'sitting at her lamp-lit desk poring over her paperwork'.[99] This was the famous *The Acting Manager*. These portraits represented determined efforts by Sickert to assert himself as an individual artist and not merely as a student of Whistler. The etching was exhibited at the Royal Academy in 1885, a first for the artist.

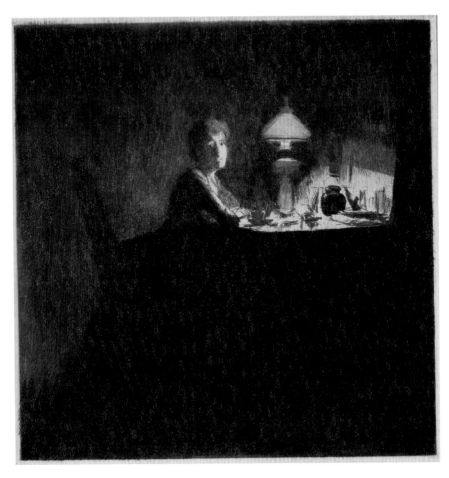

Miss Lenoir etching: The Acting Manager *by her good friend the artist Walter Sickert.*

London in the 1880s through to the turn of the century was characterised by an appetite for modernity, and the thrill of innovation. Technological, artistic, architectural, retail and other changes were adopted by avid consumers, from the lower middle classes to the aristocracy. One characteristic of the changing society was an increasing mingling of individuals, who would not, in previous years, have crossed one another's paths in a social situation, such were the stringent stratifications practised by those at the top. But now, the cosmopolitan capital, driven by rapid economic change

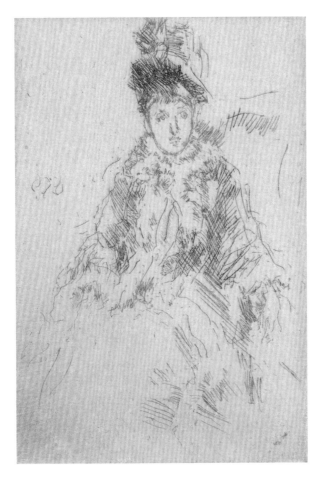

The Fur Tippet: by Helen's close friend James MacNeill
Whistler, who was known as 'The Butterfly'.

and led by the debonair, pleasure-seeking Prince of Wales, ushered in all kinds of new participants to the most elite of social gatherings and pastimes. The legendary French actress, Sarah Bernhardt, recalled how in 1879 she had hosted an 'inauguration' party in London to launch an exhibition of her artistic creations, which was attended by the Prince and Princess of Wales. She wrote that 1,200 members of the 'English aristocracy and the celebrities of London' had come to meet her, and 'Mr Gladstone did me the great honour of talking to me for about ten minutes'.[100]

Fired up by the opportunities of this modern Britain, D'Oyly was never happy unless he had a major, inevitably expensive and risky project under way, and he was determined to build a magnificent new hotel by the theatre. His dream of transforming the Embankment by the construction of a luxury hotel was frighteningly ambitious and exciting – exactly the kind of investment he loved. The Savoy Hotel, on the Strand, would be a jewel in the Savoy crown, a natural extension of the Savoy quality entertainment brand. It would also be incredibly expensive. Beginning with the land purchase in 1884, the project would take four years and right from the start added to the 'large drain on the ready money',[101] as Helen told Whistler; the new building 'seems to be a regular sponge in the way it takes money!' She was involved in every stage of the design process, even when travelling, as D'Oyly consulted her about everything.

Chapter VIII

Australia and Global Success

1885–87

Now, at long last, Helen was to make the trip to Australia. This was to organise a *Mikado* tour with their Australian manager, but of course would also be an opportunity to see her family. On 20 July 1885, Helen Lenoir disembarked near Adelaide, to set eyes on her mother and siblings for the first time in eight years. She arrived a celebrity with much fanfare, and on 4 August a full interview (conducted by her brother John) was printed in the *South Australia Advertiser* and numerous other papers. Helen explained that her expertise on copyright law had come about as a result of the large numbers of pirate performances of the Gilbert & Sullivan productions in America. In one instance, a case over a breach of copyright of *The Pirates of Penzance* was still ongoing after six years. In addition to explaining the workload entailed in running these court cases, Helen provided details on how she dealt with running five different companies all over the United States. The *Sydney Evening News* wrote that 'Miss Lenoir appears to be gifted with marvellous managing capacity, and it is said in America such wonderful administrative powers and business aptitude in a young lady have caused a perfect sensation'.[102]

Helen brought stardust with her and must have observed that life had not been easy for the Black family. John had struggled enormously, having tried with little success to earn his living by farming in Baroota, north of Adelaide. Ellen was still financing the whole family. Alfred was training as a surveyor, and Hilda had been living at home, where, as John noted, she was 'unhappy', and was 'being very difficult

and causing many unpleasant scenes'.[103] Already, some five years previously, Ellen had been trying to convince her difficult daughter to return to England with an allowance provided by her.[104] Hilda did return to England some time in 1885 or 1886, living in Clifton near her mother's sister, Aunt Emily. John had rushed into a land purchase despite his lack of experience, and ended up buying farming land so poor that it was uneconomic. To do this he had borrowed £900 from his mother, and was left practically destitute when the property took years to sell for a pittance, thus losing nearly £1,000 of his mother's capital. Relations soured between John and Alfred, who each felt that the other was getting more from their mother. John resented Alfred for living comfortably with Ellen free of charge.

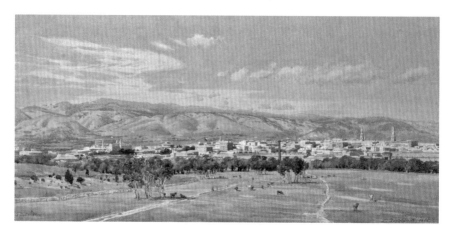

Rural Australia: remote and beautiful, South Australia is huge, covering an area of over one million square kilometres.

Helen could not fail to realise that life had been tough: John's wife Alice, an Australian-born daughter of a farming couple who had emigrated from Falmouth, had married him aged 17. She had then immediately plunged into the hardships of frontier living, where the arduous clearing of brush to provide arable land was a never-ending, physically gruelling battle fought in extreme heat with insect invasions and other hardships. It was a lonely business, and the couple were quite isolated, as the other small farmers in the rural area

worked desperately hard to eke out existences on what many began to realise was poor-quality land. One day, Alice had to lock herself in the small wooden house after a hired man, armed with a sheaf-knife, wandered in from the paddock, telling her that it was 'awful lonesome out there, missus'. Later, on his return, John had to chase him with a revolver – and from that time the couple slept with their windows shut, despite the stifling heat, for fear of intruders.[105] In the summer they toiled under blazing sun, fighting off the black flies as well as kangaroos and emus who fed at the wheat-heaps.

In 1883 John was convinced by his young wife that the lack of water and poor soil made their lives unsustainable, and they sold the stock and implements at a loss and left Baroota. John once again started at the bottom of the pile, and to support him in his new role as a cub reporter, Alice – with a young daughter and running their new home – proved herself able and adaptable, as she helped her husband to learn Pitman shorthand by reading him the newspaper in the light of the kerosene lamp.[106] By 1885, at the time of Helen's visit, Ellen had helped John to find a job as a reporter, and bought him a house in Norwood, a suburb of Adelaide. This was far more congenial, although he was not very well paid. Life was hard and John struggled with healthcare as well as financial insecurity: that April, his wife Alice, just 23, had had six of her teeth pulled, and 11 fillings, while 30-year-old John had four new fillings and seven extractions.[107] Although John's diaries later recount happy times with his growing family, and the simple pleasures they enjoyed, life was a constant struggle.

It was quite an unhappy extended family, as John and Alfred squabbled over their mother's investments. Helen was thus met with a mixed picture. There is little record of how 63-year-old Ellen felt about the move to Adelaide, but certainly there was no suggestion of returning to Britain. Helen had arrived in the wake of the huge success of *The Mikado*, which was being fêted throughout the English-speaking world. The new production was massive, both in its innovative and exotic setting in a fictitious village in Japan, inspired by the British craze for all things Japanese through the 1860s and 1870s, and in its impressive staging. Great care had been taken, with considerable expense, in making the costumes, which were in

the main produced by the celebrated English firm of Liberty, crafted with the finest authentic silks and embroideries. Helen travelled on to Melbourne after spending two weeks with her mother, with the prompt book and band parts for *The Mikado*, to be handed over to Mr Williamson, who had earlier in London that year obtained the sole rights to the piece in Australasia. With Helen's help, he was preparing to open the opera at Christmas.

From Melbourne Helen went on to Sydney, then took the boat to San Francisco on 13 August. She had spent less than a month in Australia, but could spare no more time. The plan was for her to join D'Oyly, Sullivan and Gilbert to supervise the all-important New York opening of *The Mikado*. The project was surrounded with secrecy, in order to foil the plans of the spurned New York promoter Mr Duff, of the Standard Theatre, to pirate the piece before it had launched. D'Oyly, hearing of the plot, had quickly secured a commitment from Liberty's not to supply Duff with any costumes or fabric, and had had all the costumes and Japanese silks bought up in Paris, thus depriving Duff of a critical element of the piece. The entire company – including D'Oyly – travelled under false names in order to arrive in America before Duff had time to launch his pirate production. The cloak and dagger scheme was entirely successful, and *The Mikado* opened to huge enthusiasm. Within weeks, the piece was the talk of the town: 'Ladies adopted Mikado fashions and walked in a delicate, Japanese way; the vocal scores sold thousands upon thousands of copies, as they did in London; Japanese curios became all the rage; there were Mikado jokes, Mikado caricatures, Mikado parodies.'[108]

This blockbuster reaffirmed the success of the Savoy Theatre and its franchise, and D'Oyly and the partners exploited it to the full, ramping up the publicity and encouraging its commercialisation. As in England, all kinds of products were sold using the popular show. The various characters of the opera were featured on trade cards 'advertising spool silk, dental cream, soap, cotton thread, Waterbury watches, and corsets'. The lead 'Mikado' 'sold Lautz Bros. "Pure & Healthy Soap"; and he had a kerosene stove named after him'.[109] What D'Oyly was keen to do was to ensure that the money made would as much as possible find its way to the Savoy coffers, for the benefit of

his partners and the firm.

The Savoy Theatre management team had from its inception

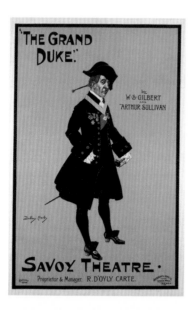

Illustrators, costume designers and dressmakers, set creators, props managers and others contributed their creative excellence to the Gilbert & Sullivan and Savoy ventures.

benefited from the development of advertising in Britain. D'Oyly and Helen excelled in understanding the importance of timing and the need for high-quality communication. Helen was a keen proponent of using the programmes to attract advertisers. This enabled the Savoy to offer the programmes for free – to which they drew attention in all their publicity – and it brought together other high-quality brands that were eager to reach a lucrative market. The advertisements were often themed with the production, thus generating mutual branding benefits. Furthermore, the companies paid handsomely for the right to advertise, thus providing the partners with another income stream. Both D'Oyly and Helen believed that the front of house was as important as what was happening on the stage, and behind it. Patrons were welcomed as valued guests, from the moment of purchasing their allocated seats to queuing without a scrimmage, to using the cloakroom facilities free of charge, to receiving their beautiful programmes and being guided by courteous staff who were not allowed to take tips. It transformed the theatre experience into a genteel, delightful evening out, where everyone was expected to behave with dignity and courtesy. The rowdiness was confined to enthusiastic singing and requests for encores. Regulars who knew the Gilbert & Sullivan repertoire by heart sang gustily before the performance began, as excited patrons in the pit joined in.

The sense of belonging was reinforced by knowing the words of the operas, by buying the associated merchandise, and it was remarked of the audiences that for 'all their gaiety and laughter', a 'performance of a Gilbert & Sullivan opera at the Savoy, with a rapt audience following every word in their programme, and turning the page at the same time, was reminiscent of a prayer meeting in a church or chapel'.[110] First nights were especially lively; *The Mikado* opening was adorned by the likes of the Duke and Duchess of Edinburgh and Princess Louise and Prince Louis of Battenberg. Socialites such as Lady Randolph Churchill (better known as Winston Churchill's mother, Jennie Churchill) and other close friends of the Prince of Wales took boxes and formed part of the spectacle, bedecked in splendid silks and diamonds, all glittering brightly against the velvet backdrop. Audiences peered up at them through their opera glasses

– enjoying more than one entertainment for the ticket price. Gossip was exchanged as the excitement reached fever pitch. To be at an opening night was a treat not to be missed. Lady Randolph Churchill recalled of first nights that 'no one who did not assist at them can realize the unbounded enthusiasm with which they were received or the excitement with which a new work was looked forward to by the public'. Indeed, she claimed, the first night 'was quite a national event'.[111]

For all classes, the sheet music was in great demand. Cunningham Bridgeman, a long-time writer for the Savoy, observed that when the score of *The Gondoliers* was published, 'twelve men were kept packing from morn till night, and on the first day 20,000 copies (eleven wagon loads) of the vocal score alone were despatched'. The presses 'were still kept going at high pressure', he added, as 'the first order executed by the publishers, including the pianoforte score, the vocal score, the dance, and other arrangements reached 70,000'.[112] The franchise was always quick to profit from product placement and promotions. As early as 1882, during the *Iolanthe* run, a full-page advertisement in the programme for the Liberty emporium had as its head: 'The Dresses worn in this Opera are made from Liberty's Art Fabrics'.[113] Other pieces included in their programmes specific references to the providers of materials used, from the parquet flooring to the jewellery worn by the actresses – from the Parisian Diamond Company.[114]

The wares being advertised were more readily available than ever before. Since the advent of the Great Exhibition in 1851, retailers such as William Whiteley, Richard Barker, James Marshall (of Marshall & Snelgrove) and others had established beautiful emporiums in central London selling all manner of linens, gloves, hats, fans, silks, costume jewellery, furs and artificial flowers.[115] These retail palaces opened up safe and attractive public space to thousands of middle-class shoppers, and successfully promoted spending money as both a necessity and a leisure pursuit. The overlap of the gorgeous costumes, sets and accessories seen on the Savoy stage with others pictured in the programmes contributed to a rise in conspicuous consumerism that was fuelled by the economic prosperity of much of society, accelerated by the new modes of transportation, communication and

technological developments of the period. As the gaps between the poor and the comfortably off widened, so did the inexorable march of so-called progress, where vast swathes of the middle class lived more comfortably, surrounded by trinkets and memorabilia.

Helen was an extremely keen proponent of merchandising, and put her experience in mercantile New York to good use, using the performances to advertise and promote many of the pieces and costumes used on the stage. Gilbert created very atmospheric locations for his libretti, in exotic locales, using beautiful scenery and costumes. The dresses and jewellery were always magnificent and wonderfully made – many theatre-goers purchased fabrics from Liberty and other suppliers (helpfully featuring in advertisements paid for in the free programmes). Helen was responsible for launching advertisements in the Savoy handouts, having seen them featured in America. A particular success was achieved with *Mikado* mania. In England and especially in America, 'Mikado Rooms' became the rage. A journalist reported that 'A New York gentleman had a "Mikado room" which cost at least $150,000; the wife of a steamboat speculator had one which cost $300,000; and a Baltimore gentleman had a collection of swords in his "Mikado Room" which were alone worth about $100,000.'[116] Well-off customers in England proved just as eager to show off their knowledge of the libretto and music, purchasing sheet music and learning to perform the songs at home. The wealthier also customised rooms, filling them with trinkets and pictures inspired by the opera.

Ladies' magazines such as *Queen* and *The Lady* became ever more popular, and were so reliant on advertising revenues that advertisements filled more and more pages. Women journalists were hired, extolling the allure of consumerism, and, further, strongly advocated female independence by using public transport, conveying the genteel inhabitants of the prosperous suburbs to an increasingly safe and welcoming West End.[117] These trends – a thriving theatre district, away from (although adjacent to) the prostitutes and pornographic shops, the development of a consumer culture promoted by spectacle and underpinned by a proliferation of the material goods on offer, and a safe and reliable public transportation system – converged to create in London a booming metropolis, awash with cash and aspiration.

Helen was both efficient and popular: at a company dinner in 1887
for the opera H.M.S. Pinafore, *she was toasted and cheered.*

The middle classes were drawn to the delights of the capital and were made comfortable with more public conveniences for women, which had been utterly lacking before (one of the more unpleasant risks of coming into London for women was that of being 'caught short'). Coming into town for shopping, supper and then a show became a real possibility – and a delightful one.

The Savoy Theatre played a huge role in these developments. The magnificent sets and costumes, produced by Nathan's costume house, were a keen draw, and the beautifully designed costumes were imitated and reproduced in the stores. The costumes for all the operas were designed by the talented artist Percy Anderson. Pictures of leading actresses appeared in the press, and dressmakers thrived in recreating their dresses and accessories for an avid market. Edith Cook, author of *Highways and Byways in London*, wrote in 1894 that she knew 'of many well-to-do girls who never think of buying their season's hats and gowns' until they had seen them on one of the star actresses of the day. Indeed, for her, 'Millinery and costume are the most important factors in the modern theatre.'[118] Periodicals portraying the actors in costume proliferated, and by 1900 there

were as many as 50 illustrated magazines available. Actors posed for photographs, which were sold in shops and on newsstands.[119] The first news photograph was printed in a London paper in 1890 and from that moment the explosive advance in photographic techniques and the appetite for printed photographs became the rage – drawing together art, entertainment, celebrity, fashion and retail. All of these developments increased the popularity of the theatres catering to the upper and middle classes exponentially. The Savoy franchise was raking in thousands.

The income generated for the Savoy in terms of advertising, advance bookings and publicity was such that D'Oyly insisted on implementing Helen's delayed pay rise. Writing in November 1886, he explained in a lengthy letter that she knew 'very well', as did 'all those who know anything about my affairs', that he 'could not have done the business at all at any rate on nothing like the same scale without you'. It was to him only fair that she should have the yearly salary of £1,000 as well as profits of 10% of his share. He insisted further, despite her previous protest that this was too much, that he had taken advice from his solicitor, Mr Fladgate, who had agreed to sending amounts backdating to 1882. His only regret, he wrote, was that it had taken so long to finalise the arrangements, 'for whenever I mentioned the matter you always put it off on the grounds that there was no hurry and that there was no ready money to spare'.[120]

Without even taking into consideration the profit share – which was substantial – this income, calculated using GDP values, gave Helen the 2018 equivalent of an annual salary worth £835,000, or, if considering the relative (or 'prestige') value to the total output of the economy, an income of £1.7 million. These figures give us a sense of how much Helen was earning compared to the earnings of the population around her.[121] She had definitely entered the realms of the wealthy. (Perhaps it bears repeating that a teacher earned on average £120.) While her clever brother John scrambled for newspaper contracts, and architect-in-training Alfred lived off their mother, Helen had proved her worth in absolute market terms – and this salary also tells us about the very large amounts of money accumulating in the Savoy coffers.

Chapter IX

Savoy Glamour

1888

A S FREQUENT TRAVELLERS TO THE United States, where large cities were well ahead of London in developing luxury hotels, Helen and D'Oyly knew what they wanted for their new hotel. They had both approved of the luxury landmark hotels in America, which catered for the most discerning and demanding of guests. In London, hotels were a necessary inconvenience for travelling foreigners or for those unfortunate county families without town houses; visiting royalties were accommodated in one of the palaces available to the British crown. From its inception, D'Oyly and Helen wanted a hotel that would offer luxury and comfort on a scale provided in the most exclusive private residences. Furthermore, it would open up beautiful, safe public space where guests and Londoners might dine, converse and be seen. D'Oyly's appetite for risk had, if anything, grown sharper and his determination was fixed on this latest project. A prospectus was produced at the end of May 1888, after D'Oyly was awarded a full licence the previous month. Subscribers were invited to apply for 10,000 preference shares (these holders would be entitled to a preferential dividend at 7% of the annual profits) and 10,000 ordinary shares, priced at £10 each, to raise a share capital of £200,000. 'Friends and family' were invited to join, and many members of the management team purchased shares.

Helen and D'Oyly threw their time and energy into this huge venture – the hotel, constructed with non-combustible materials, would feature the first 'luxurious ascending rooms', or lifts. These were installed by the American Elevator Company and were the

The Savoy Hotel: the building of this resplendent hotel, magnificently sited on the River Thames, led to a regeneration of the area which made it safer for the middle and upper classes to frequent the entertainments of the thriving West End of London.

largest ever seen in Europe. Never had so many bathrooms been created in one London building: every suite of two or more rooms had its own marble bathroom – 70 in total. A deep artesian well supplied an independent source of water and a power plant in the basement provided electric lighting in all the rooms and throughout the hotel. The restaurant would serve *haute cuisine* and was to attract the most aristocratic and well-heeled clientele. Room service would arrive after guests had ordered through the speaking-tubes in their rooms. Every detail of decor was thought through, with no expense spared. The large sums of money needed, and the huge workload brought about by the project, meant that D'Oyly's energies were channelled into this new area of business. The grand launch was planned to coincide with the opening of the London season and the wedding of Princess Louise and the Duke of Fife on 27 July 1889.

The burden of running the Savoy Theatre profit-making machine was thus primarily on Helen's shoulders, and she responded to this demand with characteristic drive and competence. Her most important task was to keep Gilbert and Sullivan on track. When D'Oyly had tied the pair by contract to produce operas by order (with six months' notice) for the Savoy, he placed upon both men a commitment that Sullivan in particular found hard to bear. There were so many other enticing demands on his time. He was deeply honoured to be the conductor of the Leeds Music Festival (from 1880 to 1889). In addition to his composing work, for which he was much celebrated, he was torn between his love life and his immensely busy and glamorous social life, and, sadly, he succumbed to the very modern disease of burn-out. Yet he continued traipsing round the spas and casinos of the Continent, trying on the one hand to improve his health and on the other indulging his passions for music, gambling, good food, wine and company – especially that of women. His long-time mistress, the American socialite Fanny Ronalds, competed with younger mistresses for Sullivan's favours – and his delightful, charming presence was constantly sought in royal and aristocratic circles.

The composer's friendship with the royal family – and his intimacy with Bertie, the Prince of Wales – went some way towards

legitimising the stage and the opera in Victorian society. Bertie had expensive tastes which made great inroads into his allowance. His mother was disapproving, and he sought the company of plutocrats, who were more than happy to fund his lavish lifestyle and underwrite his gambling. The *bon viveur*, in turn, insisted that society hostesses desiring his company should include his wealthy friends, as well as pretty actresses and opera singers. The Savoy Theatre pieces were known to be perfectly acceptable, never too risqué or politically devious, using the most gentle mockery to poke fun at stuffiness – without, however, ever going too far, and thus remaining eminently respectable. One of the company's stars, the singer Jessie Bond, was regularly requested by Sullivan to sing at private entertainments at his home for Bertie. These engagements were entirely above board, she recalled, and she was treated most respectfully.[122]

She recalled, further, how much trouble was taken to ensure that the Savoy company remained respectable, and untainted by the more insalubrious reputations of the larger theatre world. 'An outsider would hardly credit the strict discipline of our life behind the scenes,' she wrote. The men and women were separated, into dressing-rooms on either side of the stage; there was no 'lingering about' allowed, and when not actually playing, they were sent immediately to their separate rooms. There was never 'a theatre run on lines of such strict propriety', she recalled, and 'no breath of scandal ever touched it in all the twenty years of my experience'.[123] Discipline was also exerted onstage and in rehearsal. Lateness and foolish mistakes were notoriously punishable by a fine, as Jessie lamented.[124]

All four partners, as well as Michael Gunn, were determined to professionalise their offer, and part of this was assuming a duty of care to the employees, the cast and crew as well as the numerous stagehands and small companies who provided the sets, costumes and props. There were no unions or safety nets for actors and singers who fell on hard times, and D'Oyly was renowned for his generosity. Both he and Helen felt the strongest possible responsibility to provide well-remunerated employment and contracts. The Savoy company was one of the first theatrical enterprises to run on businesslike lines and sound management principles; the ethos was that of treating

people fairly, and expecting them to do likewise in turn. There were regular 'family' events, to celebrate the end of a run or to mark other achievements. These feasts were informal yet generously catered, organised for the company and a select few, with much merriment and, usually, some spontaneous acting and singing. D'Oyly hosted many picnics on the river, where the ensuing choruses drew boats from everywhere to hear the famous Savoy melodies *al fresco*. A particularly appreciated feature was the egalitarian nature of these get-togethers, where the famous stars such as George Grossmith and Rutland Barrington happily made way for 'the humblest and most modest chorister to display his or her shining talent which, on the stage, had been kept under a bushel, latent and undreamed of'.[125]

Providing the members of the company with security was an important principle in which the D'Oyly Carte management took great pride. The life of an actor was notoriously precarious, as even the big stars struggled to make ends meet, especially if they wanted a family life. The celebrated Stella Campbell lurched from one financial crisis to another, trying to support two children. Like other celebrities, she went on an exhausting American tour when things were desperate, to generate some income. 'The life of the stage is a hard one,' she wrote, 'the sacrifices it demands are enormous.'[126] When her mother fell gravely ill, she wrote to her from America that she had begun performing 'one-night-stands'. She confided that 'the work is rather dreadful, but the thought that I have a little money to spare in case those I love want it, is a great comfort, and you, darling, have first claim always...'.[127]

Both D'Oyly and Helen were renowned for their generosity to those who worked for the company. The famed Irish musical director 'Jimmy' Glover was a great admirer of the kindness shown to the cast and musicians, noting in his memoirs that 'the generosity of both himself and his wife to those who had served him well knew no bounds'. To one retiring tenor they gave £1,000 and this was only 'one case of hundreds'.[128] The financial demands on the Savoy firm remained, therefore, and depended to a large degree on the uneasy relationship between the two most essential individuals: Gilbert and Sullivan. Gilbert continually wished for more autonomy in

the company and made his views plain. In a disagreement about an opening piece, he wrote that as D'Oyly had not permitted him 'to have any voice in the control of the Theatre that Sullivan & I have raised to its present position of exceptional prosperity and distinction', he had 'no alternative but to accept the position you assign me – during the few months that our agreement has yet to run'. Gilbert, when riled, was extremely aggressive in his correspondence, far more so than his partners, adding that if his plan of working to rule for the remainder of the agreement 'should result in inconvenience or loss to yourself, you will do me the justice to remember that it is of your own creation'.[129]

This quarrel was smoothed over, and the next challenge was getting Sullivan, who had been working hard on a collaboration for the Leeds Festival, to focus on setting music to Gilbert's new creation, *Ruddigore*. It was very difficult to pin down the composer and he hated writing on command, noting despairingly in his diary: 'Do they think me a barrel-organ?'[130] He felt overworked and pressed on all sides, especially after the Prince of Wales requested him to set to music an ode composed by Tennyson for the forthcoming Colonial and Indian Exhibition. Still, he was attending race-meetings and enjoying concerts in the company of Liszt, who was visiting London, and by September it was clear that no new opera would be ready. Happily, *Mikado* attendances, having flagged somewhat, picked up and the pressure was reduced. Gilbert delivered the libretto on 5 November and it was decided to produce *Ruddigore* at the end of January 1887.

The new piece met with mixed reviews, and some critics felt that perhaps the magic was wearing off. The public were most appreciative, however, and the opening night 'presented all the familiar features of a Savoy *premiere*: all the world of literature, science, art, politics, the law and Society', including Lord and Lady Churchill, and other political heavyweights such as Henry Labouchere. Artists and legal luminaries mingled with the aristocracy and all marvelled at the 'Great Picture-gallery of Ruddigore Castle with Hawes Craven's wondrous portraits, so life-like as to come to actual life during the evening'.[131] The piece had a successful and profitable run – but at

288 performances fell short of the 300 that the partners considered a success. *Ruddigore* did not find enormous favour in New York – Helen travelled out with the company to New York and the piece opened on 21 February 1887 but closed two months later. The franchise seemed, nevertheless, to go from strength to strength. The Savoy operas continued to cater for the educated and well-off with their intelligent and witty dialogue and lovely music. They also provided enjoyment to those less well-off, who happily filed into the pit and sang along with huge enthusiasm to the tuneful songs. The lingering problem, as always, was Sullivan's chronic dissatisfaction with the lightweight music for which he was being recognised, and his growing desire to create more classical opera. He was increasingly disengaged and left that February for his favourite hotel in Monte Carlo.

Both men, however, relished the high incomes they were drawing, and they both continued to enjoy expensive lifestyles. As their standard of living and number of luxuries rose, they became captive to the Savoy income stream. Keeping the plots and music fresh was a big challenge, and D'Oyly was not necessarily the best person to manage these two artists on this front. Sullivan was not a problem – he, D'Oyly and Helen were the best of friends, united by warm personalities and a shared love of music. They were on first-name terms, something that never happened with Gilbert. The playwright, however, perpetually suspicious of D'Oyly's propensity to spread himself rather thin, was another proposition. He needed to be cajoled and flattered to feel valued. Helen found herself managing Gilbert more and more, as he was inclined to respect both her approach and her reasoning. Every time he and D'Oyly had an argument, it became inflamed. Gilbert had longstanding issues with the impresario, and D'Oyly had tired of placating the author. After each spat, Helen had to step in to make the peace. She did so by breaking down the argument, using her formidable proficiency in logic – which appealed to the former barrister. At the end of a typically long, detailed, explanatory letter after an argument between Gilbert and D'Oyly in March 1888 over the timing of a dress rehearsal, she concluded by apologising for the length of the letter: 'but I am really anxious to clear your mind of what I know to be a totally erroneous impression – namely that Mr

Carte has ever wished in any way to "dictate" to you'.[132]

She had to step in, first because she was far more effective than D'Oyly at handling Gilbert, and secondly because D'Oyly was overwhelmed by organising the finance for the new hotel. In addition to 'handling' the two creatives, there was also the day-to-day management of the acting companies, crews and orchestras. With a semi-permanent company based at the Savoy, human resources became far more important. D'Oyly's strengths came from his thorough understanding of talent and how to find it; where he was less strong was in understanding and accommodating the myriad human frailties and foibles that are part and parcel of a virtually permanent workforce. Helen, in addition to her formidable financial brain, had high empathy skills – and members of the company and staff turned to her in times of need. D'Oyly was accustomed to dealing with the superstars such as George Grossmith, Rutland Barrington and Jessie Bond from his agency days, but despite his unerring eye for detail – he toured the theatre before every performance to make sure that all was correct – he was happy to delegate to Helen the overall supervision of the cast at the Savoy and of the touring companies. An increasingly crucial part of her job was to ensure that the great levels of commitment and motivation required for the actors to perform night after night, to a high standard, were maintained. It was difficult to sustain performance levels, especially for the stars who carried the show.

The American theatre actress, Mary Anderson, expressed her delight at leaving the stage in 1890 for marriage after a hugely successful international career. 'Night after night the selfsame words for months on end,' she lamented, 'the same dressing and changing of costumes to the strains of an orchestra; the call-boy, with his perpetual "Half-hour", "Five minutes", "Are you ready, Miss?"' Working with the same actors – 'with usually the identical gestures, intonations – all grew to be more and more monotonous'. And she was certainly not alone, recalling that she had often 'discussed these weighty chains of the theatre with my colleagues, including most of the great actors of the time'. Most had agreed with her, 'especially about the long runs and the one-night-stands in America'.[133] However, Helen had the great asset of seemingly inexhaustible energy. She was a 'clever

and indefatigable' manager, pronounced the *York Herald* in 1887. Despite having just arrived from New York, and in spite of the 'many anxieties associated with the pair of "Ruddigore" companies', she looked 'none the worse for wear' and was 'quite a celebrity in the States, where her tact and energy make her extremely popular'.[134]

The investment in Helen's time was very lucrative. The touring companies continued to bring in substantial and welcome revenues. By the 1880s, the Savoy companies were continually touring the provinces with the operas.[135] The management of these tours was an intricate business, for which Helen's organising skills were perfectly suited. All the scenery, props, costumes for the entire cast of principals and chorus were packed, transported, set up, dismantled, repacked, and again transported as the companies travelled from city to city. These extremely valuable properties were voluminous and fragile, and enormous care was needed to supervise them. When the markets of America and Australia were added into the management equation, the logistical preparations and controls were enormously challenging. Helen was a human spreadsheet, who commanded the vast details of productions and contracts, as well as individuals, in her head. Her colleague Cunningham Bridgeman wrote that 'her advice and suggestions were invariably adopted'. He declared that rarely, if ever, 'was a woman found to possess such a thorough knowledge of the principles of sound finance, with absolute mastery of details either with respect to the intricate figures of a financial statement or the most subtle and involved clauses of a legal document'.[136] And press comment continued throughout 1887 and 1888, praising the skills of an outstanding businesswoman. At home, regional and national newspapers marvelled at Helen's career.[137]

The London-based American correspondent of the *Boston Herald*, *New York Herald* and other prominent newspapers, Annie Wakeman, wrote in February 1887 of a 'clear-headed woman', who was Mr Carte's 'right hand man'. About to depart for another trip to America to run operations there, Helen Lenoir was, she explained, 'known on both sides of the Atlantic as the business manageress of the Savoy ventures'. Wakeman wrote that she had already had 'unbounded respect' for Lenoir's ability, but an interview had revealed even more:

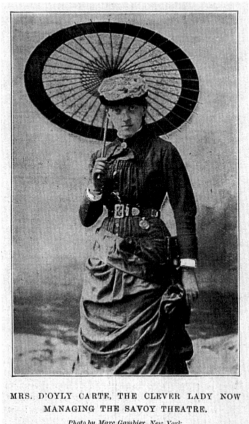

MRS. D'OYLY CARTE, THE CLEVER LADY NOW
MANAGING THE SAVOY THEATRE.

Photo by Marc Gambier, New York.

Helen with parasol: a clever young businesswoman.

'her conversational points versatile and delightful, her mastery of
subjects fairly magical, and her energy indefatigable'. The journalist
professed her 'honest admiration for the charm of manner' and
'her sensibility to her absorbing personal magnetism'. Interestingly,
a recurrent theme was an insistence on Helen's femininity. Even
Wakeman, herself an intrepid pioneer in a male-dominated profession,
pointed out that the manager was 'never masculine, yet always brave
and self-poised'. She was 'the sort of woman who makes you renew
your faith in woman's equality in mental gifts...'. [138]

Chapter X

Marriage

1888

BUSINESS TRIUMPHS NOTWITHSTANDING, the year 1887 ended for Helen and her family on an incredibly sad note. Hilda, residing in Clifton, hanged herself with a bell-rope in her rented room on 18 December. She had been so miserable that her death did not come as a complete shock, although it was undoubtedly a horrific discovery and there was an inquest. Such was the distance, in every sense, to Australia that the family in Adelaide didn't even find out until six weeks later, when John received Helen's letter. Ellen was 'consoled', John hoped, when she realised 'that however sad the thing was, and especially the last few years of poor Hilda's life, it is really for the best as it is'. Both Helen and Aunt Emily had written to tell them all 'how hopeless a case it was', although John and his mother had hoped that Hilda 'might improve greatly and grow much happier', perhaps returning to them in Australia. He and Alice took 'great comfort', he added, from the 'two or three friendly letters from poor Hilda in which she showed a kindly interest in us and all the children'.[139]

Evidence provided at the coroner's court determined that Hilda, aged 36, had always been 'eccentric' and had a number of 'imaginary troubles', for which she had received medical attention. Doctors at her last examination, however, had not believed that she needed to be confined.[140] The whole story is a deeply sad one. Hilda and those like her were condemned to a life of misery. Despite her long illness, the final act was shocking and highly unusual. She was one of 32 female suicides in the county of Gloucestershire that decade.[141] So, even though there was undoubtably under-reporting due to the

remaining stigma, taking one's life was a socially abhorrent, tragic act. Helen would not have escaped feelings of guilt and despair. She had deep wells of family affection and loyalty – writing weekly to her mother and brothers and sending all of them annual gifts of money (each family member received £50 every year until Helen's death, in addition to other cash gifts and presents, as recorded in John's diaries). Helen visited Hilda, but neither she nor her aunt were able to help, in the end. It is, significantly, at this devastating time, ten years after they had first met, and three years after Blanche's death, that Helen and D'Oyly decided that they would marry.

On a happier note, *The Mikado* was still very successful, and Helen and D'Oyly set out via Paris to Berlin for the opening in Germany, accompanied by D'Oyly's two sons, Lucas and Rupert. The boys were greatly fond of Helen, and she spent considerable time with them. Although there were no rumours of any scandal, D'Oyly and Helen made no secret of spending time together. In January 1888, both Lucas (now 16) and Rupert (now 12) were at Winchester College and correspondence as well as diary entries from Lucas portray the warm, close relationship the boys shared with Helen (whom Lucas refers to as 'HL' or 'Miss Lenoir'). The boys, D'Oyly and Helen went to the theatre together during the January break. Before his return to Winchester, Lucas and his father went to the Turkish baths and then dined with 'HL' at the Café Royal.[142] Outings including Helen as well as other relatives took place during breaks late in March and early April (when Lucas matter-of-factly recorded that he had bought flowers, 'and gave them to Miss Lenoir').[143]

It came as no surprise to those who knew them when D'Oyly and Helen quietly married on 12 April 1888. It was a red-letter day for Lucas – his diary entry recorded in scarlet ink: 'At 11.30 Father was married to Miss Lenoir,' noting that Sir Arthur Sullivan and Sir James and Lady Caird (old friends of the Black family) were present.[144] Sullivan, as ever a devoted friend to both, was the best man. Helen wore black, in mourning still for Hilda. After the intimate ceremony at the Chapel Royal, Savoy, the newly-weds returned to their freshly decorated home in Adelphi Terrace to have lunch with the wedding party and the boys, Lucas excitedly noting that 'the servants

knew nothing about it'.[145] The two boys accompanied the pair on honeymoon, travelling on the midday train to Dover. Surprisingly, Helen left them the following day to return to London, while D'Oyly and the boys made their way to Paris, where she joined them two days later. Lucas recounted how they went to meet her at the station 'with a huge bunch of violets'.[146] She was now officially part of a loving and much-loved family. Helen adopted her husband's surname, and was officially 'Mrs Carte'. However, such was the strength of the D'Oyly Carte brand that she was widely known as Helen D'Oyly Carte.

There is no doubting the immense affection between Helen and her stepsons. She took them shopping in Paris for presents, they dined together and attended the theatre and the opera. When, two days later, the boys left to return to school, Lucas wrote of how 'cut up' his younger brother Rupert was about 'leaving the Guv and Helen', and 'unable to eat anything on that account'.[147] It is easy to see how Helen – warm, empathetic and thoughtful – had become an essential part of the boys' lives. Rupert had lost his mother at the age of nine, Lucas at 13 – and Blanche had been unwell for some time before her death. D'Oyly had grown up in a closely knit family, and with Helen he recreated a warm family environment for himself and his sons.

The couple had asked their good friend, Whistler, to devise a colour scheme for the new home they would share on Adelphi Terrace, a short walk from the Savoy Theatre. The house, built by Robert and James Adam in the 1770s, had glorious historical features and overlooked the River Thames. The magnificent first-floor sitting room, with three French windows opening out on to a balcony, featured an original moulded ceiling with a decorative painting of the Three Graces by Anthony Zucchi or his wife, Angelica Kauffmann – both artists who produced decorative paintings for the Adam brothers. Whistler devised 'exact shades' of paint colour, mixing them himself, to brighten up the old rooms. The staircase walls were painted light pink, the dining room a deep pink, and the beautiful library an astonishing primrose yellow, which was similar to that he had chosen for his own drawing room. Helen later wrote happily that it 'seemed as if the sun was shining however dark the day'.[148]

D'Oyly and Helen cherished life in their beautiful home, and

commissioned cooks from the Savoy kitchens for entertaining guests. Helen had an impressive collection of cookery books, guarded by a stuffed Florida alligator. They both adored their dog, Trapp, known for his appreciation of music, and his predecessors – Jack the monkey, Sam the bulldog and Winks the cat – provided silent company in the billiard room. Their union was to all eyes an incredibly happy one, and the pair continued to work as hard as ever. In fact, the marriage seemed to lift their combined creative and work skills to new heights. D'Oyly's ambition was underpinned by the constant comfort and support brought to him by his partner. It was a contented life for the pair, who were entirely in sympathy with one another. They remained important figures in the world of entertainment and hospitality, and were close to a number of artists and writers. They were both keen supporters of the arts and of their artist friends. Red lustre bowls by the Arts and Crafts designer and artist William de Morgan stood in a row above the fireplace in the pink dining room.

Helen and D'Oyly were welcome guests in the art world, but their true passion was for their theatre. It was devastating for D'Oyly when his health began to fail. Heart problems were undoubtedly exacerbated by his highly stressful work habits. Long hours compounded with risky financial ventures were stressful and exhausting. There was no let-up. Keeping Gilbert and Sullivan on track had proved a necessary underpinning to the business, and there were still frequent quarrels, usually provoked by Sullivan's refusal to collaborate with Gilbert's ideas for whimsical, escapist, 'topsy-turvy' plotlines. It was more important than ever, though, to keep the pair happy and productive, as the new hotel was a massive cash drain and a source of constant anxiety.

The family in Australia – especially Helen's mother – yearned for her visit. In May 1888, Helen had written that she was planning to marry D'Oyly. She offered to pay for her mother to travel and to cover all her expenses for a visit to England. Ellen wished to see her daughter, her sister, and the friends that she had left behind. This would also give her a chance to meet Helen's husband. Ellen sailed out on 22 May, for a visit that was to last six months. She was met by her daughter and her sister Emily at Bristol, where Helen remained for a few days. Then 'on account of the constant calls of business in

Helen and D'Oyly at Home: similar to the image here, the pair chose to surround themselves with beautiful art and crafted objects created by their many friends in the art community.

London', she ran 'up and down between the two places', according to her brother John.[149] By September, Ellen had moved into Adelphi Terrace – 'Helen's beautiful house', as John described it.[150]

Sadly, the weather that summer was appalling – wet and cold. It was terrible for Ellen's health, and put paid to any notion of permanently

settling back in England. Instead, Helen treated her mother to a trip with her to Brindisi, going via Paris, Milan, Genoa, and spending some days in Rome. Ellen then made her way back to Australia, where her two sons continued to squabble over her money. 'Poor mother,' wrote John some years later, 'she wants to have her £90 annuity from the British Linen Bank paid over to herself so that she may have a little pocket money. At present the whole of her £500 of income seems to get into Alfred's hands.'[151]

Chapter XI

Sailing Close to the Wind
1890

T HE TRIUMPH OF THE NEXT production, *The Yeomen of the Guard*, which opened on 3 October 1888, was especially sweet for D'Oyly and Helen, as once again there had been trouble between the two creatives. Sullivan wearied of fitting his operatic music to Gilbert's plots, which he found trite. Happily, in this instance, Gilbert was more than up to the challenge, and produced an opera that found favour with the composer. Everyone was hoping for a hit; D'Oyly had had to put on several revivals to avoid an empty theatre – with salaries and mortgage costs still to be paid. He was also in full fundraising mode for his hotel and could not afford a dry income stream. The Gilbert & Sullivan productions had proved themselves, even when not at their best, to be the most successful money-making proposition the theatre world had known. Once again, the impresario was optimistically looking for more investment opportunities. He had the idea of building a newer, larger theatre to house the Gilbert & Sullivan productions. Gilbert, however, was staunchly against the idea, and D'Oyly was persuaded to drop it, though he had never lost his ambition to build an English opera house, which would provide the most magnificent venue for operatic performance.

Both Sullivan and Gilbert were anxious about the public reception to *Yeomen*, but the overall reaction was very positive. There were some excellent notices, as well as the odd criticism. And at first the piece did really well. After a year, however, the attendances dropped off – which caused Sullivan great worry. Simmering with latent discontent, he regularly complained about his music coming second

to Gilbert's words. Fortunately, the two resolved their differences, and the author came up trumps with a new libretto – after one plot rejection by Sullivan – with *The Gondoliers*, which opened to great acclaim in December 1889. The press and public were delighted with the piece, charmingly set in Venice. Famous Savoy players such as Rutland Barrington and Rosina Brandram excelled, and the piece played to packed audiences every night. The Prince and Princess of Wales – and other members of the royal family – paid numerous visits to the theatre during the run, with Bertie expressing his view 'that this was the best of the Gilbert & Sullivan operas'.[152] It was like the days of *The Mikado* – and, indeed, *The Gondoliers* ran to an outstanding 550 performances. Like the other Savoy pieces, the costumes and sets were quite magnificent and of the highest quality. Indeed, this high expenditure played a leading part in the devastating 'Carpet Quarrel' that broke out later in 1890.

Working on the long score had exhausted the fragile Sullivan, who disappeared for a holiday in the South of France to recover. Gilbert, too, took a three-month holiday in India with his wife Lucy. Helen and D'Oyly travelled to New York, and were there for two months, to sort out difficulties with the American production of *The Gondoliers*, which had opened in January to public acclaim but poor reviews. After an overhaul, a revised production was launched in February. Despite some major changes, including some cast replacements, the production petered out after two months, and the company returned to England that April. A complete financial fiasco had been averted, but it was a close-run thing. With such a revenue-sensitive business, and two major building projects in hand, D'Oyly was right to be concerned about finances. He explained in a letter to Gilbert that he had convinced Sullivan to collaborate with the author again, 'on the old lines', and as 'an inducement to this', D'Oyly had agreed to produce Sullivan's 'Grand Opera' at the new theatre.

Although D'Oyly had hoped to transfer all of the Savoy productions to a new theatre that he had begun to build at Cambridge Circus, he had abandoned this idea because of Gilbert's objections, and, he informed the playwright, had that day given up a potential tenant for the Savoy Theatre who had agreed to pay £5,000 rent per annum. 'I

know I need not urge on you that time is now most important,' he added, as business was 'not great' and he hoped to avoid having to close the theatre.[153] So it is clear that D'Oyly was sailing very, very close to the edge in 1889. There were two major building projects in progress, and an uncertain revenue stream from the Savoy Theatre. In order to ensure Sullivan's cooperation to produce a new Gilbert & Sullivan piece, he had to promise the composer his new theatre; this meant that he had to fill two theatres simultaneously. Each piece would, inevitably, have high upfront production costs, which would have to be met before any income was earned.

It was around this time that D'Oyly purchased a small private island in the River Thames, near Weybridge. Eyot House, which he and Helen helped to design, was large and very comfortable, with 13 bedrooms, five bathrooms, four reception rooms, a ballroom, a large garden and nearly two acres of wooded grounds. The Cartes hosted many jolly boat picnics for the cast members, who joined in games and singing in the boats. Sullivan and Gilbert both visited, and the Cartes were hospitable, entertaining frequent guests. Lucas and Rupert spent many happy hours exploring the island where, memorably, their father kept a small crocodile.

Eyot House: an island sanctuary on the River Thames for the overworked couple — who, nevertheless, always brought their work with them.

Unfortunately, the Savoy edifice had growing cracks. In what was possibly the worst timing imaginable, the so-called 'Carpet Quarrel' broke out in April 1890. This began over Gilbert's violent objection to the very high expenses associated with the production of *The Gondoliers*. He was incandescent with fury at having discovered that D'Oyly had charged the £500 for new carpets for the Savoy to the expenses deducted from the profit share. Gilbert felt – very strongly – that this was in violation of the agreement that repairs attributable to the performance were the only ones to be listed as expenses. He believed that the cost of new carpets for front-of-house should fall squarely in the landlord's lap. He challenged D'Oyly in person on 21 April, using violent language and manner. Helen was present, and she later calmly pointed out to Gilbert that he 'had seemed so different from your usual self and it all came so suddenly and was really so entirely unprovoked'.[154] Matters did indeed become very heated, insults were exchanged and deep-seated unhappiness was revealed. D'Oyly pointed out that he could charge £5,000 rent instead of the current £4,000, whereupon the author stormed off, saying that the Savoy could find another writer.

This was far from the first time that Gilbert had objected to expenses, despite the fact that he, and Sullivan, were completely in agreement with the very high production standards set by the impresario. Indeed, many of the production expenses were incurred by Gilbert, who directly ordered many of the costumes and props. As far back as 1882, he had written to D'Oyly disputing advertisement and stage costs; he was unhappy with the £15 per week for printing and with the size of the gas bill.[155] Sullivan was put in a dreadful position: not only were D'Oyly and Helen his dear friends, D'Oyly was going to put on his long-cherished Classical opera in the new theatre. He had also, unlike Gilbert, invested in D'Oyly's building projects. He was quite horrified at the breakdown, and, ever conflict-averse, tried to appease both sides. Sadly, Gilbert was not to be placated and demanded loyalty. Even though Sullivan agreed that the production costs had indeed been high, he was dismayed at how quickly the dispute escalated, threatening to rip apart the partnership.

Never were the differing temperaments so nakedly – and publicly

– displayed. 'The rupture between Gilbert and Sullivan was a foregone conclusion with everybody who was acquainted with the dispositions and tempers of the two men,' trumpeted the Manchester-based *Umpire* ('says a writer in New York *Truth*'), adding that 'the only wonder is that the golden link of interest was strong enough to hold such opposite forces together so long'. The playwright was 'a canny Scotsman, and an obtrusive personality that will scarce brook opposition', it went on, and the composer 'a careless Irishman, full of artistic feelings, and neglectful of matters merely pecuniary'.[156]

It was huge news. The duo was incredibly famous, and the Savoy brand was constantly in the public eye – frequent advertisements, reviews and interviews featured prominently in the press. The break-up horrified and saddened their legions of fans. It was akin to John and Paul breaking up the Beatles, Oasis splitting, Geri leaving the Spice Girls. Headlines dominated the news: the vast sums involved, the super-rich personalities, the fallout for the theatre, and the disappointment of hundreds of thousands of fans who would miss the operas enormously. D'Oyly and Helen had been midwives to the greatest theatrical franchise ever known, providing joy to thousands and thousands of people worldwide; they had employed hundreds of talented individuals, and made the four of them very rich indeed.

And indeed, it was, over and over, the money that grabbed the headlines. An unfortunately delayed payment to Gilbert in July infuriated him so much that he went ahead with a disastrous court case. Ever litigious and feeling angry that Sullivan had refused to back him up, he lashed out at the golden goose. He was particularly sensitive to sly suggestions in the press and elsewhere that he was jealous of D'Oyly's plans for what would become the Royal English Opera House. Sadly, the press had a field day, and indeed, the numbers revealed were staggering. Over the previous 11 years, each of the partners had received a colossal £90,000 under the Savoy management. This represents £11.6 million in 2020[157] – so nearly £35 million were shared between the three official partners, and these are profits. Understandably, when D'Oyly demonstrated that the carpet refurbishment cost £140, Sullivan was furious.

But things had gone too far, and all the resentments, large and small,

that had plagued the partners were aired; Gilbert felt beleaguered and then livid when Sullivan was duplicitous in providing a certain piece of evidence about outstanding expenses – that supported D'Oyly Carte – in the court case. It was the final straw, and the collaborators broke apart with great animosity. Legal matters were settled amicably a few months later, however, when Gilbert reached out to Helen – the only one he still trusted (and never stopped trusting).

When Helen gently but firmly took Gilbert forensically through the evidence, the former barrister was somewhat abashed. 'You have always been so courteous to me personally,' she wrote,

> that I did not like writing anything that may annoy you ... but it seems to me to be quite as much due to you as to Mr Carte that I should say what occurred at that interview. The fact that you believe Mr Carte said the words you impute to him must have been, and has evidently been, an annoyance to you as you believe yourself to have been deliberately insulted. It is right, therefore, to you as well as to Mr Carte that your mind should be, if possible, disabused of this mistake so that you may be able to look at the business matters before you in a calm way.[158]

It had, after all, been a misunderstanding and the playwright, himself suffering terribly from painful gout, had thrown away the most successful partnership ever known in the entertainment industry over a paltry sum that D'Oyly – typically careless – had ultimately been able to justify. It was, perhaps, inevitable that strains would eventually tear asunder such different temperaments. As we have seen, Gilbert and Sullivan were of different backgrounds, interests and temperaments – and the playwright tended to annoy his collaborator with his acerbic banter. As a joke, for example, Gilbert would declare in public: 'My cook gets £80 a year and gives me a kipper. Sullivan's cook gets £500 a year for giving him the same thing in French.'[159] But it seems clear, further, that Gilbert was suffering from paranoia and D'Oyly exacerbated this by taking his eye off his biggest cash cow. D'Oyly was also physically unwell with heart trouble; he was stressed and overworked and very overstretched with his new projects. And it was

true that he was careless and less meticulous than he should have been – a sign that he was, indeed, overstretched. Gilbert was convinced that there were further anomalies and determined to forensically sift through the accounts. D'Oyly Carte was happy for him to do so, and an auditor was appointed.

Meanwhile, Helen was also conducting the delicate negotiations with Sullivan over the profit share at the new theatre. Building was in progress, and she had laid the foundation stone at what is now the very successful Palace Theatre on 15 December 1888. As ever, her calm forensic approach was invaluable in laying out the challenges. 'I further understand from your letter and also from what you said to us, that your idea now goes a little further than merely you should run no risk and that in the event of a great success you should do well, but also that if the receipts should prove small or moderate (so that there is a considerable loss) you should still be in receipt of a considerable sum.' She was not passing judgement, she hastened to add, merely laying out the facts as she understood them. 'I always think it right in a big enterprise like this,' she continued, 'to look the risks fairly in the face – and there is no question that in this enterprise the risks are very, very serious and the chances of ultimate profit are not very great.'[160]

Included in this lengthy letter to Sullivan was a detailed breakdown of the costs, and a meticulous chart showing what Carte and Sullivan would each receive under graduated bookings per performance, pointing out that the impresario would need £2,100 in takings per performance just to break even.[161] While leading these critical negotiations with the composer, correspondence with Gilbert continued, and she agreed to meet him face to face in September 1890; a series of letters was exchanged throughout October. On 4 November, Helen informed the warm-hearted Gilbert that D'Oyly's eldest son Lucas, who had just begun studying at Magdalen College, Oxford, was suffering from typhoid fever. Gilbert was always deeply sensitive to family feeling, to relationships and to illness, and he lost no time at all in reaching out to D'Oyly, expressing his warmest sympathy. This sad illness broke the ice, and restored the relationship between D'Oyly and the playwright.

Unfortunately, the damage caused by Sullivan's testimony rankled, and he and Gilbert remained estranged. Sullivan wrote to his erstwhile partner that he was not 'exaggerating when I tell you that I am physically and mentally ill over this wretched business. I have not yet got over the shock of seeing our names coupled, not in brilliant collaboration over a work destined for world-wide celebrity, but in hostile antagonism over a few miserable pounds.'[162] Largely – if not entirely – due to Helen's diplomacy and negotiating skill, D'Oyly and Gilbert reconciled towards the end of 1890, although nothing would ever be the same between the partners, and Sullivan refused to apologise to Gilbert for his untrue evidence. And when the playwright demanded to see all the accounts since the beginning of the partnership, he was informed by D'Oyly that in that case he would have to forgo the profits from the bar and the programme advertisements that he had received, these normally going in their entirety to the theatre proprietor.[163] With her extensive legal experience, Helen was determined to avoid any possible controversies with Gilbert, and every single step between the Cartes and the dramatist was meticulously documented, to avoid any possibility of further legal action.

Chapter XII

High Society

1891

THE YEARS 1890 AND 1891 brought new beginnings for all the partners. Helen was kept extremely busy running the Savoy companies, supporting D'Oyly and playing a leading part in designing the new hotel. Organising the finances for this huge investment was fraught and immensely stressful. D'Oyly's uncle Robert wrote to him in sympathy, saying that the 'Savoy mansions affair must be a matter of great anxiety to both you and Helen – and for me don't do it again. Life is scarcely worth having at such a sacrifice.'[164] Originally intended as luxury serviced flats, Savoy Mansions was to be London's most luxurious and secure hotel extension (built to the highest safety specifications), and a natural development of the high-end Savoy brand. Theatre-goers would be attracted to its fine restaurant, and guests from all over the world would be drawn to the luxuries of electricity, ensuite bathrooms, room service, lashings of hot water and beautiful design. As if this were not enough of a massive project, D'Oyly was naturally preoccupied by the building of his magnificent new theatre at Cambridge Circus, built specifically to house grand opera performances.

As Helen had predicted, the risks were very high. D'Oyly had for many years spread the risk with touring companies, advertising, music printing and other income opportunities. A strong income stream was virtually guaranteed through the sale of sheet music, and these sales established 'their perennial appeal by their availability to a public without regular access to the theatre'.[165] However, the prospect of expensive failure was always present. Gilbert worked

with Savoyards to appeal to Savoy fans, writing a new play with Alfred Cellier (brother of Frank), and another, much less successful, with George Grossmith. He then collaborated with the Savoy actor Rutland Barrington, who was hoping to make a career as a theatrical manager; Gilbert revived a previously written play, to put on at Barrington's St James's Theatre. It turned out to be a failure (which contributed to Barrington's rapid demise as a manager – he was soon back in the Savoy fold). Gilbert had further ambitions, however, and had acquired a site to build a new theatre, the Garrick, on Charing Cross Road. He had taken a loan and had 'plunged all [his] available capital & a good deal more'[166] into the project, and the new theatre, in theory, was to open at the end of 1890.

Sullivan meanwhile wrote a piece with the dramatist Sydney Grundy and pursued his passion for dramatic opera, composing his only grand opera, *Ivanhoe*. He was, as always, late in delivering the piece, making life very difficult for the Cartes, who were ready with the palatial new Royal English Opera House. Sullivan's long-awaited dream – suggested to him by Queen Victoria, to his rapturous delight – became reality with the opening of *Ivanhoe* to a packed opera house, resplendent with royals and the cream of British society. Gilbert, offered a box, had refused to attend (he did, though, quietly attend a later performance). This did nothing to soothe hurt feelings: Sullivan noted bitterly in his diary that he had received three letters from the playwright, 'his last a rough & insolent refusal to come to the performance of "Ivanhoe"'.[167]

Others though, turned up with enthusiasm, keen to appreciate the famous composer's new venture. D'Oyly's articulated ambition to establish English grand opera at a new theatre (most frequently known as the Palace) was printed in the programmes. *Ivanhoe* was widely reviewed, mostly favourably, and ran to 160 performances. This is a great result for dramatic opera, but for D'Oyly it was a failure: he did not recoup the enormous production costs, and he then scrambled to find another hit. It did not take long for the impresario to realise that his dream of bringing English grand opera to the stage in its own dedicated theatre was not financially viable. There were simply not enough members of the public prepared to pay to see dramatic

opera night after night, as they would do for a comic opera. This was D'Oyly's biggest failure – and it demonstrated a triumph of optimism and enthusiasm over sound business judgement. The disadvantages of producing dramatic opera were well known: high production costs, a limited London season, the need for a great many boxes had already resulted in the failure of a number of ventures. James Mapleson's National Opera House, set up as a limited company in 1879, was wound up the following year. Ten years later, Henry Leslie, manager of the Lyric Theatre, tried to produce opera at the Haymarket in 1889 and failed as well – ending up in liquidation in 1890.[168]

By 1 August 1891, D'Oyly realised that he had to close the theatre at least temporarily – it had been an impossible dream. The Cartes departed on a month-long recuperative holiday to the Continent. Despite attempts to continue with another piece, and a brief revival of *Ivanhoe*, D'Oyly closed the house permanently on 16 January 1892. Opinion was divided over what had gone so wrong.[169] The *Pall Mall Gazette* wrote wryly of the impossibility of continuing to throw 'operatic pearls before swine' and that 'the Englishman's opera-house is the music-hall'.[170] *The Times*, on the other hand, had published a column a month earlier that criticised the impresario for the 'fatuity of performing a single serious opera for months together'.[171] Sullivan, however, was encouraged by his *succès d'estime*, taking enormous pride in the compliments received from the Queen. The 'crowning' glory was Victoria's gracious acceptance of the dedication of the opera to her.

The Savoy Theatre struggled after the demise of the Gilbert & Sullivan production line. A new play, the first to be produced that was not by the famous duo, was put on. *The Nautch Girl* by George Dance and Edward Solomon ran for an acceptable 200 performances. It was difficult, however, to replicate the previous success. The public, the critics, the Cartes, the actors, musicians, stagehands and administrative and managerial team all longed for the pair to reconcile. It had become clear to both composer and librettist that it was cold outside the protective, high-end, no-expenses-spared Savoy Theatre, where they were considered heroes. It took some time, but even D'Oyly realised that there was nothing to compare with the Gilbert & Sullivan franchise. Various productions by other authors

and composers that he commissioned after the breakdown simply failed to ignite in the way the previous plays had done, and at one point the Savoy Theatre was dark for three months. In October 1891, after an 18-month split, the composer and dramatist famously made their peace. They decided over the following Christmas break to collaborate on a new piece, much to everyone's relief.

While Helen took complete charge of the theatre, touring companies, and operations abroad, D'Oyly focused primarily on his hotel project. Capital of £200,000 had been raised for the project at the end of May 1888, as we have seen (page 75). The advertisements boasted of the many features of the hotel – the fresh water provided by an artesian well, the beautiful location along the river and of course all the bathrooms. Much was made of the restaurant, which was to be world-class.

Eating in a public place was not considered habitual for the well-to-do in the Victorian era. Gentlemen ate in their clubs, but women who could afford the Savoy prices were not expected to eat in a public restaurant. D'Oyly knew that this might be a problem, and to overcome it he set up a committee to give advice and feedback on menus and to patronise the restaurant in order to give it publicity. Socially prominent figures including Earl Grey, Reuben Sassoon, Colonel Oliphant, the Marquess of Granby, Hwfa Williams and Arthur Sullivan did their best to attract the Marlborough House Set – the socially influential insiders close to the Prince of Wales. Once again, D'Oyly showed his flair for marketing, using 'influencers' to help attract the paying punters.

It was still a struggle, however, to overcome the social barriers. At first, the restaurant failed to attract diners other than those in large groups. Fancy balls, charity dinners, regimental dinners and occasionally, a fashionable wedding formed the bulk of the dining-room business, especially after November 1889, when a licence for music and dancing was obtained. Despite this limited market, business was satisfactory, and at the first directors' meeting in September 1889, the reports were favourable, with a 10% dividend expected. Efforts were redoubled to attract social diners. Just a year later, however, the outlook was gloomier: the dividend was a proposed 7% and there had

been several profit warnings. The directors insisted on the instant dismissal of the general manager, who then issued a writ, and a very costly settlement was made out of court.

D'Oyly, who had been unwell, took immediate action. Both he and Arthur Sullivan were huge admirers of the celebrated Swiss hotelier César Ritz, who was running successful luxury hotels in Cannes and Baden-Baden. D'Oyly had immediately warmed to Ritz while on visits to Monte Carlo; the two men recognised in each other the qualities of a self-made man (Ritz had grown up in a peasant family in a small Alpine village). Ritz was both a social climber – he carefully studied his wealthy clientele and learned to cater to the rich and famous – and an astonishingly hard worker. D'Oyly was convinced that the talented hotelier – more of an impresario than a manager – would be the perfect man to run the Savoy. He now made a second attempt to recruit him. Finally, the star hotel manager agreed to work at the Savoy, insisting, however, on bringing his own expensive team, including the extraordinary chef Auguste Escoffier to join as the *chef de cuisine*. Among other conditions was the freedom to continue his other businesses for six months of the year, and to be given expensive accommodation at the hotel for himself and his young wife, Marie.[172]

A massive public relations drive was launched. Ritz and Escoffier were well known to the Prince of Wales and to the many aristocrats who travelled to the luxurious watering-holes. The Prince and his acolytes were delighted to be fawned over in the posh restaurant. Hwfa Williams and Arthur Sullivan, the most socialite of the directors, threw dinner party after dinner party, which were reported in awed tones in the newspapers and magazines, where the magnificent menus and names of glamorous guests were published. D'Oyly also wrote to his friends and acquaintances, entreating them to patronise the establishment. Ralph David Blumenfeld, the famous American journalist (later editor of the *Daily Mail* and then the *Daily Express*), recorded that D'Oyly entreated him 'to go and live at the Savoy rather than in Duke Street St James's', promising that he could 'have similar accommodation, bedroom, bath, sitting room and valeting for £2 – 1s [*sic*] a week. He says he is having difficulty in inducing people to

patronise the Hotel.' The restaurant was 'certainly not popular', he added, but Blumenfeld felt that that was perhaps due 'to the failure of Londoners to adopt the continental habit of dining at Hotels & Restaurants'. The Savoy was 'given over to people from abroad, and they are not many'.[173]

To encourage custom, and in tandem with the arrival of the superstar hotelier and chef, the 'Committee of Taste' was beefed up, and now included the socialite diplomat Marquis de Soveral, Count Albert Mensdorff, the courtier Earl of Chesterfield and the diplomat (later Ambassador) the Hon. Francis Bertie. It worked like a charm. With his eye back on the ball, D'Oyly found his golden touch, and business picked up. In 1890, the world-famous figure-skater Louis Rubinstein, from Canada, came to stay, as did the wealthy financier and social titan Sir Edgar Vincent (later Viscount D'Abernon), governor of the Imperial Ottoman Bank. Sarah Bernhardt became a regular, and European nobles along with well-heeled Americans flocked to the now famous Savoy. The astounding Australian opera *diva* Nellie Melba (later Dame Nellie) retreated there during marriage difficulties (and had a famous dessert created in her honour). Melba, who took herself and her demands very seriously, wrote scathingly of her previous experience of London hotels: 'The cooking was execrable, the carpets were dirty, the linen was medieval, the service was an insult.' At her first stay in the Savoy, she felt that she 'had landed in paradise'.[174] Artists were inspired by the magnificent views from the roof, and both Whistler and Claude Monet painted the sunrise over London Bridge from there.

There were pre-theatre dinners and opera suppers for patrons of the Savoy Theatre, and during performances the *beau monde*, dressed in their finery and diamonds, brought glamour and taste to the splendid dining-room. As always, D'Oyly and Helen were keen to adopt the latest trends and harness the most modern technological advances. There were musical events galore, and in December 1891, in the private dining room, *The Sorcerer* was used to demonstrate a new French invention, the Theatrophone. The machine was connected to the Savoy Theatre to demonstrate how private subscribers could listen directly to a performance of *The Nautch Girl*.

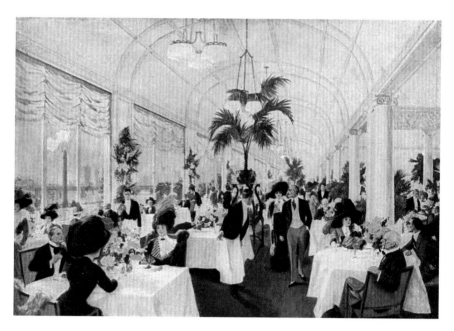

The Savoy Terrace Restaurant, overlooking the Embankment

What really made the difference to the success of the Savoy was the approval and patronage of the Prince of Wales. His mistress, Lillie Langtry, held little suppers catered by her great friend Ritz. Where Bertie ventured, celebrities and aristocrats, self-made businessmen and aspirant families followed. The modernity of the hotel, with its suites of rooms and bathrooms, the magnificent restaurants and the sparkling Savoy Theatre produced an effect never seen before in London. Whereas in America anything new was embraced, in Britain trends were slower to follow. The imprimatur of the fun-loving, socially inclusive Prince of Wales (as long as those included were beautiful or rich) broke down many of the older social barriers, and the Savoy was careful, as an institution, to preserve the decorum and high standards needed to receive royal approval. It took some years, for example, before women were allowed to dine on their own, and they were carefully scrutinised for their social suitability. By the mid-1890s, the Savoy was constantly in the news and on the social pages.

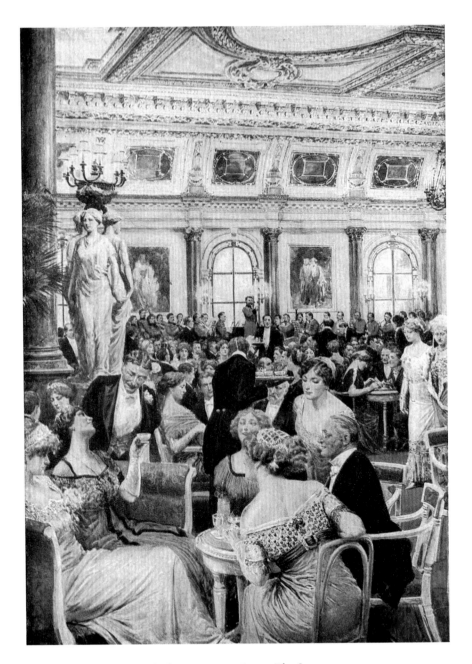

A glamorous evening at The Savoy

As was noted in an 1891 publication surveying the immigrant populations of London, the restaurant had become 'a not insignificant site in an emergent celebrity culture'.[175] Magnificent affairs garnered press attention and further embedded the Savoy brand in the public consciousness. The pretender to the French throne, the playboy Duc d'Orléans, took a suite, and a special dining service in Vallauris china was made for his sole use, patterned in gold, bearing the all-important *fleur-de-lys* on a background of French blue. Escoffier personally watermarked the ducal menu every day, on special paper, with the royal crest.[176] In June 1895, the Duc hosted a dinner and reception for the marriage of his sister, which royal figures from all over Europe – and the Princess of Wales – attended at the Savoy Hotel. The marriage was the most important event on the social calendar and the press avidly reported details of the sumptuous ceremony and gifts. The association of the Savoy Hotel for the evening celebration was a complete triumph.

Regular guests included all the famous actors of the day – Sir Henry Irving moved in, as did the artist James Whistler, who made an etching of the hotel while it was under construction. Opera singers, dancers and other performers at the nearby Opera House insisted on staying where high society and superstars met. The link to the Savoy Theatre was reinforced by the patronage of very many members of the theatrical world, who were able to network successfully at one of the restaurants, or indeed in one of the private rooms, named for the Savoyard operas: *Iolanthe*, *Gondoliers*, *Pinafore* and *Mikado*, each with corresponding decor.

In 1891, further honours had been showered on the Savoy company with two command performances for the Queen: *The Gondoliers* at Windsor in March, and *The Mikado* at Balmoral in September. Despite the successes, however, these were still challenging financial times for the company, and hopes were pinned on a new Gilbert & Sullivan piece. Gilbert preferred to deal with Helen, and from this time forward it is she to whom he turned. 'I am quite prepared to take your statement as regards the Electric Light account, without investigation,' he wrote amiably in May 1891.[177] In October, he told her to do as she thought 'best' about selling off used scenery.[178]

So friendly were relations that the playwright asked her to buy the Executioner's axe and block used in *Yeomen of the Guard* as a souvenir for him – 'I should like to have them as a relic of the best of our joint work at the Savoy.'[179] Helen was, at the same time, cajoling Sullivan to focus on his commitments. He was plagued with ill health, suffering particularly from excruciating kidney stones – yet he continued to burn the candle at both ends, travelling to the Continent and frequenting his beloved casinos.

Chapter XIII

Running a Tight Ship

1892

'THOUGH DECEPTIVELY "slight, fragile, and delicately built" Helen had unbounded energy and determination, "a clear intellect" and a generous, compassionate nature.'[180] While six typewriters clacked incessantly, 200 letters arrived daily as the slim figure ran a tight ship, instructing clerks, administrators and copyists. Securities and artists' agreements were filed away safely in 'five great safes'.[181] She was now running the Savoy company practically single-handed as D'Oyly struggled to cope with the challenges of the Savoy Hotel. In February 1891, she sacked one of her junior managers, a Mr Pickering, gently reproaching him for a visit that

> only caused a scene that was exceedingly painful to me, and you may be quite sure that when I wrote you as I did it was because I saw definitely that it was impossible the office could continue in the way it had been doing and that the whole thing had been fully considered and nothing was to be gained by prolonging any discussion on it.

A solid training in logic, enhanced immeasurably by years of experience in managing artists, musicians and general staff, made her a high-quality manager who nevertheless acted with understanding and compassion. 'It comes back simply to this,' she went on to explain to the hapless Mr Pickering, 'you could not possibly remain as second to a person [his superior] with whom you were on unfriendly terms – in such cases the office and the business must suffer.' Reminding him

that he had been 'fully warned' by her several months previously, she proposed to enclose a testimonial and added that she had 'no doubt' that he would find that it had 'been very much better' for him in the end and she believed that he would have 'no difficulty in getting work'.[182] A journalist interviewing D'Oyly in 1892 remarked on meeting Helen Carte that she was 'a splendid businesswoman', who carried 'every statistic connected with the establishment at her fingers' ends'.[183]

Her kindness was legendary, and under her auspices, the Savoy companies were renowned for high standards of compassionate decency. Even the acid-tongued playwright George Bernard Shaw, in response to a plea from the actress Ellen Terry for a protégée, suggested that she speak to the Cartes for a place, for 'they are the only people in the comic opera line in London, as far as I know, with whom the signorina's niceness would not be a disadvantage'.[184] Helen continued to act as the essential 'safe hands' to deal with Gilbert – and it was patently clear that Gilbert was happier dealing with her direct. He was 'quite content to leave the matter in your hands', he wrote genially in February 1891, in answer to her query about granting certain permission to amateurs to perform the plays.[185] Pleasant correspondence between the two continued throughout 1892 and 1893 and retained its amiable tone as arrangements for the new opera took place.

As Helen ran the theatre – and managed Gilbert – D'Oyly was being attacked on other fronts. The *Financial Standard & Imperial Post* ran a veritable vendetta against his management of the hotel company, and in November 1891, the paper hinted at financial irregularities and strongly urged shareholders 'to convene a meeting on their own account, and appoint a committee of investigation', declaring that 'many and startling will be the revelations'.[186] Bringing Ritz on board was paying off, though, despite his cushy contract allowing him to spend six months away from the hotel working on other projects. D'Oyly's ambitions grew, as he looked to expand his hotel empire. By early 1892, reviews of superlative dining appeared in the press.[187] Famous celebrities including Emile Zola, Wilde and many European royalties became regulars, and the dining room a magnet for chic

London.[188] Nellie Melba moved in during 1892 and 1893 while singing at Covent Garden Opera House.

D'Oyly's ambitious wings, however, were increasingly clipped by health problems. He was periodically unwell. As his life was becoming ever more fulfilled and happier, he just added pressure upon pressure to grow his empire. Leisure time was at a premium, and he brought his work home with him. Lucas and Rupert, thrilled by their father's remarriage, spent weekends and holidays with him and Helen at their magnificent home on the island in the Thames near Shepperton Lock. Apparently D'Oyly had hoped to use this luxurious mansion as a secluded annexe, reachable only by boat, for favoured guests of the Savoy. Local magistrates refused him a liquor licence, however, which made those plans impracticable. But D'Oyly loved it there, as did the boys, who explored the island pools, swamps and streams. Helen and D'Oyly retreated to their idyll, with their work, whenever they could, as it was less than 20 miles from Charing Cross.

They needed the rest, of which they took little, and so did William Gilbert and Arthur Sullivan, who both struggled with their health. Like D'Oyly, they pushed through illness. Sullivan had long had many issues, which were enormously exacerbated by his hectic lifestyle. Long hours, excessive socialising, travelling and intense, last-minute work efforts combined to weaken an already vulnerable constitution. Any benefits from regular trips to European spas were nullified by high-stakes marathons at the casinos and at the racecourse. He owned several racehorses in the 1880s and 1890s, among which were *Comic Opera* and, wonderfully, *Helen Carte*. These two thoroughbreds raced alongside one another in July 1894.[189] Sullivan also slyly named one of his horses *Devil's Dyke* – an unsubtle reference to his frenemy Gilbert, who had bought a splendid estate called Grim's Dyke. The shared passion of the racecourse united D'Oyly, Helen and Sullivan, who loved attending the races together, and met many of their friends on important race days.

These special days, and Ascot especially, were where high and low society alike indulged in the national pastime of racing and gambling. Celebrities of the day, the well-known and lesser-known actresses promenaded in the latest fashions to an adoring public. Luminaries of

the theatre, music, literary and artistic worlds joined the aristocracy and royalty to celebrate the joys of the turf. Owning racehorses was a passion shared by a number of theatre managers, and on Ascot Sunday the 'Gaiety Girls' of George Edwardes's theatre were punted up and down the banks at Maidenhead, to the delight of the crowds. Ruby Miller thrilled at the attention: 'We girls would lie in the punts on vari-coloured cushions, wearing enchanting summer frocks in white or pastel shades of silk muslin, tussore silk or broderie anglaise, our hats of leghorn trimmed with wide velvet ribbons and flowers.' They were 'not allowed to tan' and 'never wore make-up off stage, so our natural pink-and-white or cream complexions had to be protected by large silk sunshades'.[190]

The races, the dinners, the performances, the parties – the glamorous lifestyle took its toll on the hard-working quartet. Sullivan, the most social of them, suffered. His kidney problems, heart issues and general exhaustion predicated a need to pace himself. Gilbert shared his worries about him with Helen in May 1892, writing that he 'was afraid these repeated relapses must seriously affect his strength'.[191] Both Helen and D'Oyly suffered from the problems brought about by chronic exhaustion and overwork, but it was as if the adrenalin kept them going. Neither seemed capable of moderating their lifestyles; D'Oyly had no sooner finished one enormous project than another was begun.

Gilbert, too, had health problems. Gout was his nearly constant nightmare, plaguing him with pain and causing this somewhat tetchy man to become even more irritable. The pain was so debilitating that this very disciplined worker was unable to put pen to paper. 'I have been laid up with the most violent attack of gout in both feet & in the right hand,' he informed Helen in May 1893. He had 'not been able to do anything but swear for the last 18 days'.[192] He was immobilised by the illness, and unable to leave the house. In July his doctor told him that it was 'absolutely necessary' for him to go to Homburg for a cure or the gout would worsen. This was unfortunate timing, as he was working on Act II of the new piece. Gilbert wrote from Homburg in August to say that unfortunately the waters had not helped much, and in September he was 'sorry to say that I have had a

bad relapse & am now completely crippled'. He needed crutches but was determined to attend the play reading that week.[193]

In October 1893, as they made ready to launch the new play, *Utopia Ltd*, Helen explained to an eager journalist what the process entailed. On being interviewed as he worked in his stage-box, D'Oyly had directed the reporter to his wife: 'You ought not to question me,' he asserted, 'but Mrs Carte. She's the businesswoman, and she really can do two things at one time – six, I believe.' Helen duly recounted how early rehearsals began 'six or seven weeks beforehand with the music only'. The music was learned by heart, and Sullivan rehearsed the band on its own. Then Gilbert read the play out to the whole company, and the parts were assigned. 'It isn't until the fifth week of rehearsals that songs and dialogue begin to go together,' she added, as:

> things have to be altered to meet the needs of the case. For instance, in the beginning Sir Arthur and Mr Gilbert make mutual concessions, the one altering the music to fit the songs, and the other adapting the songs to go with the music; and the scenery – although a model of the *tout ensemble* is made at first – is continually altered to fit the grouping and provide for the exits and the entrances.[194]

Helen explained how they had kept a book of artists for casting since 1877, which now contained the names of 7,000 artists, with their 'voice, appearance, and the ability of each lady or gentleman carefully catalogued'. They needed a large base, she explained, as they had five touring companies – and a provincial company for *Utopia Ltd* would be sent out 'in about six weeks, and another at Christmas'. What she hasn't told you, D'Oyly chimed in, is 'that it is she who manages these companies, arranges all the dates, all the bookings – we are booked up to the end of 1894 – and every other detail of organisation. I have an idea that she does it with some kind of conjuring with a map of England and a "Bradshaw" [national railway schedule].'[195]

A large portion of her time was still spent managing Sullivan and Gilbert. They were once again at odds and had found the process of collaboration on *Utopia* a far from joyous experience. Although

Gilbert had grudgingly agreed to let bygones be bygones, there were lingering hurts. He was, however, more dependent on the high revenues generated by his work for the Savoy than ever. In 1890 he had purchased, as we have seen, a magnificent property from Robert Herriot of Hambros Bank. This superb estate, Grim's Dyke, was his reward for years of graft and success, and he made the most of it. The stable block was converted into garages for his impressive motorcar collection and he added an observatory for stargazing. A suit of armour adorned the hall, and his bathroom was equipped with a weighing-machine.[196] Gilbert's wife, Lucy, a keen gardener and talented landscaper, designed a spectacular 30 acres of exotic gardens. The grounds included a lake – Gilbert was a keen swimmer – as well as a croquet lawn, walled garden, vinery, apiary and farm. There were facilities for their animals: Jersey cattle, horses, pigs and fowl and, famously, a menagerie of pets including monkeys, lemurs, a lynx, and others. There were always kittens and cats, for Gilbert adored animals and, childless himself, loved small children to visit and enjoy the pets and wildlife.

Despite a seemingly successful visit to Gilbert's handsome home – strewn with Persian rugs, tiled fireplaces, monogrammed china, valuable pictures and over 5,000 books – that spring, Sullivan was writing to Helen in September 1893: 'For your sake, poor child, I am very glad you have a satisfactory letter from the Dyke (Devil's Dyke it ought to be called).'[197] Gilbert then caused difficulties over how his protégée, the American singer Nancy McIntosh, was treated. He and his wife Lucy had become fond of the young woman, whom they treated as an adoptive daughter. The playwright was eager to further her career, insisted on her being cast in *Utopia* despite her lack of any acting experience, and he was somewhat blinded in his assessment of her talents and position. When Miss McIntosh made a fuss over some publicity photographs, Helen had to remonstrate. Gilbert backed down and apologised, and told Helen that her letter had been 'fair & just & reasonable in every word'.[198]

The production expenses for the new play were enormous, and Helen sought to impose financial discipline. She had even confided in her brother John, who recorded that she had written of 'an enormous

loss' after letting out the English Opera House.[199] Gilbert was aware of the constraints, but still insisted on the highest quality costumes, sets and props. In the matter of costumes, he was intransigent. 'The expenses are very heavy,' he wrote, 'and I understand that the theatre being closed must add enormously to them. However, I suppose that can't be helped.' And, as far as Nancy McIntosh (playing Zara) was concerned, he wanted 'a very light, "lace-y", "chiffon-y", dainty dress…. My idea is that this (a most important dress) should be obtained from Paris and I am writing to an extremely well-dressed lady who gets all her dresses from Paris to find out the best dressmaker to go to.' The measurements could be sent to Paris, he continued, and alterations could be made in London as needed. The stylish London dressmakers Russell & Allen were 'scarcely the people for this particular kind of dress'.[200] Furthermore, he wanted 'any quantity of diamonds – tiaras – rivières etc for all the ladies – or very nearly all'.[201]

Costs were a contentious issue. D'Oyly and Sullivan retained their partnership agreement, but had been keen to have an arrangement with Gilbert that would preclude him from access to the accounts. After some difficult correspondence, the librettist eventually agreed to give up the partnership and instead to take 11% of the gross receipts. He was annoyed at being in a different position from that of Sullivan, but ultimately agreed to the arrangement in exchange for compromises made to him. It was hardly the surest of footings, and the creative process had proved a thorny one, but at last *Utopia Ltd* was launched to a rapturous public on 7 October 1893.

The opening night was met with relief and joy from the tens of reporters and hundreds of guests who had been invited, or had been lucky enough to secure a ticket. 'There was a fine show of diamonds at the production of the new Gilbert & Sullivan opera last Saturday night,' chronicled one newspaper, 'and a very liberal sprinkling of the Society element, all the smart women being anxious to see what a "Drawing-room" would be like in "Utopia", and whether the manners and customs prevalent at Buckingham Palace on drawing-room days would be reproduced here.'[202] However, although initial reaction was positive, and the reviews were, in the main, enthusiastic, there was an underlying unease, an unspoken sense that this piece

was not quite up to the old Savoy standard. A poignant moment reinforced the perception that the duo were, perhaps, losing their modernity. In taking their curtain call, Gilbert leaned heavily on his stick, and Sullivan looked wan and unwell. And, after the initial period of sentiment and nostalgia, sales dropped, and *Utopia* closed after a respectable run of 245 performances. Respectable, yes – but not in the league of the successes of yore.

Because of the high production costs – a magnificent royal drawing room scene had necessitated costumes and wigs worth hundreds and hundreds of pounds – D'Oyly felt that the piece was a failure. Gilbert had done better than the partners, with takings of £4,600 versus the £1,800 earned by Sullivan and D'Oyly. The costs having been so high, D'Oyly asked Gilbert to consider trimming down the extravagance for the next opera. The playwright had a strong voice in the casting process, and D'Oyly wondered whether they might use less expensive stars. A further issue, which concerned all four of them, was the suitability of Gilbert's protégée, Nancy, who was not charismatic on stage. Sullivan and D'Oyly were determined to get rid of her, and even Helen acknowledged that the soprano needed to go, admitting that Nancy was 'amiable' and 'sweet', and she couldn't understand why she 'should be such a wet blanket and such a damper on the performance'.[203] Gilbert, however, stood by the singer, and would not budge. Sullivan was annoyed and, with D'Oyly's and Helen's support, refused to work with McIntosh again.

Chapter XIV

D'Oyly's Toils
1895–1900

THE FRAGILE GILBERT & SULLIVAN franchise had cracked again, and each went their own way. All, including Helen, still suffered from health problems. The Cartes continued, however, to put in 14-hour days, working in their offices and in their stage-box from which they viewed rehearsals and performances, taking work with them. Suffering from inevitable exhaustion, Helen fell victim to frequent headaches, and was also vulnerable to chest problems. D'Oyly pushed himself immensely hard as well, and had a bad heart. So poor was his condition that it was even reported in the press: 'Mr D'Oyly Carte is somewhat seriously ill.'[204] Indeed, from this time, D'Oyly's health became ever more precarious and he never fully recovered, living as a semi-invalid. The house at Adelphi Terrace was extremely comfortable, and equipped with an elevator. Helen held the fort at the theatre, and looked after her husband with tenderness and care. She was also helping to train Rupert in the business – he had been working in an accountancy firm, and in 1894 he joined the firm as an 18-year-old assistant, when his father was ill. A mere five years later, he was an assistant managing director, wholly committed to the business.

Both Gilbert and Sullivan sought, once again, other partners to create operas, while Helen and the increasingly frail D'Oyly staged a revival of the popular *Mikado*. Revivals were good for filling the theatre and keeping the semi-permanent company and permanent staff employed, but they were always less profitable and less popular than new material. Another piece, a romantic light opera called

Mirette, did not find favour with the public, and it seemed that the Savoy's best days might be over. Public taste was evolving, too. Modern pieces, such as Ibsen's *A Doll's House*, were controversial, but interesting, provocative and more resonant with the social trends that were reflecting greater opportunities for women in the public sphere, and an increased interest in what had traditionally been considered '*women's*' interests and aspirations, confined exclusively to the home. The view that the theatre had responsibilities to educate as well as to entertain – as expounded so vigorously, for example, by George Bernard Shaw in his capacity as dramatic critic of the *Saturday Review* from 1895 – was never going to find favour with the Savoy audiences.

It was thus with relief that the Cartes were able to persuade Gilbert and Sullivan to collaborate on another new opera, which they hoped would open in 1896. Helen would have to manage the pair and keep them on track; she was shouldering more and more of the day-to-day responsibility, telling her brother that D'Oyly had had to 'quite give up business'.[205] Indeed, his doctor had insisted on D'Oyly's confinement to the home. Helen had hoped to take him on a trip to Australia when he was somewhat better but, just a few months later, she wrote to her brother that due to his 'aneurism of the heart', her husband was 'still too sick to leave'.[206]

In September 1895 Helen reported that she and D'Oyly were touring in North Wales. D'Oyly's health and mobility were so poor that he had to be carried up the stairs.[207] An old opera by Sullivan was refreshed and revived but ran for fewer than 100 performances (a failure by Savoy and Sullivan standards). Fortunately, the Savoy Hotel was flourishing, and had become a renowned magnet for international travellers seeking the epitome of luxury and glamour. César Ritz and his colleague Escoffier had elevated the dining offer to one of the highest levels. Bookings soared as the restaurant gained a reputation for the finest cuisine. The dazzling spectacle of the beautiful people, dressed in evening attire replete with sparkling jewels, became a most attractive feature. The presence of renowned actors was always a draw, mixing the fashionable with the talented. The world of the reputable theatre (as opposed to the music hall), as that of the artist, had moved from a quite bohemian fringe to an

overlap with society at the highest levels. The legendary American actress Ethel Barrymore wrote of taking tea every Thursday with Mrs John Hay, the American Ambassador's wife, and of attending balls, dances and dinners where she mingled with Whistler, the Asquiths, the du Mauriers and other diplomats, artists, and politicians.

> I was also great friends with quite a different group of people, Lady Lister-Kaye and Sir John and her sister the Duchess of Manchester and her beautiful young twin daughters and Kim, her son. Lady Lister-Kaye [one of the famed trio of the Cuban American Yznaga sisters from Louisiana] was very kind to me, and I would go very often to her house in Manchester Square. One of the people who was often there was Prince Francis of Teck whom they all called Frankie Teck. He used to talk a great deal about his sister, May, who was then Duchess of York [and later Queen Mary].[208]

Musical Sunday evenings became so popular, noted one journalist, that 'Society of all sorts – even the portion which has elaborate establishments and trained cooks in personal possession – has made the Sunday evening dinner at the Savoy something of a function. So much so, indeed, that nowadays you must engage your table beforehand.' Some 350 guests were entertained each evening, and it was a military operation in the kitchens to produce the superlative food, 'all of which must be hot and perfectly cooked'. Gas lamps and unshaded candles had been replaced by soft electric lights covered in pink silk, and each table held a flower arrangement. In full evening dress, the clientele looked wonderful and there were many celebrities. The Duc d'Orléans was surrounded by his suite, while opposite him might be an 'Indian Rajah and his fellow-travellers, all of whom were in brilliant Oriental costumes'. At every table one could spot 'the man of letters of the moment, the fashionable portrait painters, the Men of the City, and many Americans'.

The stage was well represented, with Mrs Langtry, Jenny Lind and Nellie Melba frequent guests, while the band played 'the Pilgrims' March from *Tannhäuser, The Jewel of Asia*, or a selection from the

latest Spanish operetta'.[209] Success led to optimism and, at Ritz's instigation, the Grand Hotel of Rome was purchased and added to the group, as was the site of Claridge's Hotel in London. This hotel, made up of two establishments that had been joined together, was promptly demolished and construction work was begun on a magnificent, distinguished hotel with modern fittings, featuring 200 guest rooms. With this side of the business demanding investment, it was all the more critical to produce income where it was possible.

The robust popularity of the Savoy was much needed to weather the crisis of the sensational conviction of Oscar Wilde in May 1895 for homosexual acts – described by the judge as so heinous that he would rather have ruled over a murder trial. Lurid evidence of intimate dinners with young men, stained sheets and other insalubrious details of the author's prolonged stay in a Savoy suite were provided to a shocked jury.[210] Although details were kept out of the press at the time, there was enough horrified gossip to damage the playwright and the hotel. Wilde went to prison after the third trial and the scandal was greeted by widespread derision and a closing of bourgeois ranks. It followed the Cleveland Street scandal of 1889, in which a police raid on a club revealed that a large number of prominent men had been availing themselves of young male post-boys; these highly placed men included, it was rumoured, Lord Arthur Somerset, equerry to the Prince of Wales, and possibly even the Prince's own son, Albert Victor.

While men such as the artist Edward Poynter, President of the Royal Academy, the authors and artists Joseph Conrad, Aubrey Beardsley (a friend of the Cartes and contributor to an in-house Savoy magazine), Arthur William Symonds, art critic Walter Pater and some musicians were perhaps talked about in hushed tones, they were socially accepted as long as overt sexual behaviour did not take place publicly. Too much scandal – as in the case of Wilde – could kill a career and a reputation. The Prince of Wales was notoriously hardline on this matter. The Savoy managed to weather the storm, although the affair did little to help D'Oyly's health, and Helen shouldered even more of the day-to-day responsibility of managing the franchise.

Business had much improved, and this was in great part due to

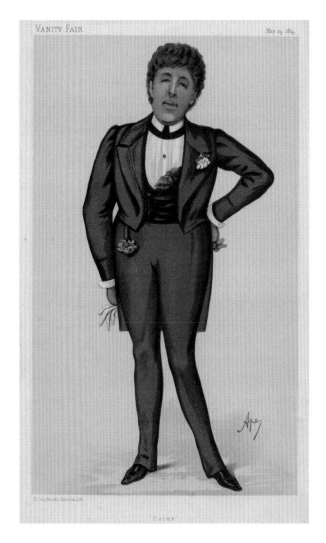

Oscar Wilde: the sharp-tongued Irish dandy was an immensely clever writer and wit. He dismayed his many friends and high society at large when his overt homosexuality was made public in a world where discretion was key.

the magic of Ritz, Escoffier and their teams. Unfortunately, more trouble lay on the horizon. Unknown to the directors, major theft and fraud were taking place. D'Oyly's illness meant that there had been a lamentable lack of supervisory control, and kitchen profits fell dramatically. An anonymous note (assumed to be from a

disgruntled employee) enumerated all kinds of illicit activity, from organised kickbacks from suppliers to outright theft. Some of this was behaviour common to hotel kitchens on the Continent, but it had taken on far greater proportions than habitual. After a team of private investigators presented their evidence to the Board, there was no choice but to dismiss Ritz, Escoffier and the second-in-command, Louis Echenard. A particular grievance was that Ritz was lining up investors for his own new hotel in London, wining and dining them in the Savoy, and having his wife Marie use the housekeeping and other hotel services while she shopped for the furnishings of a hotel Ritz planned to open in Italy.

Ritz, Escoffier and Echenard were unceremoniously sacked in March 1898. The embarrassing affair was hushed up at the time and not fully revealed until nearly a century later. Suspicions of theft had led, as we have seen, to a covert investigation, and at a shareholders' meeting – held behind closed doors, with no press allowed – the firm of private detectives hired produced a report, along with that of the auditor, that decisively demonstrated a dirty saga of kickbacks, abuses of company generosity and many 'freebies' with which Ritz was not just feathering his own nest, but currying favour at the Savoy's considerable expense, with potential backers to support him in a new hotel venture in London, for which he had set up a company, together with Escoffier. Ritz's wife Marie in a later book maintained a fiction that a 'Mrs W.' had caused the problems. This refers to the formidable Head of Housekeeping, Frances Willis, the trusted nurse who had brought up Lucas and Rupert, and who headed up the housekeeping staff at the hotel. Later information has shown that large-scale theft did indeed take place, and that both Ritz and Escoffier were at the epicentre of the wrongdoing.

However, there was little to be gained – and much to lose – in a public scandal, especially as so much of the hotel's and restaurant's reputation had been built on the back of the popular hotelier. The loss of the celebrated chef Escoffier would be equally unappealing to the guests. The secret legal proceedings were lengthy and no one emerged well during the two-year exploratory process – neither Ritz and others for stealing, nor Carte and his directors for missing it. An

out-of-court settlement was reached on 29 January 1900, including the provision that no facts would ever be given to the press (this was respected until the leak 90 years later). The whole affair was shocking – Ritz and Escoffier had done everything possible to make the Savoy dining experience a success, and they had done it brilliantly. D'Oyly, who clearly turned a deaf ear to criticisms of his stars, could not overlook the blatant cheating. Urgent steps were taken to protect the shareholders.

D'Oyly's illness was the cause of a lack of the tight supervision needed to run both the hotel and the restaurant. Changes were needed. First, Rupert Carte was appointed to the board. Together with his stepmother, he paid attention to improving the systems. Helen spent more time on managing the hotel, in addition to the theatre business, leading to even longer workdays. Many of the foreign staff had departed with Escoffier and joined the newly formed Ritz corporation. New staff were hired, requiring training and closer supervision. The directors rallied, hosting dinners and courting favourable press coverage. The *Sunday Telegraph* was able to report in April 1899 that it was 'quite a relief to turn to the Savoy Hotel, where the dividend had been returned to 10 per cent, as a result of the change of management in March last year'.[211]

The newest opera, called *The Grand Duke*, had opened in March 1896. It was magnificently staged, in the Savoy tradition, and welcomed with joy by an adoring public. Although initial enthusiasm was huge, the piece itself was disappointing, and it ran for a paltry 123 performances. The partnership ended for the fourth and final time. Sullivan admitted that he was relieved, telling the playwright (and editor of *Punch* magazine) Frank Burnand: 'Another week's rehearsal with W.S.G. and I should have gone raving mad.'[212] He wished, however, to continue to compose for the Savoy. Both men were disappointed by the piece, each knowing that it was not his best work. And both found the whole experience depressing. To make matters even more troubled, Helen's beloved dog, Trapp, died. 'She and D'Oyly are quite heartbroken over it,' wrote her brother John. 'Helen speaks of him as "her only child".'[213]

The famous Hungarian soprano, Ilka Pálmay, had very warm

feelings of admiration and affection for Helen – calling her a 'person of genius'. The soprano and the manager shared a passion for dogs. Trapp was, Pálmay recalled, a 'large dog of really human intelligence' and Helen's 'best friend'.[214] Helen and D'Oyly were absolutely devastated, and the wire-haired terrier was buried on D'Oyly Carte Island, with a plaque inscribed: 'In memory of the much loved and loving Trapp, who died June 11th, 1896, the more than friend and constant companion for nearly nine years of Richard and Helen D'Oyly Carte.'[215]

Sullivan, however, kept Helen busy helping him to manage his chaotic finances. This was not because of a lack of income – far from it. Each year, thousands of pounds poured into his coffers, but exited even more quickly. Gambling, expensive travels, expensive friends and high living generally exhausted his finances. He had often turned to Helen over the years to help him out of a pinch. On his way to St Moritz with the socialite Baron Hirsch (another intimate of the Prince of Wales) he wrote to Helen that he didn't want to worry her, but as he was overdrawn at the bank, he asked whether she would, 'like a dear', pay his Grand Duke money into his account there, 'as soon as you can'.[216]

These additional worries added to Helen's large workload. Both she and D'Oyly, though he was so ill, remained hugely committed to the business and to the many people they employed. There was the added pressure of what had become a burgeoning hotel group, with demanding directors and shareholders. The main income stream, generated for two decades by the Gilbert & Sullivan dream team franchise, had come to a halt, and was unlikely ever to be revived. Further, all the original partners struggled with health issues, which grew more pressing as the years went by. There was no question, though, of giving up. An empty theatre was a disaster, and Helen put *The Mikado* back on as a revival to fill seats. This was very successful, running to 226 performances. After the short run of *His Majesty*, a new comic opera by different authors, the Cartes decided to stage another revival and chose *The Yeomen of the Guard*. Gilbert was brought on board to oversee rehearsals and provide initial input for £200. As was his usual custom, he approved the cast selections of the

Cartes, and conducted the rehearsals. The piece opened on 5 May 1897 and the first night – as per the old tradition – was conducted by Sullivan.

Yeomen ran to an acceptable 186 performances, ending in November 1897. Helen had written to Sullivan that in August 1897 she had to 'keep running up and down to see after D'Oyly' and had been 'quite unable' to get through her work. She was at her office 'from 10.0 [*sic*] AM till 11.30 PM unceasingly except for a hasty dinner but my work is quite over my head'.[217] This did not prevent her, however, from providing him with a long, detailed explanation of various modelling scenarios based on attendance, sharing risk, and demonstrations of how percentages work and why certain pieces had been financial failures. She explained that she had to keep the flow of pieces going at the theatre, in the hope of producing an income stream. The profits from the theatre business were needed for investments in the hotel group and building development.

Fortunately, there was still a huge appetite for spectacle in England, heightened in 1897, the year of Queen Victoria's Diamond Jubilee. On 22 June, the Queen, accompanied by 50,000 troops, was driven in the open state landau through streets lined with thousands of cheering spectators. They roared wildly, waved flags and broke into renditions of the national anthem. Many foreigners attended, including enthusiastic Americans – which did wonders for business at the Savoy Hotel and Restaurant. So numerous were these rich transatlantic invaders that 'Lady Masque' referred snidely to them in her article for *The Lady's Realm*, one of the most popular women's magazines at the time. Lamenting the lack of viewing tickets for the great event, she declared that the 'best places seem to have been snapped up by wealthy Americans and rich nonentities, who seem to think they can carry everything before them; and our old nobility are shouldered aside'.[218]

The Gilbert & Sullivan offer reinforced a sense of Englishness and catered to a sense of insularity and inclusivity. Back in 1887, Gilbert had claimed to Sullivan: 'we are world-known, and as much an institution as Westminster Abbey'.[219] Despite their varied subject-matter and, often, exotic locations, the operas were, as David Cannadine has

astutely observed, 'in fact all about England'.[220] This was quite true, and the, at times, pointed teasing in the pieces illustrates the unease beneath the surface of a traditionally stable and conservative society. Shifting sands were evidenced by the larger numbers of gentlemen in trade and their families taking on more prominent roles in society, along with foreigners – still distrusted by many Britons. Catty comments were made about Park Lane becoming known as 'Kaffir Lane', as so many South African financiers had moved there, as well as 'wealthy Jews'. For columnists such as 'Lady Masque', this was an unwelcome change, and she was not alone in her distaste. The Prince of Wales, with his coterie of wealthy friends – many of them Jewish, many of them American – did much to normalise their place in upmarket social life, their presence demanded at parties, dinners in country homes and at the racecourse. Many of the more traditional set found this unacceptable.

The prestigious and increasingly popular Savoy Theatre, with its glamorous restaurant, was a perfect nexus of aristocrats, talented artists, writers, singers and other creatives, and foreign wealth. A dinner given by the wife of Savoy director Hwfa Williams in May 1898 included all the *crème de la crème*, and featured in the press. The *World* excitedly reported that 'all the pretty women in London seemed to be present'. Among the guests named were the German-born Duchess of Devonshire, a society doyenne (quite a coup), the Prince of Wales's intimate Consuelo, Duchess of Manchester, an American, as well as Lily Duchess of Marlborough (also American), the Duchess of Leeds, Lady Howe, and many other brilliant society ladies. The politician Lord Rosebery, the Duke of Roxburghe, Count Albert Mensdorff and scores of others were 'divided into small parties at separate tables'. Other guests had been invited for the dancing, of which Lady Helen Vincent 'was the beauty'. A 'capital supper was provided later on', making the evening supremely successful. The arrangements of the dinner, dancing and supper, gushed the paper, 'reflect the greatest credit on the Savoy management'.[221]

Chapter XV

Standing Alone

1898

BUSINESS RECOVERED. Sullivan composed a new opera, *The Beauty Stone*, which had its premiere on 28 May 1898. He then worked with the librettist Basil Hood on *The Rose of Persia*, which launched at the end of November 1899. This piece was more successful for Sullivan and the Savoy, running to 213 performances. A further share offering for the hotel group took place in June 1899 – and the total share capital of the company was now £425,000.[222] The capital was increased in order to amalgamate Claridge's with the Savoy and the Grand Hotel Rome, and issue was made of 17,500 shares at £10 each (priced at £13 a share).[223] *Vanity Fair* proclaimed in an article that D'Oyly Carte, 'although more or less an invalid', was at the head of an organisation of 'Hotel and Theatre Companies that controls a capitalisation of between a million and a half and two millions sterling'.[224] In addition, the group now included the Restaurant Marivaux in Paris.

The expansion was risky, especially given the state of D'Oyly's health. Yet, innovations continued apace. Dinner dances – originally known as 'American dinners' – became a very popular feature at the Savoy. It was now acceptable – and even desirable – for wealthy Londoners, not just foreigners, to entertain there. As one correspondent noted in a New York paper, in this way 'the host and hostess are relieved of all domestic anxiety whatever, and even if they are a bit more expensive than a "home dinner", certainly to people who are well off they are worth the difference'.[225] The need to attract regular custom remained, and the business depended on the profits

from the theatre both to sustain expenditure and to provide publicity
for the Savoy, and on a ready supply of audiences eager to dine before
or sup after the performances.

The growing hotel and restaurant businesses placed continual
pressure on the theatre, and it was a constant struggle to keep the
theatre business churning out profits as it had in its heyday. It did
not take much to sway attendance figures. The changeable British
weather was always a factor: Helen wrote to Sullivan in September
1898 that the hot weather that summer was 'awful'. Despite the
lack of theatre-goers because of the heat ('the theatre is really cool
but nobody believes it') and the dearth of Americans at the hotel
for the same reason, the six-monthly Savoy accounts had come out
'excellently'. This was because of the 'horrible amount of work' that
she and Rupert had put in, yet she thought 'it is getting on a right
basis'. She planned to remove *Gondoliers* and replace it with *Sorcerer*, she
explained, and she hoped that Sullivan would conduct the orchestra
for the opening night on 22 September. She was extremely anxious
to hear from him to know where he was and how he was.[226]

The letters from Helen to Sullivan during these years became
very pointed, and one can observe the frustration engendered by the
composer's habit of disappearing for weeks – indeed months – on end
with no forwarding address or news. This was partly, no doubt, his way
of alleviating stress, and dealing with the Savoy and Helen's reiterated
demands was extremely stressful. His health was poor, and his social
life very lively. Gambling featured largely. Work on the prestigious
Leeds Festival had exhausted him. Helen was certainly sharp in some
of her correspondence, yet one feels enormous sympathy imagining
what it was like to open a letter from the composer who, already
late for delivering his work, announced that he was 'going to breezy
Newmarket', his address: the 'Jockey Club Rooms'. Yet he had been
'staggered by receiving two accounts which for the moment I am unable
to pay', hoping that she would lend him £1,700 for three weeks.[227]

Thus Helen was busy not only trying to help Sullivan manage his
finances, but also to settle terms with his new collaborators. As ever,
the composer struggled to focus on the fine details, and in this instance
he was at a disadvantage without Gilbert, who was a fierce negotiator

and always scrupulously fair to his partner. He ultimately felt that he had been forced into a profit rather than percentage agreement with the playwrights Pinero and Carr, and was unhappy about it. Sullivan complained to Helen, writing to her that he had ultimately agreed to their demands for her:

> But I want you to know, that it was entirely for your sake that I have changed my decision. I thought of you and all the trouble you have had already – of the work you have to do with the hotels as well as the theatre – of your anxiety about D'Oyly, and of your standing quite alone. I thought of all this, and considered the worry you would have again with this fresh difficulty, and it seemed so cruel to add to your anxieties and responsibilities, and so I gave way...[228]

Helen indeed stood alone. She was training up Rupert, now aged 22, to take on more responsibility, but he was still very young and inexperienced. Meanwhile, she decided to continue with the revivals. *The Gondoliers* was staged in March 1898, directed by Gilbert. Sullivan was on holiday on the French Riviera, and would not be present for the opening night. Gilbert was in London, preparing to testify in yet another court case. He was on excellent terms with Helen, dealing with her exclusively for his business – and his personal affairs. The playwright was suing the editor of *The Era* for libel, and had asked Helen to be a character witness. After a forceful cross-examination by the famed litigator Edward Carson, where all Gilbert's previous quarrels and court cases were raked over, the author was livid when the special jury could not come to a verdict. 'My case was tried before a Judge who is a monument of senile inability,' he expostulated to Helen.[229]

In January 1899 Helen herself became ill. Some weeks later, she was still unwell: 'I am very sorry to hear that you are still out of health,' wrote Gilbert in March, 'I hoped you had quite picked up again by this time.'[230] More than two months later, she had not picked up. Gilbert wrote that he was 'sorry to hear that you are again indisposed'.[231] Despite this, she was still working incredibly hard. She

explained to her mother that she was 'struck' on 'the carrying out of some enormous scheme which is still on hand for raising the street leading from the Strand to the Savoy Theatre and building a lot of modern houses or flats along the street'. D'Oyly had been 'buying up the properties for years past with a view to this'. Helen added that her husband had 'been very ill again' and that she herself was ill with 'worry and overwork'.[232] The stress must have been extraordinary: the Cartes had invested £100,000 in the building scheme – of which £50,000 was a bank loan.[233]

Yet it was another touch of genius, as the area cried out for redevelopment. Even the better parts of London were not immune to the tide of human wreckage that seeped westwards. The Embankment, despite its proximity to the glamorous theatres, hotels and restaurants, drew in the most miserably poor of London. Attracted by the gardens, electric lighting and Salvation Army soup tickets, the theatre area was insalubrious, to say the least. 'I walked home along the Embankment this morning at two o'clock with the editor of the Standard,' wrote Ralph D. Blumenfeld, who moved to London in 1894. 'Every bench from Blackfriars to Westminster Bridge was filled with shivering people, all huddled up – men, women and children.'[234] Theatres, despite their much-improved image, remained linked to the thriving prostitution in the area. In the evening this market moved from the Oxford–Bond–Regent Street area to the theatre districts.[235]

Crime abounded, and the actors exiting the Savoy and other theatres had to be especially careful, as pickpockets preyed on them and a week's pay was easily stolen from pockets and purses. The gloom was exacerbated by the soot deposits and filthy air that were ever-present, along with the notorious London fogs. Investment in the area could do little for the air, but it could address the decrepitude and improve the appearance. Although the 'edginess' of the theatre district may have provided a welcome frisson to many of the male audiences, the gentrification of the theatre, shopping and dining offer increasingly precluded the insalubrious prostitution trade. Better lighting and access would reduce crime and ensure safer experiences for guests and actors alike.

Although her mother was longing to see her, Helen wrote putting

Beggars on the Embankment: cheek by jowl to an area packed with shops, theatres, restaurants and taverns lived the poorest of the poor, begging for a crust while living on the streets. The regeneration of filthy slums in the West End came at a huge cost for many of the city's most miserable inhabitants, as the homeless faced more and more police harassment. The Savoy Theatre, along with the other major performing houses, led charitable giving to improve living conditions for the desperate underclass.

off visit after visit. To add to her stress, John sent reports of Ellen's declining health that were truly alarming. In April 1899, Helen cabled her brother with her anxieties, followed by a letter suggesting that she could either come out immediately on her own, or, if Ellen were well enough and could wait, she would come with D'Oyly, 'although he will be a terrible trouble owing to the infirm state of his health and the constant attention which he requires'. She enclosed a cheque for £30, 'for cabling if necessary'.[236] This concern for her mother was yet another burden for her to bear. While nursing her husband and ensuring that the boys were well – Lucas had qualified as a barrister – she was running the Savoy Hotel Group with Rupert, as well as trying to extract original material from Sullivan and other

composer/writer teams. Revivals were never as popular as original material, and could be relied upon only at judicious intervals, as Helen well knew.

The revival of *The Gondoliers* in July 1898 had been followed by a trip down memory lane with *Sorcerer* and *Trial by Jury*. Gilbert and Sullivan reunited for the 21st anniversary, taking a silent bow – but they did not speak. There was clearly no reconciliation or further collaboration on the horizon and thus the Savoy needed to find material elsewhere. Helen herself wrote new dialogue and lyrics for a version of *The Lucky Star*, a French operetta that had been adapted for the American market. This piece opened in January 1899 and proved a surprising success, running for five months. More revivals – rehearsed by Gilbert – followed: after *Trial by Jury*, *H.M.S. Pinafore* opened in May 1899. Helen pinned her hopes on new material from Sullivan.

Alarmingly, however, his health was in decline, and he was at his most frustrating – ignoring deadlines, disappearing to the Continent for weeks on end without a word and socialising with a frenzy that boded ill for his wellbeing. Helen lost her patience on more than one occasion, writing sharp letters to the composer. 'I returned to town yesterday and thought I should be sure to find a note from you in reply to my business letter to you of last week but I found nothing,' she chided. On sending down to his house, she added, she was told that he was away, travelling in Switzerland. She begged him to either wire or write to her 'to say if I am to understand that the business arrangements are concluded in accordance with my last letter'. The matter had been 'going on such a tremendous time and has been altogether so worrying that I must really beg you must give me clear assurance that things are now settled'.[237] At this stage, Sullivan and the Cartes were so intertwined in friendship and finances (he had invested in the hotels and remained a prominent Board member) that there was an element of claustrophobia creeping into the relationship, exacerbated by the nervous tensions and health issues of all three.

As the composer grew more discontented and fatigued, he took a pessimistic view of the Savoy Theatre. He complained to Helen and wrote angrily to his secretary of his feelings of being tied to

'the deck of a sinking ship'.[238] Helen replied with a lengthy letter in July 1898, going through a long list of alleged applicants requesting to put a piece on at the Savoy. 'I am only going into this report,' she explained, 'because it only [*sic*] dawned on me from things you said and wrote that you were in some way mixing up the fact that the new operas here have not been successful lately.' The idea of the Theatre 'going down', she added, 'is really so absurdly otherwise if you only knew.' Instead, the difficulty about the Savoy was 'rather that everybody wants to have it'.[239] This is hard to believe, and the following day she wrote again, having had a letter from him. In this missive, she explains her position very clearly.

> You ask me about the future. I don't want as I told you to carry on the Theatre unless it is for your pieces – that was our object. I am still absolutely convinced that the public thirst for a gay bright pretty amusing book – with your music…. Nothing has occurred to alter my ideas about this. But they won't stand a heavy dull book however well written – they must have fun – rapidly – brightness.[240]

In this Helen was certainly right. The nation's mood had changed. Rather than being – even gently – teased and provoked, audiences wanted release and joyful entertainment. In many ways, Victoria's triumphant Jubilee might be considered the apex of British imperial might. Cracks began to appear more visible in the seemingly solid realm. The second Boer War, which began in October 1899, was a response to alarming rebellious rumblings from South Africa, and troops were sent to the colony. Guerrilla warfare ensued, and it took over two years to achieve a costly victory. This was a sobering experience for a nation accustomed to dominating. A deepening economic depression added to anxieties, which were exacerbated at a political and business level by competition between the great powers of Europe and a scramble for colonies in Africa. Theatre companies put on benefit performances to raise funds for the widows and children of British soldiers. After the gruelling conflict ended, the public wanted relief. Light, happy pieces were what was needed – but

although Sullivan's music was often exactly that, it proved impossible to find librettists with Gilbert's erstwhile golden touch.

Arthur Sullivan, suffering terribly from recurring kidney trouble, fretted over his compositions. On 13 May 1900, he enjoyed what was to be his last birthday, celebrating with Helen and D'Oyly, along with his adoptive nephew Herbert (Bertie), his secretary Wilfred Bendall and long-time paramour Fanny Ronalds. This last birthday celebration was held at the Savoy. No one, however, realised just how sick he was. Sullivan had been ill for so long, and had gone from spa to spa for years. He repeatedly insisted that he was able to work. Helen clearly had no idea of how serious things were, and she was frequently ill herself that year. In March 1900, Sullivan wrote that he had heard that she was 'very far from well and that the doctors urged your going away without delay. I fear, my dear Helen, there is too much truth to this.' She was 'overworked', he added, and needed to 'stop in time', or she would 'break down suddenly'.[241] Helen took no notice of her own health problems. Plans were made about the next opera – which, she explained, was a necessity, as were the revivals. They were 'compelled', she explained, to keep producing pieces, 'before we can let either the Hotels or Theatre out of our hands to complete the Strand Entrance finance'.[242]

There was so much pressure to generate revenue, with payments owed to the bank and dividends to shareholders. In October 1900, she assured Sullivan that regrets were unhelpful: 'I know it is never a bit of use worrying over what is past. All I will bother you or myself about is the immediate future.'[243]

Chapter XVI

The Watershed

1901

Helen needed to balance the immediate and pressing demands of the Savoy with the health constraints of their beloved friend. The composer yearned to be productive, and often claimed that he was on the mend. In October 1900 he told Helen that he was better and working again. She replied:

> I cannot – as you will I know realize – think of worrying you when you are ill. [Rather] what I really want from you is some clear idea of the worst that can happen to us. What I must get at is what is the latest the production is likely to be? Don't make it better than it is – just let me calmly face the worst – it is the kindest to everyone in the long run.

The seasoned manager was particularly concerned to keep the theatre open: 'A closed theatre soon loses its good name.'[244] Sullivan's response was reassuring, promising to deliver the piece in a little over six weeks. This Helen was unprepared to accept, however. The voice of experience prevailed. 'Allowing for vicissitudes that usually arise – such as difficulties over bad rehearsals, through unforeseen concerts – or any alterations that the author or yourself might wish to make – or other accidents (apart from illness),' she explained in her reply, 'we might add, say, a week or half a week – and consider we might reckon on producing in 7 to 8 weeks.'

They must, she added, also consider the possibility that he would be 'having such amount of illness as might delay matters'. Helen told

her friend that she was unwilling to countenance having to press him if he felt tired: it would be 'cruel and impossible'. Given that the previous evening's takings were down to £42, and that a production scheduled to open in seven weeks – even were that to be a certainty, which it couldn't be – 'would mean at least 3 weeks closure – a thing as I said discouraging and demoralizing'. She had therefore concluded that the best way forward – 'the only plan in all our interests' – would be to revive *Patience*, opening in early November, and to produce the new opera on 8 December, giving them all breathing space. 'This we can do "on our heads",' she continued, 'it gives you one week more than you state – it will keep everybody cheerful and in salaries and it will not compel me to feel I am driven to worrying you night & day – a thing I cannot bear....' [245]

The last months of 1900 were terribly fraught for all. D'Oyly was laid up in Weybridge in early November, while Helen rushed up and down to London. Gilbert had been very ill as well. Helen told Sullivan that she had gone to see the author at rehearsal, and he had looked 'very thin and weak poor fellow – his arms were like cotton wool'. Gilbert had asked, she recounted, if Sullivan could be persuaded to attend the opening of the *Patience* revival. She had not been hopeful, she continued, but it would be very special if all three of the original triumvirate could take the stage – it would probably be their last chance. [246] The composer was not at all keen. He told Helen that he had no wish to refuse her, but he was not happy, writing:

> ... it's a little strong on the part of Gilbert, to lay such stress on my coming and taking the call with him. I have no doubt that it is in the highest degree amusing for him, and is a humorous situation such as he loves to go before the public in the most harmonious manner, and then turn his back deliberately upon me.... He committed the outrage as I told you, of cutting me dead in the street. I survived it, but I am not going to, wittingly, indulge him in a similar pleasure if I can help it.... [247]

Sullivan ultimately responded to the sentimental call, writing that 'if it would really please Gilbert to have me there and go on with

him I will come. Let us bury the hatchet and smoke the pipe of peace.'[248] Helen was delighted and joked that she had suggested to D'Oyly 'that we should have an original effect of three Bath chairs descend – or a procession of Bath chairs!'[249] Sadly, this reunion was not to be. On 7 November, Arthur Sullivan was far too ill to attend the performance. 'Good luck to you all,' he wrote to Helen with a shaky hand. Gilbert and D'Oyly took to the stage to acknowledge the tremendous applause. Gilbert wrote to Sullivan: 'The old opera woke up splendidly.'[250] Less than two weeks later, on 22 November, the composer suddenly died, at the age of 58. The unexpected death sent shockwaves throughout the world. Arthur Sullivan had wished for a small family funeral, and to be buried close to his beloved mother, father and brothers in Brompton Cemetery, but this was not to be. The Queen overruled his wishes and directed that the funeral service should be conducted in the Chapel Royal, and that the famous composer be given the honour of a burial in St Paul's Cathedral.

The Times summed up the national feeling in a long tribute the day following his death:

> The death of Sir Arthur Sullivan, in his 59th year, may be said without hyperbole to have plunged the whole of the Empire in gloom; for many years he has ranked with the most distinguished personages, rather than with ordinary musicians. Never in the history of the art has a position such as his been held by a composer.[251]

It was an unexpected loss for Gilbert. On a cruise to Egypt for his health, he had written, 'I sincerely hope to find you right again on my return.'[252] The dramatist was relieved, though, to have somewhat made up their quarrel just before Sullivan's death.

Faring rather better than had Sullivan after their final split, Gilbert continued to thrive financially. His play, *The Mountebanks*, was a great success and his writing career flourished. On the personal front, he was enjoying life, despite his problems with gout. Lucy and he loved entertaining at Grim's Dyke, where the pets had full rein of the house, with little tablecloths laid out for their meals, taken with

the family. The Gilberts lived in the lap of luxury, looked after by 28 indoor and 14 outdoor servants. Guests played croquet with Gilbert on one of the two separate lawns laid out for this purpose, took walks throughout the 100-acre property, and swam or went boating on the lake. Gilbert, with military discipline, took a swim every day from April or May to September. Since 1891 he had been a Justice of the Peace for Middlesex and in 1902 he became a Deputy-Lieutenant for the county.

The loss of Sullivan was a huge personal as well as professional blow for Helen and D'Oyly. He, however, was so ill with bronchitis that he could not leave his bed, and Helen attended the funeral on her own. Writing to Fanny Ronalds, Helen expressed her sadness: '... although I realize the enormous loss the world generally has suffered – I can think of nothing at present but the personal loss – the loss of so very dear and true a friend.'[253] With D'Oyly so ill, Helen believed that she could not realistically be absent from the Savoy business. She was the specialist in the economics of audience management, knowing how to 'read' attendance trends and react accordingly. The Savoy held 1,274 seats, including 175 comfortable seats in the stalls, 187 in the dress circle and 178 in the upper circle, as well as the prestigious boxes with 78 seats. These tickets were purchased in advance by the well-to-do, who were requested to attend in evening dress. They arrived primarily by carriage. A further 650-odd customers could be accommodated in the cheaper seats, in the pit seats behind the stalls, in the amphitheatre and squeezed on to benches in the topmost gallery.

A full house was obviously the most successful of theatre nights, but where the business consisted of long theatre runs, a break-even point was reached when production costs had been met, and the variable and fixed costs of the production were covered by the income from the tickets, advertising and refreshments. However, when audience figures began to drop, a management decision had to be made on how much and how often to buy advertising to stimulate demand. A seasoned manager such as Helen made frequent judgments on how to fill the house, and when to wind down a production. Further, it was critical to have another piece in early rehearsal before reaching

the end of a production, and it was important to limit the nights the theatre was dark for final rehearsals.

Thus Helen had to carefully decide when to put up the boards announcing the end of a run, as doing so could encourage last-minute attendance, but it could also, conversely, signal to customers that the production was old hat. The best pieces played as successes for as long a period as possible. So, gauging the demand by observing attendance figures and trends was an essential skill, which required knowledge as well as intuition. Reading the life arc of a piece made the difference between profit and loss. Added to this mix was of course managing the cast: actors fell ill or fell down on the job, and needed to be constantly supervised and overseen. Although the director was responsible for ensuring high quality throughout the matinee and evening performances week after week, month after month, both D'Oyly (when he was well) and Helen attended the plays almost every night, working in their offices, darting into the theatre to check on the performance. Much depended on operational supervision: of the attendants, the cast and orchestra, the directors of the operas themselves, as well as the audience. In addition to this operational supervision, the daily administration, keeping the whole machine humming, was essential.

There was now a Board of Directors to satisfy, as well as shareholders in the hotel group. All this constant, exhausting activity took place within the competitive environment of London's West End. Some 30 major theatres were located near the Savoy, not to mention the many music halls and venues that offered concerts, private recitals, lectures and other entertainments for an avid Victorian public. Theatres such as the Gaiety, the Prince of Wales, the Haymarket, and Henry Irving's Lyceum competed to draw affluent patrons who, despite the popularity of the pit for the less up-scale clientele, were the primary targets for the impresarios. Indeed, cultivating a brand became an important part of building up a successful theatre, and the Savoy was inextricably linked with the Gilbert & Sullivan franchise. Fervent fans, as well as the players, proudly referred to themselves as 'Savoyards' and felt strong ownership in the brand.

On 24 March 1901, Helen telegraphed her family that D'Oyly was

very ill with dropsy. Just days later, on 3 April, that larger-than-life figure, brimming with enthusiasm, verve and determination, breathed his last at Adelphi Terrace. He was 56 years old.

Chapter XVII

Picking Up the Pieces

1901

THE WORLD OF THEATRE and entertainment lost a much-lauded champion, but Helen lost her world. For nearly 25 years she and D'Oyly had been a team. Losing him was like dying. As a testament to her love for him, she determined to put her responsibilities first. She had made promises to her husband before his death, and would fulfil his wishes, and do right by her stepchildren, D'Oyly's family and the company. Helen's profound grief was compounded by the anxiety over the unfinished business left by D'Oyly's death. He had made her sole executrix by a codicil to his will in November 1900. When probate was granted in April 1901 (later re-estimated and re-sworn in August) it was found that he had left an estate valued at over £250,000 (this compares to that of Arthur Sullivan, whose high spending and gambling had diminished his assets to just over £54,000). This estate − worth about £30 million in 2020 − represented a huge responsibility. There was the lease of the Savoy Theatre to manage, the transfer of all the debenture shares D'Oyly had left to family and members of staff and the theatre company, the transfer of the Weybridge property to Rupert (who had decided that he wanted to keep it), giving up the lease at Adelphi Terrace and other complicated issues.

D'Oyly had left close to £20,000 to his devoted staff, of which £6,000 was to the loyal and vigilant Frances Willis. Legacies needed to be distributed to senior and junior staff members, as well as to domestic and theatre employees. D'Oyly had taken care of his own − rewarding secretaries, bar staff, messengers, accountants and

others. Helen therefore spent the next year sorting out annuities and
payments to ensure that her husband's wishes were respected, and
that no one would be forgotten. She was the principal beneficiary,
inheriting the contents of both their residences and a third of the
residuary estate held in trust. The two boys received another third,
with the proviso that Helen should receive half the income from their
share. The remaining third was divided among D'Oyly's siblings.

The enormous challenge was, as Helen later explained to John,
that although the estate was large, there was 'very little easy cash'.
Instead, 'it was almost all in the shares and debentures at the hotel
and theatre', which they 'can not and must not sell'. Helen, almost
out of her mind with grief, set to the task with tenacity. After paying
£30,000 in death duties and £20,000 in legacies, she 'ruefully' took
her third, of which she used £10,000 to purchase the 'old operas',
which she would use as a pension for 'some old servants'.[254] It was a
horrible time. She had looked after D'Oyly for years with tenderness
and affection. To the end, they were 'partners in crime', discussing all
their decisions about the business, both exhibiting the same passion
and dedication to the theatre, the hotels and the work. She wrote to
her family that she felt herself 'a thing that has been hacked in two
and the wound aches more as time goes'. Yet she was spared nothing:
'I will not attempt to tell you all the legal and other difficulties I have
had at every step of closing up my affairs,' she wrote to John,

> and the awful number of things I have had to think of in trying to
> provide for old and now feeble servants – and I so fear forgetting
> someone. There are many pensioners for whom I wish to bank
> sums of money, and for some I am buying annuities. You know
> that, like yourself, I only consider money as a trust to be used for
> the benefit of others and that is all I wish to do with anything
> that may come to me (beyond my own old savings) which suffice
> for my needs.[255]

While the death of her husband came as no great surprise to those
who knew him, Helen was overcome by a deep depression. The
only thing that kept her alive, she later explained to Rupert, was

her commitment to look after the devoted Savoy players and staff. She would not leave them unprovided for, as D'Oyly's estate had to be wound up, and its assets converted to cash as much as possible. This would enable her to settle debts, including the outstanding mortgage for the Palace Theatre, provide for employees and others, and set up a comfortable future for Lucas and Rupert. Her plan was to wind down the business, and to sell or give away all or most of her household goods. Rupert would have the home at Weybridge. Meanwhile, her mother pushed for her daughter to come to live with her in Australia. Within weeks, Helen realised two things: first, that she could not sail to Australia to be with her mother; and secondly, that the Savoy Theatre and the rights to the Gilbert & Sullivan and other productions were worth next to nothing unless they were expertly managed. The hotel group, too, needed firm hands at the tiller, and Rupert was not sufficiently experienced to run the hotels on his own.

The supremo set to work. In the space of months, Helen relinquished the theatre lease and its remaining repertory company to the theatre manager William Greet, who also took on one of the two remaining touring companies. This left one D'Oyly Carte Opera Company for her to manage, the touring 'C' company which was still performing five Gilbert & Sullivan operas as well as Sullivan's *The Rose of Persia*. She also continued to manage the very profitable companies touring abroad with which she had had such success. The Adelphi Terrace home was given up by paying out £1,000 to terminate the lease two years early, and Helen moved in June 1901 to Beaufort Buildings, serviced flats that formed part of the Savoy Hotel. There she insisted on paying full rent and charges. She explained to her mother that she had a huge amount of work to do, having 'personally bought up out of the estate all the Gilbert & Sullivan Operas for four years and I am making a settlement of them for the benefit of our old staff, who will run them, taking the fees and who will thus, I hope, make a little capital fund (if they save it) to go against bad times'.[256]

Before dying, D'Oyly had, as we have seen, extracted from his wife a promise to 'wind up his affairs'.[257] In addition to settling the estate, Helen had to ensure that the new piece begun by Arthur Sullivan,

The Emerald Isle, was completed and rehearsed in time to open on 27 April – just over three weeks hence. The Cartes had commissioned Edward German – a one-time second violin in the Savoy orchestra and now a composer in his own right – to work with the writer Basil Hood to finish the opera. There was, as well, an additional, confidential matter – 'connected with our terrible loss', which Helen later mentioned to Rupert, without going into details. She explained that although D'Oyly had asked her 'at the time' to bring Rupert into it, she had 'refused to do so, as I did not think it right, and preferred to bear it and do it alone'.

This matter probably concerned the ugly sackings and legal proceedings with Ritz, Escoffier and Louis Echenard. The court case was aborted after two very expensive years, when the dishonest trio realised that the evidence of their thievery was overwhelming. It was extremely awkward, however, for the directors of the group, who faced ridicule and criticism at having been so lax. D'Oyly's illness had left a major management gap, and in order to preserve the group capital, a huge amount of restorative work was needed. Public confidence was essential for the hotel and theatre businesses, and shareholder confidence critical for the hotels.

There was thus considerable – and immediate – pressure on Helen to ensure profitability from the theatre in order to meet obligations to shareholders in the hotel group. There was an outstanding mortgage on the Palace Theatre. Helen explained to Rupert that she had at first been in despair when told that the estate would take up to three years to settle, but she had 'hurried everybody on' and the estate was settled by the end of November 1901. Making decisions about her future had been extremely stressful, she added. Her mother was insistent on Helen coming out to her, but she had decided, after her initial shock, that she could not bear to do so: 'I had no strength to live if I tore myself away from everything & everybody with whom for 25 years I had been associated and who were associated with the person who had been everything to me. I simply could not do it.' [258]

The problem, she explained to Rupert – to whom she was extremely close – was that she was so lonely without D'Oyly and their business partnership. The carefully curated life, built over years with hard

work, camaraderie and love, had, for her, come to an end with the loss of D'Oyly and the life they had constructed. Helen was so miserable that she contemplated suicide, feeling that life had lost its meaning. It was not in her nature, however, to leave matters hanging or any unfinished business. She thought through her plans thoroughly. She wasn't unduly worried about her mother, now nearly 80 – 'so that an extra grief does not now mean much'. There was great concern, though, about Rupert. Hopes that Lucas might join his brother had not been realised. Lucas had worked successfully as a barrister, going on to work as private secretary to the Lord Chief Justice, Lord Russell of Killowen, aiding him with the Venezuela Arbitration of 1899. He had then, however, become very ill with tuberculosis. Tragically, he was unable to work, and moved to Norfolk, to live in an open-air sanatorium. This was especially sad for such a young man who had been extremely athletic and a prize fencer. For now, Lucas lived away from his family and friends, as he became ever more unwell.

Helen was giving serious thought to killing herself. John was astonished to receive a letter from her, warning her family not to divulge any details – including her age – in the event of her death. The instruction was puzzling, John recorded, finding it 'very morbid'.[259] What is astonishing is that Helen, in thinking through her demise, was committed to maintaining the fiction of her age beyond the grave. She also asked her mother to remove her from her will. The plan was to see everyone settled, and then to quietly make away with herself – she had even discussed it with D'Oyly before his passing.

Friends began to worry about Helen's wellbeing. Letters had poured in after D'Oyly's death, as colleagues, friends and members of the extended theatre community reached out to Helen in her great loss. To those whom she knew, Helen described the pain and suffering of her husband's agonising death. 'The care of him must have been a great strain on you,' wrote their American publisher, 'and I should think you might be well nigh broken yourself.'[260] The successful impresario Squire Bancroft sent his warmest sympathies, reassuring Helen that her 'dear husband' had had 'a true, good woman always by his side'.[261] Gilbert wrote a lovely letter, telling Helen how the news had 'touched him profoundly'. He very much wished that he could

*Bertie: known by his friends – but never to his face – as 'Tum Tum' due
to his ever-increasing girth, was a sybaritic, gluttonous Prince who loved
and supported the worlds of art and entertainment, which flourished
during his tenure as Prince of Wales and his reign as Edward VII.*

have been in England 'to pay the last token of respect to his memory'.
Knowing the 'weight of sorrow' that she would be experiencing, he
assured Helen of how 'deeply sorry' he was for her, 'deeply sorry for
the grief that has overtaken a lady for whom, on all the vicissitudes
of our business relations, I have always felt a sincere admiration &, I
hope I may add, affection'.[262]

It was a devastating time, and private sorrows were accompanied by
public ones. The Boer War dragged on, but despite initial optimism,
it became clear that a decisive victory would not be forthcoming.
Death rates were high. As the British shipped more and more men to

Queen Victoria: the premature loss of her beloved husband Prince
Albert marked her life out for unhappiness, which she imposed on
those around her. Bertie was a constant disappointment – a view that
she communicated with great regularity to him and those in his circle.

South Africa, loss followed upon loss, and hospital ships returned full
of wounded soldiers. The defeats of December 1900 had prompted the
Queen to cancel Christmas at Osborne, and she remained at Windsor.
Even the fun-loving Prince of Wales – who earlier had not troubled
to curtail his autumnal shooting visits – was moved to record that he
was 'very despondent and can think of nothing else'.[263] It was a horrific
year for the Empire, and a terrible one for the elderly Queen Victoria,
now 81. Even the success of the army in South Africa in May 1900
failed to raise her spirits and she sank slowly into mental and physical
decline. She died surrounded by her family on 22 January 1901.

This was the end of a way of life at the apex of society. The 59-year-old playboy Bertie – the despair of his strait-laced mother – at last came to the throne. His cohort of wealthy confidants and favourites tagged along, still topping up the high costs of the King's extravagant lifestyle. Friends who were Jewish, American, or otherwise previously socially peripheral came to dominate royal society. After decades of a staid and sober materfamilias at the helm, Bertie opened the doors to a lighter, more exuberant, high-spending era. Riches were embraced and celebrated in a far more overt way, and the middle classes mimicked the aristocrats and well-heeled hangers-on. Fun became a byword no longer associated with disapproval. The end of the Boer War in May 1902 was greeted with relief.

There was not much joy for Helen, though, whose life remained very sad. Surrounded by love and sympathy, urged by her family to join them in Australia, she took some refuge in work, but her health continued to suffer, and her spirits remained abysmally low. 'I am practically dead,' she confided to Haidee Crofton, who had toured with the company in 1879: 'I don't ask anything now but to be let go quickly to join him.'[264] There was, however, no respite from the pressures of the business. During her long dark days looking after her husband, Helen had never stopped working at the theatre. The *Patience* revival had run from November 1900 to April 1901. *The Emerald Isle* had opened on 27 April and ran until November, although part-way through this run Helen sold the lease to William Greet. This sale, despite her hopes, did not solve the problem of ensuring the Savoy's prosperity. The theatre company of tight-knit Savoyards needed a run of successful plays to be financially secure. When the hits did not materialise under Greet, there was no question for Helen of abandoning her responsibilities. She decided to put on a revival of *Iolanthe*, and Gilbert agreed to supervise the rehearsals, for a fee.

Chapter XVIII

Head Above Water

1902–04

ON 7 DECEMBER 1901, some 18 years after its first appearance, Helen opened the *Iolanthe* revival. The audience gave it a rapturous reception, insisting that the manager, in spite of her protests, take a bow alongside Gilbert. After selling the lease, Helen had focused her energies on the companies touring abroad, who continued to enjoy sustained success. From Bristol to Dublin to Manchester, from South Africa to Australia, the Savoy companies met with delighted audiences at every performance. Naturally, with short runs it was easier to fill the theatres, but the remarkable longevity of the pieces was remunerative, and evidenced the ongoing popularity of the Gilbert & Sullivan brand. Social tastes were changing overall, however, and there had been concerns that the clever opera style favoured by the Savoy was no longer in vogue. Instead of gently satirical libretti set to beautiful compositions, audiences were increasingly drawn to a form of British musical theatre known as Edwardian musical comedy. Pieces such as *In Town* and *A Gaiety Girl* in the 1890s had achieved great popularity, leading to a new genre that became supremely successful. *The Geisha* in 1896, *Floradora* in 1899, *The Earl and the Girl* in 1903 and plays such as *The Arcadians* in 1909 and others drew enthusiastic audiences.

The Savoyard George Edwardes successfully ran the Gaiety Theatre after taking it over in the 1880s and hit upon a family-friendly theatrical spectacle, drawing on the traditions of the Savoy but also incorporating elements of burlesque and modern American plots with beautiful settings and modern costumes. Singing Gaiety Girls, the cast, portrayed in the latest fashions, danced as well as sang in

chorus lines, providing light-hearted entertainment and fun. These shows – widely imitated in London and America – usually featured an archetypal poor maiden who ultimately snagged an aristocrat despite the obstacles. Different contexts made their appearance, but the ending was a reliably happy engagement. These Edwardian comedies found great popularity thanks to the enchanting music, with catchy tunes that audiences could sing afterwards.

The competition for well-heeled audiences had thus increased, but there remained the pressing need to generate income – and profits – in order to honour her bedside promises to D'Oyly. The situation was very difficult. On the one hand, Helen was suffering from grief and depression, with suicidal thoughts. On the other, her profound sense of duty was engaged by the plight of anxious company members and the worries of young Rupert, so keen to run the hotel business. What happened next is quite extraordinary and caused an up-turn in Helen's life. Just as *Iolanthe* was bedding in, and she was planning out the running of the operas on tour in Africa and elsewhere, an old friend of D'Oyly's, Stanley Boulter, asked her to marry him. He was Vice-Chair of the Savoy Board, and she had known him for many years. After refusing him initially, she eventually decided to accept his offer. She later explained her feelings to Rupert in a long, heartfelt letter. There had been so many reasons, she wrote, to refuse, but the main one was that she had 'in no way altered my feeling that my one desire, after losing the person that was all the world to me – is to die and be out of it all. I always feel dead now.'

She would, however, go ahead with the marriage. Helen was, of course, writing to her stepson about the possibility of remarriage, and she would not have wished to hurt his feelings or to shock him. Protesting that she wasn't in love was completely understandable. But there is an undeniable ring of truth in her concluding words, that she was 'now-a-days only swayed by thinking what is really my duty to do – for there is nothing else left'.[265] That she was severely depressed is inarguable, and it opens up the question of whether her workaholic behaviour was a means of dealing with depressive tendencies. Certainly, the loss of her great love, with whom she had shared both a personal and a professional life, had left her at rock bottom. And whether Stanley

Boulter was in love or not, his insistence on her resuming her life with his help provided her with the motivation to move forward.

What were his motives? He may have been in love. He may have been alarmed, as Vice-Chair of the Savoy Hotels group, at the lack of income from the profitable theatre business. These profits had previously poured into the hotel group and, along with public offerings organised by Boulter, financed its expansion. Boulter, a successful barrister, had turned his considerable talents to finance, and, as founder of the Law Debenture Corporation in 1889, specialised in raising and managing large funds. There was considerable overlap and brand extension between the Savoy groups, and the brand ran across the theatre, hotels – with their expensive restaurants – and the serviced flats. Without the redoubtable talents of Gilbert & Sullivan to produce fresh, popular pieces to fly the Savoy flag, much ingenuity was required to revive the franchise and to satisfy the banks and the shareholders. Keeping Helen alive and publicly engaged in the group, and bringing her years of wisdom, contacts and experience to bear in a tricky market situation, was a very smart move.

Whatever the reasons may have been, Helen – with Rupert's blessing and encouragement – decided to take the plunge. There would be no trip to Australia, much to the family's disappointment. John was convinced that Boulter was after Helen's money, but this may be due to an understandable disappointment on his part with regard to inheritance, as he and his brother were still struggling financially. There were frequent battles between the two brothers over who had more of their ailing mother's money.[266]

Helen and Stanley Boulter married very quietly on 25 April 1902, in the church of St Martin-in-the-Fields on Trafalgar Square. Writing to Rupert before the event, Helen admitted that she could not 'pretend' to be happy. Rather, she was 'nervous and anxious & worried'. She was hoping to do what was right – 'it is at least my best chance to live'. But more than anything, she insisted, 'nothing must come between you and me and Lucas – I could not bear that. I still feel that if I could have made sure of having one or both of you regularly with me it would have sufficed', but she felt it 'impossible and unfair to so attempt to tie you'.[267]

She was marrying, yes, but it would not affect her business life. Helen informed her team that she would retain her professional name. This private decision to wed had no connections with business, she told Rupert while she was away in Switzerland with her new husband. 'I want all business letters addressed to me in my business name, as always, and in the office that is my name – just as much as Sir Henry Irving is his name.'[268] She had earned her name and built her reputation the hard way, through years of hard work and total dedication. She understood the value of a brand and the value of a name. Having lived by professional values and the highest standards, she would not relinquish the life that she had made. This was a very powerful decision. Women were assigned the name of their father and, if married, that of their husband. It was highly unusual to retain a surname for professional reasons, and this speaks to one of the main impediments to the promotion of women in the workplace. In the civil service, teaching, and in most large firms employing middle-class women, the marriage bar prevented women from pursuing their careers after they wed. The belief was that a married woman would be supported by her spouse, and should not be 'taking' jobs away from men or from single women.[269]

Instead of an extended trip to Adelaide, there was much to be done. Cables were sent to John (with prepaid replies; Helen was ever mindful of her brother's financial worries) enquiring after her mother's health, but Helen was focused on the work in hand. The Savoy Hotel Group was committed to significant expansion, which took place throughout 1902 and 1903. Running costs were high. Rupert needed Helen's help to face down competition from hotels such as the Carlton and the Cecil – and they were aware of Ritz's plan to open a magnificent new hotel overlooking Green Park. Changes begun by D'Oyly continued, at huge cost: the hotel's entrance was moved from Savoy Hill to Savoy Court, a small cul-de-sac off the Strand. Properties along the river had been expensively acquired. By 1903 buildings were demolished to make room for a splendid new building adjacent to the hotel. The Strand was famously widened by agreement with Westminster City Council. The improvements to what had been an insalubrious area continued. The famed restaurant Simpson's was bought, enlarged and extended. Re-named Simpson's-in-the-Strand by the company, it reopened in 1904.

As part of the expansion plan Rupert wanted to upgrade the hotel beds, and in 1905 commissioned a uniquely high-quality mattress, called the Savoy Bed. It was made specifically for the hotel group by the nearby manufacturing firm of James Edward Ltd. All the mattresses were covered by an attractive ticking pattern that was, memorably, made to Helen's design. This distinctive cover has become the trademark of these world-famous beds. Savoir Beds, as they are now known, lately launched a new bed in 2020, 'The Lenoir', in homage to Helen D'Oyly Carte.

Helen had moved into one of the new flats at Savoy Mansions, where she continued to reside during the working week. It is interesting to note that she is listed as sole resident – Helen D'Oyly Carte – in the flat in 1906–08.[270] Luxuriously appointed with rich brocade and modern fittings, these apartments were designed for comfortable and easy living. There was a magnificent entrance and foyer, and the individual apartments were beautifully appointed. Meals could be ordered from the kitchens, and the services of a manicurist, hairdresser and even a chiropodist were available on tap.[271] Rupert, aged 27, now stepped up to become chairman of the hotel group in 1903. Working closely with Helen, he ran the three London hotels which now included The Berkeley since 1900, the famous Simpson's restaurant and the Grand Hotel in Rome. There were also new family responsibilities for Helen: weekends, when there was time, were spent at beautiful Garston Park, the Boulter home in Godstone, Surrey. Stanley had a lively and affectionate family – with seven children by his first wife – and they welcomed Helen with warmth. There was no more talk of a visit to Australia. When her mother died on 6 July 1902, John's wife Alice, who was with her, told him that his mother 'called the nurse Helen all through the night'.[272]

Within days of Ellen's death, the two brothers were in dispute over the inheritance. Helen had of course asked to be removed from the will, and thus there were two beneficiaries. John suspected Alf of cheating him, and immediately sought legal advice, despite the expense. His diary entries over the next few weeks reveal the degree of mistrust and financial anxieties between the brothers. John was also frustrated at Helen's non-appearance, and blamed it on Stanley

Boulter. Helen wrote to John that she had been 'just about to start for Australia when the telegram of dear mother's death arrived'.[273]

With his mother's legacy, John decided to take a voyage, long dreamed of, to the Argentine, spending a month or so there followed by 12 days in England. He and Alice took second-class passages around the world, departing from Adelaide on 12 December. After an adventurous and exciting trip, they arrived in London on 9 March 1903. Helen had organised a hotel room for them at the Howard Hotel, which was located between the Strand and the Thames Embankment. This hotel was not in the luxury class of the Savoy, but it was solid, comfortable and its 189 rooms were much sought-after by travellers, including many prosperous Americans. John disliked it, finding it the kind of hotel 'where you cannot open a door for yourself, on account of the number of waiters and flunkeys'. He didn't like to change it, though, until they returned from the Continent. They had decided to extend their tour and would return to London.

Helen saw much of them and entertained them at the Savoy. There was little warmth, however, between her brother and her new husband. John commented acidly that they had seen Mr Boulter 'twice by chance' in a rail carriage as Helen and her spouse were on their way to the country. According to his account, Helen had blocked the window so that all they managed to do was to shake hands, but Boulter 'evidently had no desire to know us as we never heard a word from him. He looks a big broad-faced man and straight enough but Helen says he is consumptive.'[274] There was no visit to Godstone. On their return from a trip to the Continent, John and Alice booked into a 'cheaper hotel in the Bloomsbury district', before travelling up to Edinburgh and Wigtown. In his home town, John and his wife were warmly received as guests of his relatives John and Sally Black. They stayed at the former family home, in the old bank – 'bedrooms unchanged'.[275] Yet John did not complain of Helen in his diaries. On the contrary, he recognised her usual kindness and consideration for others. One evening during their visit she had had to cancel an evening with them; an old employee from the Savoy had been taken ill, and Helen had 'rushed off to get a doctor and nurse for her'. The following day, she had 'carried us away to dinner at the Savoy Hotel'.[276]

Chapter XIX

A Low Ebb – and Courage

1904–06

T HE OLD SAVOY COMPANY was disbanded after a new Hood and
German opera, *A Princess of Kensington*, closed in May 1903.
It was a desolate time for the Savoyards. Greet's contract came to
an end and the theatre was closed for internal works, to reopen in
February the following year. On 27 August 1903, the Savoy Theatre
and Operas Limited company applied in court to have its capital
value reduced from £75,000 to £41,250. This was because it was
believed within the company that the value assigned to its assets in
1897 had reduced considerably. This would cause additional chagrin
to Gilbert, who believed that Stanley Boulter was not to be trusted.
Meanwhile, he remained in touch with Helen over business matters.
He remained very touchy about unauthorised ad-libbing – known as
'gags' in performances by the touring company. He was, furthermore,
disappointed at the pieces being played at the theatre, produced by
Edward Laurillard, and wrote in January 1904 to Helen complaining
of 'the old show being handed over to the Philistines'.[277] Weeks later,
while the *Love Birds* musical was on, he was 'deeply sorry for the fate
that has overtaken the Savoy'.[278] Still, Helen considered the possibility
of taking on the theatre lease, with the idea of putting on some
revivals. This was in spite of her frequent illnesses: she contracted a
pulmonary infection late in 1904 which laid her up for close to a year.

As it had plagued D'Oyly's heart and lungs, the terrible smog of
London did nothing for Helen's health. She frequently suffered from
poor lung conditions, exacerbated by long hours and breathing the
poisonous fumes of the coal-fired metropolis. Lucas Carte, as we

have seen, was diagnosed with tuberculosis in 1903 and had moved to a sanatorium in Norfolk. Rupert kept the family home on Eyot Island, where he could regularly escape the foul air. When they could do so, Londoners moved into the suburbs or took country homes to find respite from the noise, dirt, overt poverty – nearly one in three Londoners lived in squalor – and terrible air of the city. The yellow fogs – pea-soupers – were common, and left a coating of grime and oily soot over buildings and streets. It was extremely unhealthy, and Helen's determination to continue working meant that she had to spend time in the insalubrious surroundings.

'I am anxious to hear how you are progressing,' wrote Gilbert in February 1905.[279] He then recommended a 'Swedish system of manipulation' that had 'worked wonders with ourselves & a dozen of our friends'.[280] John shared a letter from Helen in March stating that she was still in bed at the Savoy Hotel.[281] She had written again the following month to report that she was 'still ill in the Savoy Hotel with "pulmonary arthritis"'. This was a congestion of the lungs which she attributed to the rheumatism she had been suffering.[282] It was the same ailment that had sent her mother Ellen to the warmer, drier climes of Adelaide, and Helen was living in the worst possible environment to remain healthy. Still, she pushed ahead. When Gilbert approached her to ask about purchasing back the London rights for the operas, Helen refused for business reasons. Because she was still running a touring company, she could not see her way to separating out the touring from a London company – 'you may recollect I explained this to you when we were negotiating about two years ago'.

With no new pieces to offer audiences, she went on, the operas could only be run a week or so every two years in the large provincial cities. The towns near London were, therefore, an important additional market, which would be impossible to separate out from a London management presenting the same revivals. Indeed, she wrote, if she chose to revive the operas in London, she would abandon the touring and use the existing company and costumes. 'In that way,' she explained, 'the very large preliminary expenses would be reduced and each of the 8 operas I am at present playing could be given, say,

for 2 weeks first and then the whole of them played together as a Repertoire for as long as they seem likely to draw.' Helen reminded Gilbert that she had wished to do this 'some little while ago', but 'at your expressed desire I abandoned the idea at the time'.[283]

The playwright assured her that he had 'no recollection of having suggested any difficulties in the way of your establishing a London repertoire co. formed out of your country companies', and, furthermore, that he 'had no right to do so'.[284] He agreed to Helen's request to supervise the rehearsals for a fee, and, despite her ongoing health issues, Helen purchased a contract from him and Sullivan's heir (his nephew) for the rights, for another five years, for £5,000. Her professional determination was all the more remarkable given the letter she penned to John; he recorded that she had told him that she was 'suffering very much from arthritis and thinks it will be about a year before she can shake it off'. Trips to Brighton and Bath had not helped, and she had 'to go to bed at 6 p.m. and her muscles are very weak'. Illness dimmed neither her business mind nor her kindness and solicitude for her family. Although they had not spent all that much time together, she remained engaged with her Australian family, and generous. She was interested in what John had told her about his son George's business plans, and even offered to advance him £1,000 out of what she planned to leave him.[285] She continued to send her brothers £50 every year (over £6,000 apiece in today's money).

In December 1906, Helen firmly grasped the nettle and launched a series of Gilbert & Sullivan revivals. It was her firm desire to leave behind a theatre company and a hotel group that was a fitting legacy of D'Oyly. Lucas continued to decline and very sadly died in January 1907. Her own failing health meant that Rupert would be left on his own, and she was determined to build a strong firm for him to run. Stanley Boulter remained intricately involved in the hotel company, as Vice-Chair of the Board. His determination to satisfy the shareholders dominated his thinking about the business, which annoyed Gilbert intensely.

One tactical advantage of launching the revivals was to expand and reinforce the Savoy offer. The hotel and restaurant had now

fully recovered after the Ritz débâcle, and one business fed into the
other. Theatre-goers could dine after performances, and hotel guests
could attend a great West End show literally on their doorstep. The
hotel was especially attractive to Americans – in 1902, on the eve of
King Edward's coronation, the prestigious Pilgrims' Society of Great
Britain, made up of Americans who had made 'the pilgrimage' to
Britain, and Britons who had made their own appreciative way to
America, held their famous banquet. Headquartered at the Savoy, these
banquets took place once or twice a year, and featured speakers such as
Sir Winston Churchill. In 1907, the Pilgrims welcomed Commander
Peary in honour of his expedition to the North Pole; guests included
Captain Scott and J. Pierpont Morgan. A representation of the Polar
seas, complete with lifelike penguins and polar bears, featured a
model of Peary's ship, *Roosevelt*, hemmed in by icebergs. Nothing
was too much trouble for the fabled Savoy: the waiters were kitted
out in white furs and parkas.

The party to end all parties was probably that hosted by the
American millionaire George A. Kessler in July 1905. For his birthday,
a dinner party for 24 guests was held in the old Savoy courtyard,
which was flooded to create a Venetian canal, deep enough to
allow a huge gondola to be paddled across. This 'Gondola Dinner'
featured a stunning decor made of expertly painted reproductions
of St Mark's, the Doge's Palazzo, and other famous landmarks. The
water glinted by the light of 400 Venetian lamps, and the centrepiece
was made up of the gondola, decorated with over 12,000 roses and
12,000 carnations. The repast was served up by waiters dressed as
gondoliers. But the most extraordinary moment was created when
a baby elephant from the Italian Circus padded over a gangplank on
to the gondola, carrying on its back a huge candle-lit birthday cake.
A bevy of Gaiety Girls appeared, followed by a performance of arias
sung by the famous Italian operatic tenor Enrico Caruso.[286]

The hotel received enormous amounts of publicity from such
magnificent dinners and parties. Its renovations were very favourably
received: a new foyer led to the enlarged restaurant and it was,
famously, covered by a carpet woven in Austria because no English
loom was large enough to weave it in one piece. The old Savoy

Grill, originally a supper room for artists performing at the Savoy Theatre, was renamed Café Parisien and was less formal than the main restaurant. Evening dress was not required, and glitterati from the literary, theatrical and business worlds flocked to its jolly yet elegant atmosphere. There was, amid this success, a continuing clamour from the loyal Savoyards for more revivals. Helen thought carefully about staging these based on a genuine desire to provide for these enthusiastic audiences, and to provide employment for her company members and remaining staff. The problems of renting out the theatre were manifest, as no one had found the right formula to entice punters, despite the overall theatre boom. Having Gilbert supervise and rehearse the revivals was a masterstroke, and the author was always delighted with extra income to fund his lavish lifestyle.

It was decided that a whole season of revivals would take place, using existing repertory cast where possible, as well as costumes and props. Helen was unsure of potential audience figures, preferring to make conservative estimates and to keep upfront production costs low. Unfortunately for the meticulous and irascible Gilbert, he was given no say over the casting. Helen had learned from prior experience that allowing him control over casting led to arguments and that Gilbert should never be in a position to block her decisions. She understood far better than he the financial difference between performances of original material and those of revivals. In order to be profitable, the revivals could not afford to earn out the exorbitant production costs of yore, nor the very high salaries given to star players. The plan was thus to use the cast that had been touring, along with some additions. The first production, *The Yeomen of the Guard*, started off on a negative note. Gilbert had asked Helen to cast his protégée, Nancy McIntosh, claiming that her previous poor performances at the Savoy were due to ill health. He also wanted experienced players, including as 'many old Savoyards as possible'.[287]

Helen tried to be reasonable and tactful. She entirely agreed with him that 'a good cast is essential to the success of any production new or old'. The idea of casting older Savoyards was, however, impossible and the only two who might play their old parts, Mr Denny and Mr Temple, were not available. There was 'no financial inducement to

play revivals', she explained, 'if at best one cannot anticipate more than 3 months run to fair houses and as you know it takes 3 months of big business to recoup "preliminaries"'. In fact, the only reasons she was undertaking 'the heavy work of a revival' were because of his 'expressed desire' and the 'desire intimated by some of the public and press and the fact that the Savoy Theatre showed to be open for a while'.[288]

Gilbert was not in the best of health, nor, clearly, in the best of spirits. He was livid at Helen's letter, firing back that he 'must disabuse your mind of the idea that in putting the piece on the Savoy stage, with what I understand is your country company, you are fulfilling any expressed desire of mine'. He had certainly 'never contemplated a revival in which the parts are to be played by actors utterly unknown to London & to me'. Massively irked by not having 'the smallest voice in the casting of a London production of my own libretto', he concluded that he would 'attend rehearsals & if I find the people practicable I will carry them through to the best of my ability'.[289]

The problem was that the two old partners of the successful heyday of the Gilbert & Sullivan franchise had entirely different expectations of the revivals. For Helen, they were to be a recreation of some of the happy and profitable days of the Savoy, bringing joy to many and pounds to the coffers. For Gilbert, the revivals were to be exquisite and faithful recreations of the pieces, cast with the finest players, with the finest production values – which, rehearsed to the highest standards by him, would be a credit to him personally and to the brand. It was a profound shock to discover that his views were not to be considered on the critical matter of casting, and there ensued some of the saddest and most bitter correspondence from him to Helen.

'I must say,' he declared, that she had placed upon him 'the deepest – & I may say only – indignity every offered to me during my 40 years' connection with the stage.' It was all the more hurtful, he went on, that 'this indignity should have been inflicted upon me by a lady whom, for more than a quarter of a century, I have always held in the profoundest esteem – a lady with whom, during that long period, I have never had a word of difference'. This was something of an exaggeration. Although he had not attacked Helen personally,

his disputes with Sullivan and D'Oyly were, as we have seen, legion. However, now his attacks were directed at her, and they became personal and vindictive. He was, he acknowledged, hurt by her lack of confidence, and this hurt led him to some very nasty accusations. Gilbert refused to see an artist she had selected for the production, and wrote angrily that she would never have cast the pieces by herself had Sullivan been alive. 'It is a matter of no moment to you,' he wrote, 'but the discovery of the indifference and contempt in which you hold my opinion … has struck a blow at our lengthy association from which it can never recover.' [290]

Helen reminded him that since 1895:

> it was made clear between us at that time, if you gave Mr Carte an assignment of the old operas for a fixed payment or payments, it was impossible to attach to it any stipulations as to your approving the cast, or having a veto on it, as such lack of approval, or veto, might cause a deadlock and render the assignment valueless.[291]

His only stipulation, she continued in a lengthy letter, was that he should be asked to stage-manage any revival, with the right to refuse. This was the basis on which she had operated, Helen reminded him, for over ten years. Explaining how she could not afford to jeopardise an already risky operation by awaiting his approval of a cast, she ended her very reasonable letter by telling him that it had been 'very painful' to her that he had taken this line. 'I do not feel I deserved it,' she concluded. She would not be 'much longer in business' and 'would have preferred to end my career retaining your friendship and goodwill'.[292]

Despite this conciliatory tone, Gilbert was unappeased. He was still annoyed that Nancy McIntosh hadn't been cast (this despite the fact that he knew of her failure as an actress). He wrote that his rank in the Savoy Theatre 'appears to be somewhat between the prompter and the call-boy'. In short, he had nothing good to say, and added many further complaints.[293] The tit-for-tat correspondence continued, with Helen calmly reconstructing the decision process, and the playwright

reacting with anger and animosity. His tone became increasingly insulting. The more she refused to rise to the bait, the more abusive Gilbert became. He accused Helen of being under the influence of Stanley Boulter, whereupon she reacted strongly, declaring: 'I act in my business entirely on my own responsibility.'[294] This was Gilbert at his worst, and he was never of an easy temperament. The scene-painter and decorator Joseph Harker – a West End veteran – recalled that 'Gilbert's disposition was the least likeable that I have known among managers and producers, and this, I am afraid, is saying a great deal'.[295] After Gilbert had shouted 'violent abuse' at him about some scenery he didn't like, Harker had his 'little say, reminding him as calmly as I could in the circumstances that behaviour of that sort was old-fashioned, and that it was no longer tolerated'.[296]

Helen had tried to be as diplomatic as possible, but the vexed question of the revivals continued to put intense pressure on their relationship. Gilbert was increasingly unhappy as rehearsals for *Yeomen* progressed. He was suffering from arthritis in his leg, which did nothing to improve his temper. He felt fully justified in his annoyance – and, given that he would certainly be associated with the pieces, this was fully understandable. It is hard to fathom why Helen refused to make any compromises on the casting. On the first night, however, it became clear that she had been justified in sticking to her guns. Despite one unpleasant letter after another from the playwright, she had kept her nerve, and the reviews were very positive. Gilbert leapt on one review in *The Times* which suggested that it would have been 'obviously desirable' to have obtained 'the services of as many as possible of the old "Savoyards"'.[297] He ignored, however, the many positive comments in the same review, as well as the many other overwhelmingly favourable reviews.

Chapter XX

Triumph
1906–08

THE SUCCESS OF THE FIRST REVIVAL was undeniable. The seats were sold out, and eager theatre-goers began queueing for the gallery and the pit places many hours before the performance was due to begin. In a gesture which many in the theatre world associated with her typical kindness, Helen had refreshments provided, and then opened the doors early. As recorded by the *Daily Express*, members of the audience who entered early passed the time 'by singing familiar airs from the Savoy operas'. The spectacle was met by enormous, unbridled joy. 'They encored and re-encored, and cheered and cheered again,' continued the report, and 'when the players had all been called and wildly applauded' they called for Mr Gilbert, followed by the 'veteran conductor' Mr Cellier, and they finally enticed Helen Carte to take a bow. The audience 'shouted and bravoed and called for speeches, and the applause continued for many minutes after the safety curtain had fallen and the occupants of the stalls and dress circle had gone home'.[298] It was a triumph, with *The Era* concurring that the audience had cheered 'until absolute physical exhaustion put an end to their demonstrations'.[299]

Not so for Gilbert. It was as if his name had been trodden through the mud, to go by his continued brutal correspondence. As in the past, he had become obsessed with a putative enemy – and this time the unfortunate recipient was his old business partner, standing alone at the head of the Savoy Theatre management. Firing off these missiles and nursing his grudge seemed to cause the writer little distress. At the same time as he sent off one missive after another, leading to

tremendous hurt, Gilbert was leading a very pleasant existence at Grim's Dyke – dredging the lake, tending to his growing family of lemurs, and enjoying croquet with friends as well as spins in one of his beloved automobiles. Helen tried to remain above the fray, writing that while she had 'replied with unfailing courtesy' to his letters, this only resulted 'in their assuming a more and more discourteous – I might say abusive – tone'. She had no desire to 'say anything either unkind or discourteous in reply', and chose not to comment on them, except to point out 'that the public do not seem to agree with your estimate of the production I have made'.[300]

Gilbert seemed to positively relish reliving his days as a barrister, crafting long detailed arguments in return. He demanded that Helen specify which of his letters had been abusive, and raked over the whole painful sequence of the casting process again in minute detail. She tried, unsuccessfully, to reason with him – as she had in the past – reminding him of the legalities of the situation, and of the fact that he had had the choice of distancing himself from the revival for a payment of £1,000. He had chosen to be involved with the production, she reminded him, and to supervise rehearsals. These communications did nothing to soothe the writer's ire, and he returned with more animosity and accusations. At the same time, he was happy to begin rehearsals for *The Gondoliers* on 7 January.[301] This was typical of Gilbert: he was perfectly capable of inhabiting two entirely different personae seemingly simultaneously. Correspondence to Helen peppered with personal criticisms and claims that D'Oyly Carte would never have treated him thus (clearly a fiction) flowed as easily from his pen as did mundane, civil letters about rehearsal arrangements.

Helen, still struggling with impaired health, rose above the animosity, until Gilbert threatened to write to the theatre critics of the principal papers to dissociate himself from the casting of the revival of *The Gondoliers*. While this statement would be 'no more than the precise truth', he would 'leave the press at liberty to form an independent opinion as to whether your selection is judicious or otherwise'.[302] This had the desired effect of provoking Helen to action, and she wrote back immediately, pointing out that if the press

were to be independent, there would be no reason to write to them beforehand, and that she could only conclude that his letter would be designed to inform her that he wished 'to prejudice the minds of the critics beforehand, to the damage of my artists and possibly my business'. Should he choose to do this, she would be grateful to receive a copy of the said letter and 'the names of the critics to whom he proposed to send it'.[303] To add to Helen's turmoil, she still mourned the loss of Lucas, whose death at 34 had been a sad end to a man of great promise.

More happily, Rupert had become engaged at the end of 1906 to a beautiful young socialite, Lady Dorothy Gathorne-Hardy, youngest daughter of the Earl and Countess of Cranbrook. Just 18 years of age, Dorothy was a very attractive and well-connected young woman. As one paper wryly commented in describing the suitability of the match, Dorothy was pretty and aristocratic, and Rupert was 'a very rich man, with big interests in three of the great London hotels, and in the Savoy theatre'.[304] The wedding in the fashionable St George's Church in Hanover Square made a big social splash, and was attended by an overflowing congregation. The bride, in diamonds and pearls, was attended by eight bridesmaids and six pageboys, all beautifully dressed. After the full choral service, a reception was held at the home of Sir Reginald and Lady Hardy in Grosvenor Square. Although the match did not prove to be a happy one, it was certainly a social triumph for the Carte family.

From December 1906 to late August 1907, the Savoy Theatre Company staged four very successful revivals, concluding with a celebratory season, with accolades and full houses. So positive was the overall feedback and profitability that the season was prolonged. Despite his continuing criticisms and unpleasant accusations, Gilbert signed up for a second season, and six plays were produced between late April 1908 and the end of March 1909. Although he addressed his correspondence to Helen, Gilbert's anger was directed at the powers behind the Savoy brand, from whom he clearly felt distant and unappreciated. He had never enjoyed the warm friendly relationship with D'Oyly's sons that Sullivan had had, and Rupert was now at the helm of the hotel and restaurant group. Stanley Boulter was to his

mind associated with a new regime at the Savoy that laid too much emphasis on profitability. Now that Gilbert had no part in the profit-share, he was unconcerned with production costs and had little liking for the expanding Savoy empire. 'I must really ask you to withdraw, at once, my portrait from the advertisement of the Savoy Hotel in the evening papers,' he fumed. To further emphasise his point, he added that there was 'absolutely nothing in the business relations that have existed between us that justifies you in using my portrait in connection with the advertisement of an Eating house'.[305]

Much more happily for Helen, the public response, as well as that of the critics, remained overwhelmingly positive. The performances were highly profitable, and the new lease of life pumped welcome publicity and business into the hotels and restaurants as well. The revivals venture was seen as a personal triumph for Helen, with one paper declaring that the renewal of the franchise reminded the public of the significant role of 'Mrs D'Oyly Carte', who had 'had much to do with the unique success' of the Savoy enterprise. Indeed, 'It may be expected as well as hoped that her rare ability as a woman of business and of fine artistic instinct will secure newly marked appreciation in the welcome accorded to her present venture.'[306] An article in the *Sporting Times* sang the praises of the Scotswoman, who 'had an extraordinary appetite for work, and a gift for diplomacy'. Indeed, after 'a hard day's work at the office she would still be ready at midnight "for the sharpest consideration of a business proposal or the terms of a contract"'.[307]

In 1907, the theatre was banned from staging *The Mikado*, much to Helen's deep chagrin. After spending two hours in the Lord Chamberlain's office, arguing against the decision, she was crushed by the continued refusal. Preparation was already well under way, and it remained one of, if not the most popular of, the operas. But there was concern at possibly offending Japan after the renewal of the Anglo-Japanese alliance in 1905. Gilbert's libretti had often used foreign locales such as Japan or Italy as a means to partially disguise the gentle teasing of very British institutions, such as the judiciary or the army. Helen was upset that the piece could be in any way interpreted as being critical of Japan, but Gilbert, although personally

disappointed, was unsympathetic, replying to the news in his newly adopted aggressive persona. 'I can only say,' he wrote, 'that if the Mikado was to be produced with the same ignorant ineptitude that has characterised the other productions at the Savoy, I am heartily glad that its performance has been prohibited.'[308] The following day he acknowledged receipt of £200 from Mrs Carte for rehearsals of the new production of *Patience*.[309]

At the end of December 1908, Gilbert was writing in the friendliest manner to Helen, hoping that she was 'much better'. The 'mild weather' would help, he believed, and he sent her 'every good wish for a most Happy New Year'. And to do justice to the playwright, he brought exceptional dedication and focus to the rehearsals, doing his best – as he had promised – to work with casts not of his choosing. The works were of a high standard, and the public were agog to see which opera would next be staged. Disappointed by the Lord Chamberlain's decision, and left without a piece to prepare, Helen decided – in a brilliant public relations masterstroke – to invite the public to choose which revival opera to perform. She offered that the practicable options were: *Pinafore*, *Pirates of Penzance*, *Iolanthe* and *Princess Ida* – and announced that she would 'be glad to receive postcards from members of the public giving the name of the opera preferred'.[310]

This invitation was received with enormous enthusiasm, and close to 2,000 postcards were sent in, some of them in rhyme. *Iolanthe* was declared the winner and after this fourth opera was given, the players went on tour. For the last night, on 24 August 1907, Helen brought in another innovation by staging an evening that included more than one opera. A marathon performance which began at 4pm featured excerpts from all the four operas shown in the revival season and, with one interval of 70 minutes, the audience returned for a further musical feast of acts, including a scene from the now permitted *Mikado*.

Helen had thanked the public – and the critics – via a letter published in *The Era*. In it, she fully acknowledged the difficulty of bringing in a revival which must inevitably be compared – usually unfavourably – with the original. For this reason, she had hesitated, knowing that 'no matter how good the representation given by my Company, they

would have to stand the steady fire of [such] criticism'. She was glad to have gone ahead, however, for she had seen that her artists had 'worked their way by their merits on to the hearts and affections of thousands of the London public, to whom the performances have unmistakably given the greatest pleasure'.[311] This letter gives us a perfect example of how Helen always strove to be led by facts. She had staged the operas, putting in her best efforts, and had hoped that they would be enjoyed. The fact that the public had come in droves and made the productions such an overwhelming success was all the vindication she needed, to know that it had been a good decision.

One of the very welcome outcomes of this revival season was the honour given to William Gilbert. In what many fans considered a belated move, and decades after his partner had been so honoured, Gilbert was at last rewarded for his massive contribution to the cultural life and enjoyment of the nation by being nominated for a knighthood. He was knighted by Edward VII at Buckingham Palace on 15 July 1907 and afterwards, mystifyingly (given his views), had a celebratory lunch at the Savoy Grill. Hundreds of friends and supporters telegraphed and wrote with their congratulations. Helen was among the first and was courteously thanked by the dramatist.

What Helen had understood so well was that, in order to be profitable, the pieces staged had to have long runs. As D'Oyly's experience at the Opera House had so painfully demonstrated, the premium audiences willing to pay high prices for classic opera were too scarce to guarantee profitability. The broad appeal to the prosperous middle classes is what made the Gilbert & Sullivan franchise so successful and profitable. Both the burgeoning middle class and the less well-off revelled in the performances, which were, to add to the spectacle, adorned by the glamorous upper crust in evening dress, decking the boxes and stalls. Helen was fully conscious of these social tiers and appreciated the differing needs and characteristics. When there was a movement to abolish the queueing system for the pit places, to be replaced by bookable seats, she resisted on the basis that this was not what these audience members wanted. In the hundreds of letters that she had received over the years, she told an interviewer, there had never been any suggestion from the 'pittites' for such a change – and

they were very knowledgeable about what they wanted from the Savoy. Furthermore, 'You may also take it from me that we value the support of our pit patrons to such an extent that we should very carefully consider any suggestion from them, and endeavour to meet their wishes if it were possible.'[312]

She had endeavoured to set the record straight with Gilbert as they worked on the second revival season. In a letter about whether or not he should be paid a second fee for rehearsing the same cast in a repeat revival, Helen replied to two of his specific accusations. 'There was no question of economy in the casts in my last season,' she wrote. In fact, 'weekly salaries of my principals at that time came to a larger sum than they do at present'. In reply to his assertion that she could not possibly make any assumptions about the profitability of a second revival as she had no experience of this, she pointed out that she had indeed had one second revival – *Iolanthe* – and several in past years, 'so that I could form a fairly accurate estimate of probable result'. Helen provided specific figures for average receipts per performance, and informed him that expenses of the theatre at the present time were about £1,000 per week without fees or advance production costs, 'so that you will see it is difficult to make revivals pay'.[313] When Helen confronted him with facts, Gilbert usually found something else to be cross about.

In frustration, he frequently repeated his assertion that she was not a 'free agent'. No matter how often she denied this, and explained how much trouble she had taken to ensure a high-quality revival series to please the many fans, Gilbert repeated his belief that she on her own 'would never have treated me with the gross insolence & black ingratitude which have characterised the Savoy methods during the past 2 ½ years'. The casts were 'deplorable', 'cheap and incompetent people', 'blatant ignorance accompanied by contemptible economy' – these were but some of the terms flung about on 2 February 1909. He was convinced that Stanley Boulter was to blame.[314] However, quite extraordinarily, just five days after this letter was written, Gilbert wrote a 'secret' letter to Helen, suggesting that she produce his new libretto, the music being provided by Edward German. Blithely batting away his vitriol of the past two years, he wished 'to express my

assurance that nothing connected with those difficulties has occurred to affect my regard & respect for you personally, both in your public & private capacities'.[315]

Unsurprisingly, Helen graciously declined the offer, explaining that 'the many anxieties and responsibilities of London management' were more than her 'health and strength' would allow.[316] It was a vindication and an acknowledgement, however, of her outstanding management skills, and Gilbert knew it. Despite his myriad complaints, she had produced a winning series of revivals which, in the words of one journalist commenting on the revival of *Yeomen*, was 'not the mere revival of a play, but the re-establishment of a national institution'.[317]

Chapter XXI

The Show Must Go On
1910

IN 1910, AS THE FIVE-YEAR CONTRACT with Gilbert and Bertie Sullivan came up, Helen purchased the rights herself, and continued with the country touring. The unpleasant correspondence with Gilbert ceased; he had found other targets for his ire, and was involved in at least one lawsuit and irascible interchanges with friends and anyone who delivered a perceived slight in person or on paper. More happily, he was very busy with his work as a magistrate, with regular jolly suppers at his clubs and of course entertaining guests at Grim's Dyke, which now featured a gazelle in its menagerie.

He remained an avid swimmer, plunging into his lake most days. On 29 May 1911, he invited two young women to join him for a swim. One of them, 16-year-old Ruby Preece,[318] cried out to her teacher Isabel Emery that she was drowning. Gilbert, now a fit 74-year-old, immediately dived in and tried to save her. He died instantly of a heart attack when they both went under. Ruby was able to make her way to the bank and summoned the gardener. With the help of manservants, they set out in the rowing-boat and dragged the body ashore. The circumstances of Gilbert's death caused a sensation. Many accounts were inaccurate, claiming that there were children involved, that there were women involved, that he had drowned. In fact, the coroner's report made the facts clear. The water had been very cold, and had caused the syncope. In the words of the coroner, 'Sir William died in endeavouring to save a young lady in distress. It was a very honourable end to a great and distinguished career.'[319]

The great librettist was cremated and laid to rest at Stanmore

Cemetery. The floral tributes were many and glorious. Helen, who was unable to attend because of illness, sent a magnificent floral harp of orchids and lilies with one broken string. She wrote with heartfelt sympathy to Lucy, who responded with a warm letter, sending her love and gratitude. Helen replied, thanking her for her kindness. 'Even though I had seen little of him for so long,' she wrote, 'I always felt he was there & the blank is very great.' She took comfort in receiving, just a month or two ago, 'a very nice letter suggesting my doing some of the operas this Coronation season at the Savoy'. Although her health made this an impossibility, as she had explained to him, she liked 'to think he wished it'.[320]

Of the original quartet, Helen now stood alone. Neither Lucy Gilbert nor Bertie Sullivan had any interest in becoming involved in the business, and Helen continued to manage the repertory troupe, and to work hard alongside Rupert for the hotel group. She had fully taken her place among the theatre-managing greats. When a group of London theatre managers decided to break away from the Theatrical Managers' Association (TMA) in 1908, Helen was a founding member. She was also the only woman. These associations were a critical element in the professionalisation of the theatre world, something to which Helen had made a huge contribution. As ever, the importance of efficiency was paramount. When the TMA, which held its first meeting in 1894, became bogged down in arguments between provincial, suburban and London members, it was a logical decision to form what *The Referee* dubbed 'A Powerful New Organisation' for London specifically.[321] Concerns needed to be addressed by London-based establishments, such as the attribution of water rates, which members felt was unfair to them.

Throughout Britain, bringing the profession into a better-controlled and more regulated arena was being promoted to protect the rights of individuals working in the industry, and the management of theatres. Lobbying the London County Council, or the government, became an important activity – there was particular concern about legislation of unlicensed clubs, which undercut the theatres and proved a public safety risk. National efforts were made to create a standard contract, thus protecting actors, managers and other employees in the industry.

The Savoy company had always had, from its inception, a reputation for professional standards and a high standard of behaviour. This was especially important to ensure that women in the cast and working for the firm felt safe and secure. The poor associations of the acting world had tainted the reputations of working actresses, who still fought off assumptions that they were of the demi-monde of prostitutes, and there remained in Helen's era a slight whiff of disrepute in the profession. Her ability, her full command of her company staff and her willingness to take a public stance in the press and in professional organisations were powerful examples to other women of what was possible. The respect paid to her by her contemporaries and colleagues was legendary, and enhanced the prospects of women taking to the stage. There was, after all, always the image of the music hall and its attendant vicarious sexual pleasures provided by the scanty costumes and high kicks.[322] The insistence by the Savoy management on fully clothed actors and actresses was a deliberate policy. The presence of the competent, compassionate Helen was a further reassurance of the vice-free environment provided by the Savoy.

She fought very hard – as had D'Oyly – to provide a safe and secure working experience for the whole company. In the theatrical world, the company of cast, crew, musicians and managers were family. For those not so fortunate as to obtain a secure contract with the Savoy or another reputable theatre, life was even more precarious than that of short runs and occasional half-wages. Alma Ellerslie, whose acting had attracted a number of very positive reviews, revealed in her diary increasingly desperate tales. 'I have been to the agents this morning,' she wrote in May 1895. 'Everywhere the same, "nothing doing". No tours, or anything likely till the winter begins.'[323] And even when she had a job, the struggle continued. In September, she recorded how exhausted she was: 'Tired out after third-class journeys, weary with hunting about for lodgings, unpacking, dressing in some wretched corner, and all the miseries attendant on second-rate management.'

There was the perpetual problem of unscrupulous agents and managers, who promised much and delivered nothing. 'As a sort of forlorn hope I have even answered those absurd advertisements offering salaried engagements to novices,' lamented Ellerslie. 'It is always the

same sort of seedy looking actor, who evidently finds it impossible to get any engagement for himself. And the West End managers who offer those lucrative engagements ... always seem to be under a cloud in dingy lodgings, in the neighbourhood of Bedford Square.'[324]

More worrying still was the frequent sexual abuse and outright fraud that she, and others like her, faced. Throughout the 1880s and 1890s, with the perceived threat of 'White Slavery' (the systematic kidnapping of women and forcing them into prostitution), the theatre professionals initiated a drive to root out and expose the corrupt practices of tutors, agents and so-called managers who took advantage of young women hoping to improve their skills and obtain parts in the theatre. A number of successful prosecutions took place, resulting in prison sentences.[325]

Helen was deeply committed to helping to keep members of the company employed. Revivals had helped to fill the coffers somewhat, but she was unable to stave off economic anxieties that threatened the business after the revivals. The Liberal reforms, championed by Prime Minister Lloyd George, were designed to improve living and working conditions for the least well-off in society. To pay for this, taxes would increase for the better-off, and many business owners were alarmed at the foreseeable financial consequences. In addition, more specifically, in 1906 one of the main promises of the Liberal Party was to tackle the problem of drunkenness and public disorder by abolishing one third of the liquor licences in Britain. Furthermore, the taxation revenue lost would be recovered by imposing a compensation levy on the remaining two thirds. This measure caused enormous consternation in the hotel industry, and various lobbying efforts achieved minimal results.

In July 1910, Helen wrote to John that hotel shares 'have gone from bad to worse on the Government threats'. The company's 7%, £10 preference shares which had been valued at '£14 each for Estate Duty when I distributed the estate in 1901 are quoted at £6.3/4: ordinary £10 shares are below £5 and so on'. The theatre was 'still unlet' which was worrying as since the death of the King on 6 May 1910 there 'is quite a slump in theatres'. She and Rupert had to meet the outgoings in order to stave off 'the buccaneer shareholders' who

would foreclose if they could, Helen explained, 'so the outlook is not very cheerful'.[326] Thus despite her omnipresent health worries, Helen continued working long hours for the business.

Indeed, charity, benevolence and thoughtfulness for others were dominant values of Helen's life. Money earned was to be used for best purposes, to be enabling and life-enhancing. Self-improvement led in her case to a strong desire to improve lives for others, and especially those who came within her range of influence. Just as her financial prowess had given her opportunities to excel in business, her studies in philosophy were applied to her management and lifestyle practices. Both she and D'Oyly subscribed throughout their lives to charities established to help out-of-work and retired actors and company members. All it took was one accident, or incidence of illness, for a player, singer or worker to be left destitute and unable to provide for their families. As the English actress Violet Vanbrugh – whose successful 50-year career began in 1886 – advised:

It is a good rule in the theatre not to confess to feeling ill, to leave ailments outside the stage-door; for it is a fact, and one to bear in mind, that you are paid for your best services, and if you are ill and not giving your best, you are not of much use to the management.[327]

Without a national safety net, workers who became ill would have been lost without regular subsidies that the Cartes as well as Gilbert and Sullivan contributed to whenever approached. In this, they were very much aligned with the values espoused by the royal family and the ruling elite. The Cartes also provided funds for exhibitions and scholarships to institutions such as the Guildhall School of Music, to encourage operatic and dramatic students.

Helen was honoured by George V in 1912 with the Order of Mercy for work she had done to support him when he was Prince of Wales. The League of Mercy was the fundraising branch of the organisation by which the Prince of Wales could raise a capital fund of £2,000,000, instead of replying piecemeal to applications for help. Helen provided benefit matinees to raise funds – notably *Iolanthe* in December 1907. This

prestigious medal was awarded to 50 people annually, all of whom had provided a minimum of five years' distinguished and unpaid personal service to the League in support of the Fund. Its award to Helen was a royal recognition of her many charitable donations, schemes and support over the years since D'Oyly's death. This generosity was accompanied, nevertheless, by an astute common sense. Helen's desire was to support where necessary in times of trouble, and to invest in and enable the people working for and around her.

She was not prepared, however, to subsidise an undeserving case. When Richard Barker – in his salad days – kept asking for advances on his salary, she took him to task. Having committed to not asking Mr Carte for any extra money, after receiving a loan from her, Barker had done exactly that. 'I suppose I need not tell you I feel most hurt and annoyed,' she wrote, and would herself pay back the £30 to Mr Carte herself, having lent the money to Barker 'against his orders'. Using her typical approach, Helen expounded calmly and rationally on the situation, starting with the balance of his account. The worst of it, she explained, was that his actions put her in the unpleasant situation of having 'to write disagreeable things'. She had asked him 'not once, but many times' to spare her these 'constant accounts and worries and to draw your money regularly when due'. Although she was 'very far from wanting to meddle in your private affairs which are certainly not my business', they had been friends for so long that she could not help pointing out 'that surely there is something radically wrong in your business arrangements – it is all wrong that anyone like you – able always to earn a good income – as you always can and ought to be – should be so constantly worried and beset for money at all sorts of times'. It was an unsustainable way to live, she concluded, writing in October 1887, and it was 'always best to look money troubles right in the face'.[328]

Sad news arrived in Adelaide when Stanley Boulter's letter of 30 July 1911 was received. 'My dear little wife ruptured a small vessel in the head,' he wrote to Alfred. It was brought about by a 'paroxysm of coughing'. He was very sad to report that Helen – aged 59 – had been affected by a stroke, losing the power of her right arm. Her face and speech were affected, he wrote, although there had been 'a

slight improvement'. Progress would be slow and 'the doctors lead one to expect only a very gradual recovery'.[329] Alfred Black would be able to see his sister for himself, as the news coincided with a long-planned visit to England and the Continent with his family and John's daughter Clara. In October 1911, soon after their arrival in London, Alfred and his wife Jessie met Stanley Boulter who 'came to tears' when speaking of Helen.[330]

Yet despite her cough and overall frailty, Helen remained true to her kind and thoughtful habits and made a very welcome contribution to Alfred's trip, handing him £100 in notes (this caused antagonism between the brothers and a two-year rift, John insisting that his daughter Clara was entitled to one fourth of the sum). In March 1912 Helen sent her brother John his annual present of £50 with 'a shaky little note' explaining why she couldn't write before.[331] She never recovered, and died on 5 May 1913. The cause was cerebral haemorrhage, along with cardiac failure and bronchitis. The slight body had been slowly fading from the world, almost from the moment that Helen retired from managing the theatre company in 1910. The tributes immediately flowed in, and the obituaries were elegiac, recording the death of 'An Organising Genius'. From *The Times* to the *Pall Mall Gazette* to the more specialised *Stage* and *Era*, full-length articles were featured, many with photographs. Sensational headlines ranging from 'From Girl Clerk to Controller of the Savoy Theatre' to 'Seventeen Trips to America to Fight with Theatre Pirates' made great copy, as Helen's impressive achievements were laid out for readers.[332] There was massive coverage of her death, from the major and regional papers to society magazines such as *Tatler*.

Much was made of Helen's extraordinary career, and of the incredible alliance of such great talent and lifelong modesty. Those who had worked with her spoke universally of her remarkable ability and 'extraordinary magnetism'.[333] That she was well-loved was abundantly clear. However, the admiration at how she had raised herself from the confines of her Presbyterian background to becoming what some called 'the real founder of the Gilbert & Sullivan era'[334] was a story that ignited the imagination and admiration of all who knew her. The editor of the industry's heavyweight publication, *The Era*, wrote

memorably:

> With this extraordinary appetite for work, and this great gift
> of diplomacy, were joined a most womanly sweetness and
> gentleness. You felt that she saw through you like a glass and
> could probably outwit you; but you felt also that, from kindness
> of nature, not weakness, she would not do you any injury. And
> there was a mystery about her; you could never tell what she
> thought, and she was too clever a woman to wear her heart upon
> her sleeve.[335]

Colleagues rushed to pay tribute; the great actor Henry Lytton
recalled that Helen was 'a born businesswoman with an outstanding
gift for organisation. No financial statement was too intricate for her,
and no contract too abstruse.' He wrote of her highly specialised
knowledge of the law: 'Once when I had to put one of her letters
to me before my legal adviser ... he declared firmly "This letter
must have been written by a solicitor." He would not admit that
any woman could draw up a document so cleverly guarded were the
qualifications.'[336]

Helen's business success – she left an estate of over £117,000 –
had not come as a result of an overbearing or aggressive manner.
Despite her astute practices and decisions, she inspired warmth and
love. As her colleague, the musical director François (Frank) Cellier,
wrote, Helen was 'one of the most charming women to do business
with, and was always accessible to her artists, with whom she showed
much sympathy in all the details of their work'.[337] George Edwardes
reminisced that Helen had 'laboured day and night', and that the
'whole foundations of the Savoy business rested on her'. If 'any trouble
arose,' he went on, it was she 'who put it right'. Indeed, one 'could not
be with her a minute without feeling the extraordinary magnetism
of her presence'. He was another to claim that everyone loved her.[338]
François Cellier recollected in the prestigious *Pall Mall Gazette* that
Helen was 'one of the most charming women to do business with,
and was always accessible to her artists, with whom she showed much
sympathy in all details of their work'.[339] He marvelled that Helen's

Queen of the Savoy: Helen D'Oyly Carte.
'... there was a mystery about her; you could never tell what she thought,
and she was too clever a woman to wear her heart upon her sleeve'.

'own knowledge of detail was unsurpassable' and, astonishingly, despite her immense workload, she had written a treatise on the law of copyright between England and America. Although the family requested no flowers, the urn containing her ashes 'was almost buried by the magnificent wreaths which surrounded it'.[340]

Chapter XXII

Trailblazer

Helen died a wealthy woman, and she had clearly given a great deal of consideration to her will. The most important element was the formal handover of the business assets to Rupert, who inherited the rights, the Savoy Theatre, the D'Oyly Carte Opera Company and shares in the hotel group. This legacy is what Helen had fought so hard to protect and preserve. She had also struggled to ensure that the shares owned by friends, colleagues and company members held as much value as possible. Certainly, the hotels had been prospering, especially as well-heeled Americans flocked to London. Investment in the Savoy Hotel prior to the death of Edward VII in 1910 had created space by extending the façade down to the river and by opening up the old mansard storey to a new extension of upward walls. Thirty new rooms were created, many were extended, and a new banqueting hall seating 500 guests was added, as well as a swimming pool. The sovereign's death, though, had dealt a bitter blow to theatres and hotels as the season of mourning began. However, the overall outlook was nevertheless robust, and Helen left a strong business behind, despite the loss of the golden Gilbert & Sullivan pipeline. Rupert, as she had hoped, inherited a healthy company.

Helen had left debentures or cash to a number of faithful Savoy stalwarts and she had continued her charitable tradition by leaving £200 (over £23,000 today) to the Royal Society for the Prevention of Cruelty to Animals, as well as other amounts to charities helping actors and sick children. Fifty debentures were left to the Actors' Benevolent Fund. Helen was passionate in her espousal of charities

devoted to the wellbeing of children. When the London Theatre
Managers' Committee had wished to honour her with a commission
of her portrait in 1910, she had – with her typical modesty and altruism
– asked for the funds to be used instead for a charitable purpose.
The money was used to fund a 'Mrs D'Oyly Carte presentation cot',
for the benefit of the Children's Convalescent Home in the Victoria
Hospital for Children in Chelsea, London. (This 'naming' of cots was
a popular fundraising tool when the voluntary hospitals for children
were being extended in the early twentieth century.)

Her family was not forgotten, and Helen left a handsome legacy
of £5,000 (over £615,000 in today's money) to each of her siblings,
much to John's delight. The money was hugely important to him, for
it funded his growing body of specialist botanical research. Having
retired from journalism after his mother's death, John had published
The Naturalised Flora of South Australia in 1909. He was, thanks to
Helen's gift, able to concentrate fully on his research, and published
the definitive guides used by lay and professional botanists and
experts in vegetation in Australia for the following 50 years. His life
subsequent to publication – the books were published in four parts
between 1922 and 1929, describing 2,430 species – became one of
honours and awards and he is still considered one of the Australian
nation's finest botanists.

Media coverage upon Helen's death was enormous, with national,
regional and specialist newspapers and magazines relating the
extraordinary life of Helen D'Oyly Carte and celebrating her story:

> Exceptional business ability and great energy were combined
> with a very retiring disposition and stored in a very slight and
> fragile frame. Early hardships had given Mrs. D'Oyly Carte
> an insight into the needs of those in her employ, and her real
> sympathy and open-handedness were rewarded, not only by the
> Order of Mercy, which the King conferred upon her last year,
> but by the affection of all who worked with her.[341]

> The late Mrs. D'Oyly Carte was (says the *World*) undoubtedly
> one of the greatest women of her generation. Had she been a

man, there was no honour or dignity which she might not have attained; as it was, she enjoyed the rare distinction of maintaining her own personality despite a second marriage. Though for the last ten years she had been the wife of Mr Stanley Boulter, a gentleman well known in the City, and an active director of the Savoy Hotel Company, she remained Mrs. D'Oyly Carte to the last, as though she were a peeress in her own right. It was impossible to meet her without being deeply impressed both by the quiet charm of her manner and by the brilliant decisiveness of her intellect.[342]

'As though she were a peeress in her own right' – this certainly, over 100 years later gives us pause. Helen and women like her – trailblazers, pioneers and other women of courage – were agents of change, lending support to the movement to improve legal, civic and working conditions for women, and earning respect other than the servility accorded to peeresses. It is because of her example, running a hugely successful business for over 30 years, gaining respect along the way from male and female colleagues alike, as well as the admiration of other leaders in her industry, that laws were enacted, such as the Qualification of Women Act in 1907, which allowed for women to be elected on to borough and county councils, or to become mayor.

The success of the Liberals at the 1906 election paved the way for reforms, and there were, in addition to the better-known struggles of the suffragette movement, many campaigns to improve the lives of working women. Mary Macarthur, a prominent trades unionist from Glasgow, co-founded the National Federation of Women Workers that same year. Agitation for suffrage and equal working rights continued to grow. In 1908, some 250,000 people gathered in Hyde Park to support women's suffrage. The major reforms coming into play before the First World War were built through the efforts of millions of working women, and the example of those who broke through the barriers, on the basis of their merits, drive and determination, providing inspiration on the one hand and reassurance on the other. They showed by example how it was not only possible, but desirable, to have women at the helm, and their success was an

essential element in gaining sufficient public support for politicians to generate legislation that would be approved. Helen's position as a founding member of the important London Theatre Managers' Association in 1908 speaks eloquently to that point.

In addition to the better-known political activists like the Pankhursts and Millicent Fawcett, there were women such Elizabeth Garrett Anderson, who successfully pioneered medical studies for women – and who helped found the London School of Medicine in 1874. In 1890 Hertha Ayrton was the first woman to become a member of the Institute of Electrical Engineers, and to receive its prestigious Hughes medal in 1906. Clementina Black secured the first successful equal-pay resolution for 1,400 women workers at the match producers Bryant & May in 1888. Game-changing nurses Mary Seacole and Florence Nightingale challenged the *status quo* and struggled, with success, to improve treatment and hygiene standards for wounded soldiers, for which Nightingale was recognised by becoming the first woman to be admitted to the Order of Merit. However, it was not until 1919 that the Sex Discrimination Act permitted women entry into some professions: for the first time, they were allowed to become lawyers, veterinarians and civil servants.

The dual tracks of the fight for political suffrage and better working conditions, and the development of higher education opportunities for women – with slowly widening access to hitherto male-only workplaces – intersected during the First World War, when the imperative need for female workers in the munitions and other industries superseded previous objections. Along with the right to vote, women began to claim more representation in the workplace and outside the home. Yet progress during Helen's lifetime had been achingly slow. Despite the large numbers of talented Scottish emigrants to Britain, America, Australia and around the world, there are few records of Scottish women making their mark. Indeed, it has been claimed that 'Scottish settlements and Scottish influences abroad were male-dominated'.[343]

There were some exceptions: the missionary Mary Slessor and the pioneering doctor Elsie Inglis stand out, as does the medically trained Scottish missionary Jane Waterston, who confided to her mentor that

even though a 'woman's life [can] never be the broad, strong thing a man's may become' she needed to make her own living. 'I like to live,' she explained, 'I don't like to exist.'[344] She despaired of the useless lives of her mother and sisters, all prone to hysteria through boredom. One sister – in echoes of Hilda – took against her when Jane began to work, and refused to speak to her. Like Helen, Jane Waterston found freedom in her work and, like Helen, was not motivated by the pursuit of riches. 'It is not for money but what is the use of living if one is not to strive after the highest skill one can get in that department of work which is the choice of your life.'[345]

In a shape-shifting Victorian world, for women like Helen who sought to work outside the home because they had to and also because they wished to lead a life of purpose, it was difficult to carve out a role. On the one hand, women were expected to remain, famously, 'the Angel of the House', and social norms and trends did much to reinforce this, as did the prevailing literature and media. At the seminal and

Some six million visitors attended Prince Albert's brainchild, The Great Exhibition, designed to showcase exhibits demonstrating British superiority in crafts and industry. Its success heralded the culture of prosperous transnational consumerism in Britain, a development in which the leisure and service industries played a huge part.

hugely influential Great Exhibition of 1851, for example, the virtues and needs of the home were prioritised: displays of 'furniture, silver, china, glass, papier-mâché – all intricately ornamented in a way both complicated to create and to clean – new types of upholstery, new decorative techniques meant home was a place on which money was spent'.[346] That women should create and nurture this environment had the unexpected result of turning them into avid consumers. Yet shopping was one activity; creating the goods and supporting their distribution through a business such as that of the Savoy was quite another. There were no rules for such women and the social situation could become precarious. Women writers, of which there were an increasing number, were based in the home, and thus did not present a threat.

But women such as Helen, fully active in the cut and thrust of running a number of businesses and hundreds of workers, trod a dicey social path. Attitudes such as that expressed in a letter in 1866 to the *Englishwoman's Journal* continued to prevail for decades: 'If a woman is obliged to work, at once (although she may be a Christian and well-bred) she loses that particular position which the word "lady" conventionally designates.'[347] This was simply never the case with Helen. Although women in the workplace are no longer expected to be 'ladylike' – with all that this implied a century ago – Helen embodied a lack of arrogance grounded in a strong sense of self, and of quiet self-respect. This extended naturally into the exercise of a consistent and compassionate respect for others that had an immutable and timeless quality. Indeed, she was known as 'the most important link' in the hugely successful enterprise, because it was 'her loving personality', as well as her 'mastery of detail and her genius as an organiser', that kept the critical relationships going.[348] Her work ethic, her decency, talent and kindness transcended notions of gentility, and her extraordinary ability and temperament transcended background and class, which is why she was, for all who knew her, 'Queen of the Savoy'.

It has been convincingly argued that Britain in the 1890s – and most specifically, London – experienced the shifts in social and cultural dynamics that had been fermenting over the previous decades. Electoral reforms, begun in 1832 and extended in 1867, 1872 and 1884, put an

end to the open ballot and enfranchised thousands of working men. The voices from the margins – those of women, those of men wishing to be more open about their feelings for male–male relationships, whether these involved sex or not, and those of the labouring and working classes – became more frequently expressed. Even the prosecution of Oscar Wilde in 1895, for example, and the public scandal of Cleveland Street, served to bring the very possibility of these relationships into the public arena. That it could be discussed meant that it existed.[349] These challenges to the homogenous, bourgeois, upright Victorian model were increasingly to be found in the press, in literature, song, on the stage and in both public and private discourse.

The theatre played a huge role in representing and giving voice to all these groups. Increasing social fluidity enabled members of the working class to aspire to careers in performance if money could be found to train, and, more realistically, to enjoy the spectacles offered from the cheap pit places. Women had fought to be regarded as respectable in the theatrical profession, with considerable success – provided that their public image remained unsullied.[350] And the contributions of creative, artistic men of high sensibility were accepted as long as the rigorous social codes governing their public behaviour were observed.

We have seen that the theatre company became a family, and, as such, its world was one in which there was space for minority and marginal voices. It was a perfect environment for someone of Helen's ambitions and talents. Her lack of ego and of a desire to promote herself proved an excellent foil to the large personalities with which she was surrounded. Temperamental head chefs, frazzled composers, difficult divas and playwrights were managed with intelligence and compassion. Some cast members apparently referred to her as a mother, and, indeed, her cool head and warm heart proved invaluable to many a lost soul on the road with the troupe. Her personal attributes were invaluable, but she was also part of something bigger and very exciting: London from the 1880s up to the First World War was at the centre of a global culture that embraced foreign influence – from cuisine to music to literature to art and theatre – and where marginalised voices became heard. Women who had for years been

silent were less so, as the 'New Woman' raised her voice, and as activists fought for equality.

Helen's ability, her 'organising genius',[351] demonstrably proved to British, American and other markets that women could be at least as capable as men given the opportunity. She was fortunate in having found a mentor who supported and encouraged her, and that is much to D'Oyly Carte's credit – as well as to his advantage. There was, however, no path for her to follow, no one for her to emulate, and she had to forge her own way by creating her own role in a challenging, constantly evolving environment. Although the number of female entrepreneurs in Britain has recently been estimated to be far higher than was thought during this period – as many as 30% of all entrepreneurs were female – these represented small businesses, often run from home, and did not require managing large numbers of staff. Dressmaking, laundering, running lodgings and some shop-keeping represented the majority of female occupations,[352] and Helen was seemingly unique in the longevity of her successful career and the employment and turnover that it generated.

Far from home, far from her family, she turned her special talents to best use, and was one of the prime movers in a world-renowned, modern, global enterprise that changed the expectations for entertainment and hospitality forever and ushered in a new era for multi-media brands. Her obituary in *The Stage* brought to life her extraordinary contribution: 'It has been said that she was the real founder of the Gilbert & Sullivan era.'[353] And, in a further fascinating note, Rupert's daughter Bridget, when she divorced her husband the Earl of Cranbrook, changed her name by deed poll to Bridget D'Oyly Carte in 1932. Helen had left a lasting legacy of the importance of a name in business, a legacy that her stepson's daughter followed when she, in turn, successfully ran the business many years later.[354] It was not enough to succeed as a woman – Helen, the consummate marketeer, had understood that to have professional impact, a woman's name was just as important as that of a man. Her perception of this, and determination to act upon it, gives us yet another glimpse into the fascinating role played by Helen D'Oyly Carte as a trailblazer extraordinaire.

... the real founder of the Gilbert & Sullivan era ...

Endnotes

INTRODUCTION

[1] In order: *Grantham Journal*, 10 May 1913; *Illustrated London News*, 10 May 1913; *Manchester Courier*, 6 May; *Grantham Journal*, 10 May 1913; *Evesham Standard & West Midland Observer*, 10 May 1913; *Dundee Courier*, 6 May 1913; *Leeds Mercury*, 7 May 1913.

CHAPTER I

[2] Charles A. Malcolm, *The History of the British Linen Bank*, p.194.

[3] See Eustace Couper Black, chair, editorial committee, *Memoirs of John McConnell Black*.

[4] It was actually updated to a design by William Henry Barlow and John Hawkshaw, based on an earlier design by Brunel.

[5] Stephens, *Education in Britain, 1750–1914*, p.111.

[6] M. Vivian Hughes, *A London Family 1870–1900*, p.154 (1881).

[7] *Western Daily Press*, 17 May 1871.

[8] I am very grateful to Dr Philip Carter for generously sharing his excellent research on the lives of London's women undergraduates, 1868–1928.

[9] Wade, *Square Haunting*, pp. 96–7.

[10] See Gillian Sutherland, *In Search of the New Woman: Middle-Class Women and Work in Britain 1870–1914*, for a comprehensive view of this, especially pp.19–22.

CHAPTER II

[11] Susan Kingsley Kent, *Gender and Power in Britain, 1640–1990*; 'Liberalism Besieged, masculinity under fire, 1873–1911'. See p.232.

[12] *Philadelphia Times*, 16 May 1881, in Jones, *Helen D'Oyly Carte*, p.64.

[13] I have found Tracy C. Davis's work on actresses in the Victorian era extremely useful. See *Actresses as Working Women: Their Social Identity in Victorian Culture*, in particular.

[14] Baker, *The Rise of the Victorian Actor*, p.107.

[15] This diary was published anonymously in 1885, but has been attributed to her.

[16] H.C. Shuttleworth, ed., *The Diary of an Actress*, p.39.

[17] *Ibid.*, p.25.

CHAPTER III

[18] *The Era*, 10 May 1913.

[19] François Cellier and Cunningham Bridgeman, *Gilbert and Sullivan and Their Operas*, p.14.

[20] Paul Seeley, *Richard D'Oyly Carte*, p.11. I am grateful to the work of Paul Seeley; his meticulous biography of D'Oyly Carte has proved extremely valuable.

[21] The music publisher and instrument manufacturer William Prowse was founder of the famous Keith Prowse agency.

[22] Seeley, *op. cit.*, p.34.

[23] *The Diaries of John McConnell Black*, ed. M. Andrew & S. Clissold, p.58.

[24] R. Blackmore to Helen Lenoir, 6 September 1877; V&A Theatre Museum Archive (THM) /73/14/3/11.

[25] Andrew & Clissold, *op. cit.*, p.59.

[26] John M. Black recorded on 9 February 1878 that to 'stay here is unbearable because of Hilda'. *Ibid.*, p.69.

[27] Henry James, *English Hours*, p.5.

[28] Rohan McWilliam, *Creating the Pleasure District, 1800–1914: London's West End*, p.107. See, also, the enormously helpful work, *The London Restaurant, 1840–1914* by Brenda Assael, and in particular the Introduction, pages 1-15.

[29] Hollingshead, *Gaiety Chronicles*, p.6.

[30] Max Beerbohm, 'Pretending', quoted in *London in the Nineties*, p.13.

[31] Compton MacKenzie, *The Savoy of London*, p.41.

[32] There are excellent memoirs and biographies of Sir William Gilbert and of Sir Arthur Sullivan – both individual and joint – which have proved enormously helpful for this book. See Bibliography.

[33] Clare Barnett, in *Sullivan and His Satellites*, p.7.

[34] Tony Joseph, *The D'Oyly Carte Opera Company*, p.13.

CHAPTER IV

[35] See, in particular, Tracy C. Davis, *The Economics of the British Stage*, Michael Goron, *Gilbert and Sullivan's 'Respectable Capers'*, and Regina B. Oost, *Gilbert and Sullivan: Class and the Savoy Tradition, 1875–1896.*

[36] WSG to RDC, 11 March 1876: WSG/BL Add. MS 49,338.

[37] Andrew & Clissold, *op. cit.*, p.25.

[38] Such was its popularity that English-speaking people all over the world learned it by heart and it was regularly recited by thousands – indeed, I remember my Irish great-grandmother, born in 1885, reciting it to me.

[39] *The Era*, 10 May 1913.

[40] To avoid confusion with another George Edwards working at the Savoy, he added an 'e' to his last name.

[41] See V&A THM/73/14.

[42] *The Era*, 31 Dec. 1887.

[43] Jones, p.40.

[44] Violet Vanbrugh, *Dare to be Wise*, pp.64–5.

[45] Bailey, p.40.

[46] Smith, p.63.

[47] RDC to AS, 26 Aug. 1879; V&A THM 73/14/1/1–3.

CHAPTER V

[48] Arthur Sullivan to Mary Sullivan, late Jan. 1880, in Herbert Sullivan and Newman Flower, *Sir Arthur Sullivan*, p.105.

[49] Sophie Fuller, 'Creative Women and "Exoticism" at the Last *Fin-de-Siècle*', in *Music and Orientalism in the British Empire, 1780s–1940s*, ed. Martin Clayton and Bennett Zon (Aldershot: Aldgate, 2007), p.214.

[50] Edith Craig & Christopher St John, eds, *Ellen Terry's Memoirs*, pp.197–8.

[51] Mary Hannah Krout, *A Looker On in London*, p.6.

[52] Emily Soldene, *My Theatrical and Musical Recollections*, p.150.

[53] Craig & St John, *Ellen Terry's Memoirs*, p.198.

[54] Cited by Andrew F. Smith, *Drinking History*, p.104.

[55] Cited by Longin Pastusiak, 'Henryk Sienkiewicz', in *Abroad in America*, p.179.

[56] Eric Homberger, *Mrs Astor's New York*, pp. 228-9.

[57] I found these works especially helpful: Derek Miller, *Copyright and the Value of Performance, 1770–1911* (whose work pointed me to the very useful article 'The Twilight of the Opera Pirates' by Zvi S. Rosen in *Cardozo Arts & Entertainment Law Journal* 24 [2007]), and Tracy M. Davis, *Economics of the British Stage*.

[58] Derek Miller, *Copyright and the Value of Performance*, p.103.

[59] D'Oyly, and Helen, also instructed prosecutions for works other than Gilbert & Sullivan pieces. See, among others, an excellent account by Seeley, *op. cit.*, ch.5.

[60] V&A THM/73/14/1/1: RDC to HL, 17 Dec. 1881.

[61] V&A THM/73/14/1/1: RDC to AS, 24 May 1881.

[62] V&A THM/14/1/1 RDC to WSG, 21 Dec. 1880.

CHAPTER VI

[63] V&A THM/73/14/1/1: HL to RDC, 15 Sept. 1882.

[64] Soldene, *op. cit.*, p.295.

[65] *Ibid.*, p.296.

[66] Lindsay Harman, *A Comic Opera Life*, p.19.

[67] V&A THM/73/14/1 /1: HL to RDC 15 Sept 1882.

[68] The Hon. Mrs Alfred Lyttelton, *Women and Their Work*, p.23.

[69] V&A THM/74/14/1/1: HL to RDC, 20 Sept. 1882.

[70] Ruby Miller, *Champagne From My Slipper*, p.33.

[71] V&A THM/74/14/1/1: HL to RDC, 20 Sept. 1882.

[72] V&A THM/74/14/1/1: HL to RDC, 26 Sept. 1882.

[73] V&A THM/74/14/1/1: HL to McCaull, Esq., 29 Sept. 1882.

[74] *Hendon & Finchley Times*, 21 Jan. 1882.

[75] V&A THM/14/1/1: HL to E.E. Rice, Esq., 3 Nov. 1882.

[76] Harman, *op. cit.*, pp.50–2.

[77] V&A THM/14/1/1: RDC to HL, 31 [Oct.?] 1882.

[78] V&A THM/14/1/1: HL to Miss Roche, 20 Jan. 1883.

CHAPTER VII

[79] Rather ironically for Helen Lenoir, this opera poked fun at female university students.

[80] Cellier & Bridgeman, *op. cit.*, p.109.

[81] Asa Briggs, *A Social History of England*, p.218.

[82] Cellier & Bridgeman, *op. cit.*, p.123.

[83] V&A THM/73/14/1/4: WSG to HL, 25 Nov. 1883.

[84] V&A THM/73/14/1/4: WSG to RDC, 19 Nov. 1885.

[85] V&A THM: 25 Nov. 1883; Stedman, *Gilbert*, p.249.

[86] *Sunday Times*, 3 May 1885.

[87] Cellier & Bridgeman, *op. cit.*, p.7.

[88] *Sunday Times*, 3 May 1885.

[89] *The Era*, 13 June 1885.

[90] Cited by Zvi Rosen, p.1173, Stage History of 'The Mikado', *New York Times*, 29 May 1910, at X7.

[91] I am grateful to Paul Seeley's research for this: see Seeley, *op. cit.*, p.91.

[92] John Juxon, *Lewis and Lewis*, p.107.

[93] *Ibid.*, p.181.

[94] Library of Congress, Manuscript Division, Pennell-Whistler Collection, PWC 8/451: JW to HL, 7/14 March 1881; PWC 8?452: JW to HL, Nov./Dec. 1884.

[95] Lillie Langtry (Lady de Bathe), *The Days I Knew*, p.65.

[96] Pennell, *Life of J.M. Whistler*, vol.2, p.37.

[97] LC, MSD, PWC 8/446: JW to RDC, March 1885.

[98] Sickert had a 'cavalier attitude to picture titles', according to his biographer Matthew Sturgis, and this picture was renamed *Despair* from *Rehearsal: The End of the Act* when it was exhibited in Jan. 1895. Matthew Sturgis, *Walter Sickert: A Life*, p.226.

[99] *Ibid.*, p.118.

[100] Sarah Bernhardt, *My Double Life*, p.313.

[101] GUL, MS Whistler D139: HL to JW, 20 Dec. 1886.

CHAPTER VIII

[102] *Evening News* (Sydney), 1 Aug. 1885.

[103] Andrew & Clissold, *op. cit.*, 3 Dec. 1877, p.60.

[104] *Ibid.*, 25 Oct. 1880, p.130.

[105] J.M. Black, *Memoirs*, p.49.

[106] See *ibid.* for these recollections in Baroota and Adelaide, pp. 50–4.

[107] J.M. Black, *Memoirs*, 26 April 1885, p.231.

[108] Christopher Hibbert, *Gilbert & Sullivan and Their Victorian World*, p.186.

[109] Reginald Allen, *Sir Arthur Sullivan*, p.121.

[110] David Cannadine, 'Gilbert and Sullivan', in Roy Porter, *Myths of the English,* p.17; see G. Rowell, *Theatre in the Age of Irving* (Blackwell, 1981).

[111] Alan Hyman, *The Gaiety Years*, p.236.

[112] Cellier & Bridgeman, op. cit., p.285.

[113] Regina B. Oost, Gilbert and Sullivan: *Class and the Savoy Tradition*, 1875–1896, p.68. See 'Shopping at the Opera', pp. 63–81.

[114] *Ibid.*, pp. 68–9.

[115] See A. Wilson, *The Victorians*, pp.409–10.

[116] 'The Adventures of an Opera Company', annotated 1885, cited by Oost, *op. cit.*, p.78.

[117] Erika Diane Rappaport, *Shopping for Pleasure: Women in the Making of London's West End*, ch.4 and, in particular, pp. 122–6.

[118] Mrs E.T. Cook, *Highways and Byways in London*, p.283.

[119] Rohan McWilliam, *London's West End*, ch.6; in particular the very helpful pp.129–31.

[120] V&A THM/73/14/1/1: RDC to HL, 27 Nov. 1886.

[121] I have found these and other comparative figures at www.relativeworth.com, accessed 25 Nov. 2019.

CHAPTER IX

[122] Jessie Bond, *The Life and Reminiscences of Jessie Bond, the Old Savoyard*, pp. 117–20.

[123] *Ibid.*, p.93.

[124] *Ibid.*, p.98.

[125] Cellier & Bridgeman, *op. cit.*, p.247.

[126] Mrs Patrick Campbell, *My Life and Some Letters*, p.221.

[127] *Ibid.*, p.220.

[128] J.M. Glover, *Jimmy Glover and His Friends*, p.114.

[129] V&A THM/73/14/1/4: WSG to RDC, 1 June 1885.

[130] Herbert Sullivan and Newman Flower, *Sir Arthur Sullivan*, p.159.

[131] Cellier & Bridgeman, *op. cit.*, pp.212–13.

[132] V&A THM 73/14/1/1: HL to WSG, 20 March 1888.

[133] Mary Anderson de Navarro, *A Few More Memories*, pp.18–19.

[134] *York Herald*, 28 March 1887.

[135] See Davis, *Economics*, ch.6, 'Profit', pp. 201–40 for an excellent analysis of touring companies.

[136] Cellier & Bridgeman, *op. cit.*, pp. 415–16.

[137] *York Herald*, 28 March 1887; *Liverpool Echo*, 19 April 1888, among others.

[138] *The Sunday Herald,* Boston, 10 Feb. 1887.

CHAPTER X

[139] Letter from John McConnell Black to Helen Lenoir, 5 Feb. 1888, Black, *Diaries*, vol.II, p. 13.

[140] *The Bristol Mercury*, 21 Dec. 1887.

[141] Olive Anderson, *Suicide in Victorian and Edwardian England*, p.80.

[142] Morgan Library, Lucas Carte Diary (LCD), 25 Jan. 1888, in Jones, *op. cit.*, p.74. I am grateful to the late Brian Jones for his work in transcribing these entries, which can be found in his book (see pp.73–86).

[143] LCD, 29 March 1888, in Jones, *op. cit.*, p.76.

[144] LCD, 12 April 1888, in Jones, *op. cit.*, p.79.

[145] *Ibid.*

[146] LCD, 13 April and 15 April 1888, in Jones, *op. cit.*, pp.79–80.

[147] LCD, 17 April 1888, in Jones, *op. cit.*, p.80.

[148] Helen Carte to Joseph Pennell, 24 Sept. 1906, cited by Daniel E. Sutherland, *Whistler: A Life for Art's Sake*, p.223. See, too, Whistler Collection, University of Glasgow Library, Glasgow, and Pennell-Whistler Collection, Manuscript Department, Library of Congress, Washington D.C.

[149] Black, *Diaries*,12 Aug. 1888, p.20.

[150] *Ibid.*, 16 Sept. 1888, p.21.

[151] *Ibid.*, 23 Aug. 1890, p.45.

CHAPTER XI

[152] Cellier & Bridgeman, *op. cit.*, p.284.

[153] V&A THM G&S: RDC to WSG, 24 April 1889.

[154] V&A THM G&S: HC to WSG, 7 May 1890.

[155] V&A THM G&S: WSG to RDC, 14 Jan. 1882.

[156] *The Umpire*, 1 June 1890.

[157] Bank of England inflation calculator at www.bankofengland.co.uk, accessed 23 September 2021.

[158] V&A THM G&S: HC to WSG, 7 May 1890.

[159] Hibbert, *op. cit.*, p.170.

[160] V&A THM G&S: HC to AS, 7 June 1890.

[161] V&A THM G&S: HC to AS, 7 June 1890.

[162] Jacobs, *Arthur Sullivan*, p.322.

[163] Hibbert, *op. cit.*, p.241.

CHAPTER XII

[164] V&A THM/73/14/2/50-4/4: Robert Carte to RDC, 24 April 1889.

[165] George Rowell, *Theatre in the Age of Irving*, p.89.

[166] WSG to John Hare, Ainger, *Gilbert and Sullivan: A Dual Biography*, p.284.

[167] Sullivan, Diary, 31 Jan. 1891; Allen, *op. cit.*, p.159.

[168] See the excellent Davis, *op. cit.*, pp.265–7.

[169] There is a great deal of literature and discussion on this; among the best is by Seeley, *op. cit.*, see pages 111–26.

[170] *Pall Mall Gazette*, 'Music Notes', 16 Jan. 1892.

[171] *The Times*, 7 Dec. 1891.

[172] I am grateful to Derek Taylor, *Ritzy: British Hotels 1837–1987* for his work on the Savoy Hotel, as well as on Ritz and Escoffier and the scandal of 1895.

[173] V&A THM 73/8/4: R.D. Blumenfeld, *Diary*, 10 Nov. 1890.

[174] Nellie Melba, *Melodies and Memories*, p.228.

[175] *Chambers Journal*, 'Our City of Nations', 1891, p.205.

[176] Lucius Beebe, *The Savoy of London*, pp. 10–11.

[177] V&A THM 73/14/1/4: WSG to HC, 8 May 1891.

[178] V&A THM 73/14/1/4: WSG to HC, 12 Oct. 1891.

[179] V&A THM 73/14/1/4: WSG to HC, 3 Nov. 1891.

CHAPTER XIII

[180] BL Add.MS 89231/25/7; 5123F: Black Family Records (BFR) in 'Helen Lenoir' by C. Couper Dickson, Dec. 1979.

[181] V&A THM/30/20: '"The Million" Interviews Interesting People: A Chat with Mr D'Oyley [*sic*] Carte', 10 Dec. 1892.

[182] V&A THM/14/1/3: HC to A.E. Pickering, 23 Feb. 1891.

[183] *St Stephen's Review*, 10 Dec. 1892.

[184] G. Bernard Shaw to Ellen Terry, 1 July 1892, in Christopher St John, ed., *Ellen Terry and Bernard Shaw: A Correspondence*, p.7.

[185] V&A THM/73/14/1/5: WSG to HC, 20 Feb. 1891.

[186] V&A THM/73/30/32: *Financial Standard & Imperial Post*, 14 Nov. 1891.

[187] See, for example, *St Stephens Review*, 20 Feb. 1892.

[188] In her biography of her husband, Marie Ritz provides details on the 'elite of society' who 'surrendered to the invaders'(p.144). Ritz, *César Ritz*, see, in particular, pp.144–54.

[189] *Sporting Life*, 27 April 1894.

[190] Miller, *op. cit.*, p.36.

[191] V&A THM/73/14/1/4: WSG to HC, 1 May 1892.

[192] V&A THM/73/14/1/4: WSG to HC, 9 May 1893.

[193] V&A THM/73/14/1/4: WSG to HC, 4 Aug. 1893; 5 Aug. 1893; 5 Sept. 1893.

[194] *The Graphic*, 7 October 1893.

[195] *Ibid.*, 7 October 1893.

[196] I am grateful to Gilbert's biographer, Jane Stedman, for these and other details on Gilbert's home at Grim's Dyke. See Stedman, *op. cit.*, pp 278–9.

[197] V&A THM/73/14/1/3: AS to HC [?], Sept. 1893.

[198] V&A THM/73/14/1/4: EWSG to HC, 15 Oct. 1893.

[199] JMB Diaries vol.II, 16 July 1892, p.73.

[200] V&A THM/73/14/1/5: WSG to HC, 29 Aug. 1893.

[201] WSG to HC, 4 Aug. 1893, Ainger *op. cit.*, p.343.

[202] *Pearson's Society News*, 19 Oct. 1893.

[203] V&A THM/73/14/1/3: HC to AS, 24 Feb. 1894.

CHAPTER XIV

[204] *Western Daily Press*, 22 Dec. 1894.

[205] Black, *Diaries*, vol.II, 28 April 1895, p.100.

[206] *Ibid.*, 14 July 1895, p.102.

[207] *Ibid.*, 8 Sept. 1895, p.104.

[208] Ethel Barrymore, *Memories*, p.62.

[209] *Daily Mail*, 20 March 1897.

[210] It has been suggested that this was especially delicate for the Carte family as Lucas had been very friendly with Wilde's lover, Lord Alfred Douglas ('Bosie') at Winchester and at Magdalen, exchanging letters that make clear a passionate intimacy, if not necessarily a sexual relationship. However, as during the period of Bosie's scandalous escapades Lucas was studying to take the Bar – at which he succeeded in 1896 – and was received at the Inner Temple in 1897, he was clearly not involved in a public scandal, and was not sent away to avoid notoriety, as was typically the case. I have seen no evidence that the relationship was other than those Bosie later characterised as typical schoolboy passions – that often involved some sort of sexual activity but not illegal sodomy.

[211] *Sunday Telegraph*, 16 April 1899.

[212] AS to Frank Burnand, in Hibbert, *op. cit.*, p.255.

[213] Black, *op. cit.*, 25 July 1896, pp.127–8.

[214] Seeley, *op. cit.*, pp.140–1.

[215] Seeley, *op. cit.* (fn) 22, p.145.

[216] V&A THM/73/14/1/3: AS to HC, 22 July 1896.

[217] JPMA ref 106257: HC to AS, 4 Aug. 1897.

[218] *The Lady's Realm*, May 1897, p.225.

[219] Hesketh Pearson, *Gilbert: His Life and Strife*, p.128.
[220] David Cannadine, 'Gilbert and Sullivan: The Making and Un-Making of a British "Tradition"', in Porter, *op. cit.*, pp.20–21.
[221] V&A THM/73/30/36, *The World*, 25 May 1898.

CHAPTER XV

[222] *Standard*, 6 June 1899.
[223] *Western Mail*, 6 June 1899.
[224] *Vanity Fair*, 8 June 1899.
[225] V&A THM/73/30/36, *N.Y. Mail & Express*, 'Mrs Lane's Letter', 11 June 1898.
[226] J.P. Morgan Archive (JPMA), ref. 106250: HC to AS, 8 Sept. 1898.
[227] V&A THM/73/14/1/3: AS to HC, May [?] 1898.
[228] V&A THM/73/14/1/3: AS to HC, 3 Feb. 1898.
[229] V&A THM/73/14/1/4: WSG to HC, 31 March 1898.
[230] V&A THM/73/14/1/5–6: WSG to HC, 3 March 1899.
[231] V&A THM/73/14/1/5–6: WSG to HC, 21 May 1899.
[232] Black, *Diaries*, vol.II, 9 March 1899, p.165.
[233] *Ibid.*, 15 Feb. 1899, p.181.
[234] V&A THM/73/8/4: Ralph D. Blumenfeld, *Diary*, 10 November 1890.
[235] Davis, *Actresses*, p.83.
[236] Black, *Diaries*, vol.II, 24 May 1899, p.167.
[237] JPMA, ref. 106263: HC to AS, 28 July 1899.
[238] Cited by Seeley, *op. cit.*: AS to Bendall, 27 March 1899, p.143.
[239] JPMA, ref. 106259: HC to AS, 28 July 1898.
[240] JPMA, ref. 106260: HC to AS, 29 July 1898.
[241] V&A THM/73/14/1/3: AS to HC, 20 March 1900.
[242] JPMA, ref. 106268: HC to AS, 15 June 1900.
[243] JPMA, ref. 106269: HC to AS, 15 Oct. 1900.

CHAPTER XVI

[244] JPMA, ref. 106269: HC to AS, 15 Oct. 1900.
[245] JPMA, ref. 106270: HC to AS, 16 Oct. 1900.
[246] JPMA, ref. 106271: HC to AS, 2 Nov. 1900.
[247] V&A THM/73/14/1/3: AS to HC, 20 June 1900.
[248] Baily, *The Gilbert & Sullivan Book*, p.375.
[249] JPMA, ref. 106272: HC to AS, 3 Nov. 1900.
[250] Baily, *op. cit.*, p.376.
[251] *The Times*, 23 Nov. 1900.
[252] Hibbert, *op. cit.*, p.260.
[253] HC to Fanny Ronalds: Ainger, *op. cit.*, p.388.

CHAPTER XVII

[254] Black, *Diaries*, vol.II, p.202.
[255] *Ibid.*, 6 July 1901, p.200.

[256] *Ibid.*, 1 Aug. 1901, p.201.

[257] V&A THM/73/14/3/2: HC to Rupert Carte (RC), 4 April 1902.

[258] V&A THM/73/14/3/2: HC to RC, 4 April 1902.

[259] Black, *Diaries*, vol.II, 3 Dec. 1901, p.203.

[260] V&A THM/73/3/25: G.H. Wynkoop to HC, 30 April 1901.

[261] V&A THM/73/3/25: Sir Squire Bancroft to HC, 5 April 1901.

[262] V&A THM/73/3/25: WSG to HC, 5 April 1901.

[263] Jane Ridley, *Bertie: A Life of Edward VII*, p.337. This biography gives excellent detail on Victoria's and Bertie's lives at this time.

[264] HC to Haidee Crofton, 3 May 1901, cited by Jones, *op. cit.*, p.120.

CHAPTER XVIII

[265] V&A THM/73/14/3/2: HC to RC, 4 April 1902.

[266] See Black, *Diaries*, vol.II.

[267] V&A THM/73/14/3/2: HC to RC, 25 April 1902.

[268] V&A THM/73/14/3/2: HC to RC, 28 April 1902.

[269] There is excellent research and analysis of women in the workplace in the period. See, among others: Arlene Young, *From Spinster to Career Woman*; Angela V. John, ed., *Unequal Opportunities*; and Lee Holcombe, *Victorian Ladies at Work*. Young in particular makes very interesting points about how women were able to advance – or, more often, were held back – in various professions by existing mores and legislation. She makes very useful points about the dangers of 'exceptionalism' when it comes to studying women's careers in Victorian England.

[270] I am grateful to the Savoy archivist, Susan Scott, for sharing with me this information from the electoral register of the tenants of Savoy Court 1906–08.

[271] I am grateful to the informative work by Stanley Jackson, *The Savoy: The Romance of a Great Hotel*.

[272] Black, *Diaries,* vol.II, 6 July 1902, p.211.

[273] *Ibid.*, 12 Aug. 1902, p.217.

[274] *Ibid.,* 27 June 1903, p.225.

[275] *Ibid.,* 27 June 1903, p.226.

[276] Black, *Memoirs*, p.85.

CHAPTER XIX

[277] V&A THM/73/14/1/4: WSG to HC, 12 Jan. 1904.

[278] V&A THM/73/14/1/4: WSG to HC, 12 March 1904.

[279] V&A THM/73/14/1/5: WSG to HC, 17 Feb. 1905.

[280] V&A THM/73/14/1/5: WSG to HC, 30 March 1905.

[281] Black, *Diaries*, vol.II, 13 March 1905, p.237.

[282] *Ibid.*, 8 May 1905, p.242.

[283] V&A THM/73/14/1/4: HC to WSG, 23 May 1905.

[284] V&A THM/73/14/1/4: WSG to HC, 26 May 1905.

[285] Black, *Diaries*, vol.II, 29 July 1905, p.243.

[286] *The Sketch*, 5 July 1905; Stanley Jackson, *The Savoy*, pp.44–45.

[287] V&A THM/73/14/1/4: WSG to HC, 5 Oct. 1906.

[288] V&A THM/73/14/1/4: HC to WSG, 8 Oct. 1906.

[289] V&A THM/73/14/1/4: WSG to HC, 9 Oct. 1906.

[290] V&A THM/73/14/1/4: WSG to HC, 18 Nov. 1906.

[291] V&A THM/73/14/1/4: HC to WSG, 7 Dec. 1906.

[292] V&A THM/73/14/1/4: HC to WSG, 7 Dec. 1906.

[293] V&A THM/73/14/1/4: WSG to HC, 8 Dec. 1906.

[294] V&A THM/73/14/1/4: HC to WSG, 12 Dec. 1906.

[295] Joseph Harker, *Studio and Stage*, p.83.

[296] *Ibid.*, p.86.

[297] *The Times*, 10 Dec. 1906.

CHAPTER XX

[298] *Daily Express*, 10 Dec. 1906.

[299] *The Era*, 15 Dec. 1906.

[300] V&A THM/73/14/1/4: HC to WSG, 12 Dec. 1906.

[301] V&A THM/73/14/1/4: WSG to HC, 1 Jan. 1907.

[302] V&A THM/73/14/1/4: WSG to HC, 8 Jan. 1907.

[303] V&A THM/73/14/1/4: HC to WSG, 10 Jan. 1907.

[304] *Manchester Courier & Lancashire General Advertiser*, 22 Dec. 1906.

[305] THM/73/14/1/4: WSG to HC, 1 Feb. 1907.

[306] *Illustrated Sporting and Domestic News*, 15 Dec. 1906.

[307] *Sporting Times*, 1906; cited by Alan Hyman, *The Gaiety Years*, p.23.

[308] V&A THM/73/14/1/4: WSG to HC, 2 April 1907.

[309] V&A THM/73/14/1/4: WSG to HC, 3 April 1907.

[310] *The Times*, 19 April 1907.

[311] *The Era*, 31 Aug. 1907.

[312] *The Era*, 29 Dec. 1906.

[313] V&A THM/73/14/1/4: HC to WSG, 26 Jan. 1909.

[314] V&A THM/73/14/1/4: WSG to HC, 2 Feb. 1909.

[315] V&A THM/73/14/1/4: WSG to HC, 7 Feb. 1909.

[316] V&A THM/73/14/1/4: HC to WSG, 9 Feb. 1909.

[317] Hibbert, *op. cit.*, *Observer*, p.270.

CHAPTER XXI

[318] Ruby Patricia Preece later became an artist associated with the Bloomsbury Group. The lifelong partner of the artist Dorothy Hepworth, she became the second wife of painter Stanley Spencer but remained committed to Hepworth while exploiting Spencer.

[319] Ainger, *op. cit.*, p.440.

[320] V&A THM/73/14/3/18: HC to Lady Gilbert, 9 June 1911.

[321] *The Referee*, 19 April 1908.

[322] A vigorous campaign in 1894 in the leading newspapers vehemently criticised the renovation and expansion of the West End music halls, in particular the Alhambra and the Empire. The enormous success of these halls, and the proliferation of the resulting prostitution, provoked a crisis of moral values, and much agonising over the

decline of social values. See John Stokes, *In The Nineties*, pp.54–95.

[323] Ellerslie, ed. Shuttleworth, *The Diary of an Actress*, 16 May *c.*1885, p.43.

[324] *Ibid.*, 5 Sept. *c.*1895, p.54.

[325] See Davis, *Actresses*, pp.86–97; in particular p.87.

[326] Black, *Diaries*, vol.II, 4 Aug. 1910, p.278.

[327] Violet Vanbrugh, *Dare to be Wise*, p.91.

[328] V&A THM/73/14/1/1–3: HL to Richard Barker, 6 Oct. 1887.

[329] Black, *Diaries*, vol.III: Stanley Boulter to Alfred Black, 30 July 1911; diary entry 29 Sept. 1911, p.12.

[330] *Ibid.*, 19 Nov. 1911, p.13.

[331] *Ibid.*, 12 April 1912.

[332] *Daily Mirror*, 6 May 1913.

[333] *Yorkshire Telegraph and Star*, 6 May 1913.

[334] *The Stage*, 8 May 1913.

[335] *The Era*, 10 May 1913.

[336] Henry Lytton, *The Secrets of a Savoyard*, p.67.

[337] *Pall Mall Gazette*, 6 May 1913.

[338] *Yorkshire Telegraph and Star*, 6 May 1913.

[339] *Pall Mall Gazette*, 6 May 1913.

[340] *Birmingham Daily Gazette*, 10 May 1913.

CHAPTER XXII

[341] *The Times*, 6 May 1913.

[342] *Clifton Society*, 15 May 1913.

[343] Jenni Calder, *The Enterprising Scot*, p.22.

[344] Jane Waterston to James Stewart (her lifelong mentor), 1869 [?], in Jane E. Waterston, *The Letters of Jane Elizabeth Waterston*, p.21.

[345] Waterston to James Stewart, 21 Nov. 1886, in *Letters*, p.198.

[346] Mary Sebag-Montefiore, 'The Hidden Self: Late Victorian Childhood, Class & Culture in Mrs Molesworth's Books', in *A Victorian Quartet: Four Forgotten Women Writers*, pp.117–18.

[347] *Ibid.*, p.132.

[348] *Yorkshire Evening Post*, 6 May 1913.

[349] See, among others, H.G. Cocks, 'Respectability, Blackmail and the Transformation of Scandal', in *Nameless Offences*.

[350] See Patricia Zakreski, 'Unceasing Industry: Work and the Female Performer', in *Representing Female Artistic Labour, 1848–1890*.

[351] *Montrose, Arbroath and Brechin Review*, 9 May 1913.

[352] See the immensely helpful Bennett, *et al.*, *The Age of Entrepreneurship*, pp.192–217; in particular pp.196–203.

[353] *The Stage*, 8 May 1913.

[354] I am grateful to the Savoy archivist, Susan Scott, for providing me with this very interesting information.

Select Bibliography

Primary Sources

Barbican Music Library, City of London: Gilbert and Sullivan Collections

British Library, London: William Schwenck Gilbert (WSG) papers and WSG Diaries

J. Pierpont Morgan Library, New York City: Gilbert and Sullivan collection

The Gilbert and Sullivan Society, at: gilbertandsullivansociety.co.uk

Victoria & Albert Museum, Blythe House: Theatre Museum Archives:
D'Oyly Carte Archives THM/73

Articles, Journals and Newspapers

The Caterer and Hotel Proprietors' Gazette (later *The Caterer and Hotel-Keepers' Gazette*),
The Daily Chronicle, The Courier, The Daily News, The Era, The Evening Mail, The Graphic,
The Illustrated London News, The Illustrated Sporting and Dramatic News, The Lady,
The Lady's Realm, Pearson's Society News, Punch, The Savoy, The Sketch, The Sporting Life,
The Stage, The Pall Mall Gazette, The Queen: The Lady's Newspaper, The Theatrical Journal,
The Times, Town Topics, Yorkshire Telegraph and Star

Bailey, Peter, 'Custom, Capital and Culture in the Victorian Music Hall', in *Popular*
Culture and Custom in Nineteenth-Century England, ed. Robert Storch, vol.46, pp.180–208
(London: Routledge Library Editions: The Victorian World, 1982)

Roberts, Helene E., 'The Exquisite Slave: The Role of Clothes in the Making
of the Victorian Woman', in *Signs*, vol.2 no.3 (Spring 1977), pp.554–69
(Chicago: The University of Chicago Press, 1977)

Thomas, Zoe, 'Between Art and Commerce: Women, Business Ownership, and the
Arts and Crafts Movement', in *Past & Present,* vol.247, Issue 1, May 2020, pp.151–96

Diaries, Letters and Memoirs

Anderson de Navarro, Mary, *A Few More Memories* (London: Hutchinson & Co., 1936)

Andrew, Marjorie, and Clissold, Shirley, eds, *The Diaries of John McConnell Black,*
vol.I, Diaries One to Four, 1875–1886 with selected extracts from his 'Memoirs'
(Hawthorndene, Australia: Investigator Press, 1986)

Bancroft, M., and Bancroft, S., *Recollections of Sixty Years* (London: John Murray, 1909)

Barrington, R., *Rutland Barrington, by himself* (London: Grant Richards, 1908)

Barrington, R., *More Rutland Barrington – By himself* (London: Grant Richards, 1911)

Barrymore, Ethel, *Memories: An Autobiography by Ethel Barrymore*
(London: Hulton Press, Ltd, 1956)

Bernhardt, Sarah, *My Double Life: Memoirs of Sarah Bernhardt*
(London: William Heinemann, 1907)

Campbell, Mrs Patrick (Beatrice Stella Cornwallis-West), *My Life and Some Letters*
(London: Hutchinson & Co., 1922)

Craig, Edith, and St John, Christopher, *Ellen Terry's Memoirs*
(London: Victor Gollanz Ltd, 1933)

Black, John McConnell, *Memoirs of John McConnell Black*
(Adelaide: Hyde Park Press, 1971)

Bond, Jessie, *The Life and Reminiscences of Jessie Bond, The Old Savoyard as Told by Herself to Ethel MacGeorge* (London: John Lane, 1930)

Browne, Edith, A., *W.S. Gilbert* (London: John Lance, The Bodley Head, 1907)

Cellier, François, and Bridgeman, Cunningham, *Gilbert & Sullivan and Their Operas;
With Recollections and Anecdotes of D'Oyly Carte & Other Famous Savoyards*
(Boston: Little, Brown & Co., 1914)

Escoffier, Auguste, tr. Laurence Escoffier, *Auguste Escoffier: Memories of my Life*
(New York: Van Nostrand Reinhold, 1997)

Glover, J.M., *Jimmy Glover and His Friends* (London: Chatto & Windus, 1913)

Goldberg, Isaac, *The Story of Gilbert and Sullivan or The 'Compleat' Savoyard*
(New York: Crown, 1935)

Harker, Joseph, *Studio and Stage* (London: Nisbet & Co. Ltd, 1924)

Harman, Lindsay, *A Comic Opera Life* (West Hartlepool: William Barlow, 1924)

Hicks, Seymour, *Vintage Years when King Edward The Seventh Was Prince Of Wales*
(London: Cassell and Company Ltd, 1943)

Hollingshead, John, *Gaiety Chronicles* (London: Archibald Constable, 1898)

Hughes, M.V., *A London Family 1870–1900: A Trilogy by M. Vivian Hughes*
(London: Geoffrey Cumberlege, Oxford University Press, 1946)

James, Henry, *English Hours* (London and New York: I.B. Tauris, 2011/1905)

Jopling, Louise (Mrs Jopling-Rowe), *Twenty Years of My Life 1867–1887*
(London: Bodley Head, 1925)

Krout, Mary Hannah, *A Looker On in London* (New York: Dodd, Mead & Co., 1899)

Langtry, Lillie (Lady de Bathe), *The Days I Knew* (London: Hutchinson & Co., 1925)

Lawrence, Arthur, *Sir Arthur Sullivan: Life Story, Letters and Reminiscences*
(New York: Duffield, 1907)

Lyttleton, The Hon. Mrs Alfred, *Women and Their Work* (London: Methuen & Co, 1901)

Lytton, Henry A., *Secrets of a Savoyard* (London: Jarrolds, 1921)

Melba, Nellie, *Melodies and Memories* (London: Thornton Butterworth, Ltd., 1925)

Miller, Ruby, *Champagne From My Slipper* (London: Herbert Jenkins, 1962)

Pachter, Marc, and Wein, Frances, eds, *Abroad in America: Visitors to the New Nation
1776–1914* (Reading, MA.: National Portrait Gallery and Smithsonian Institution,
by Addison-Wesley, 1976)

Ritz, Marie Louise, *César Ritz: Host to the World* (London: Harrap & Co., 1938)

Soldene, Emily, *My Theatrical and Musical Recollections*
(London: Downey & Co. Ltd, 1897)

St John, Christopher, ed., *Ellen Terry and Bernard Shaw: A Correspondence*
(London: Constable & Co. Ltd., 1931)

Sullivan, Herbert, and Flower, Newman, *Sir Arthur Sullivan: His Life, Letters & Diaries*
(London: Cassell, 1927)

Vanbrugh, Violet, *Dare to be Wise* (London: Hodder and Stoughton, 1925)

Waterston, Jane E., *The Letters of Jane Elizabeth Waterston 1866–1905*,
ed. Lucy Bean and Elizabeth van Heyningen (Cape Town: Van Riebeeck Society,
Second Series No. 14, 1983)

Biography

Ainger, Michael, *Gilbert and Sullivan: A Dual Biography* (Oxford: Oxford University
Press, 2002)

Allen, Reginald, with D'Luhy, Gale R., *Sir Arthur Sullivan*
(New York: The Pierpont Morgan Library, 1975)

Calder, Jenni, ed., *The Enterprising Scot: Scottish Adventure and Achievement*
(Edinburgh: Royal Museum of Scotland, 1986)

Dark, Sydney, and Grey, Rowland, *W.S. Gilbert: His Life and Letters*
(London: Methuen, 1923)

Donaldson, Frances, *The Actor Managers* (London: Weidenfeld and Nicolson, 1970)

Goodman, Andrew, *Gilbert and Sullivan At Law*
(Rutherford, NJ: Fairleigh Dickinson University Press, 1983)

Heald, Henrietta, *Magnificent Women and their Revolutionary Machines*
(London: Unbound, 2019)

Hibbert, Christopher, *Gilbert & Sullivan and Their Victorian World*
(New York: American Heritage Publishing, 1976)

Jacobs, Arthur, *Arthur Sullivan: A Victorian Musician*
(Oxford and New York: Oxford University Press, 1984)

James, Kenneth, *Escoffier: The King of Chefs* (London: Hambledon, 2002)

Jones, Brian, *Helen Carte: Gilbert and Sullivan's 4th Partner*
(Basingstoke: Basingstoke Books, 2011)

Joseph, Tony, *George Grossmith: Biography of a Savoyard* (Bristol: Bunthorne, 1982)

Juxon, John, *Lewis and Lewis* (London: Collins, 1983)

Pearson, Hesketh, *Gilbert and Sullivan: A Biography*
(Looe, Cornwall: House of Stratus, 2001/1935)

Pennell, E.R. and J., *The Life of James McNeill Whistler*
(London: William Heinemann, 1908)

Pearson, Hesketh, *The Last Actor-Managers* (London: White Lion, 1974/1950)

Rowell, George, *Theatre in the Age of Irving* (Oxford: Basil Blackwell, 1981)

Seeley, Paul, *Richard D'Oyly Carte* (London and New York: Routledge, 2019)

Stedman, Jane, *W.S. Gilbert: A Classic Victorian and His Theatre* (Oxford: Oxford University Press, 1996)

Sturgis, Matthew, *Walter Sickert: A Life* (London: Harpercollins, 2005)

Sturgis, Matthew, *Oscar: A Life* (London: Head of Zeus, 2018)

Sullivan, Herbert, and Flower, Newman, *Sir Arthur Sullivan: His Life, Letters & Diaries*
(London: Cassell, 1927)

Wyndham, Henry Saxe, *Arthur Seymour Sullivan*
(London: Kegan Paul, Trench, Trubner & Co.; J. Curwen & Sons: 1926)

Secondary

Allen, Reginald, *The First Night Gilbert and Sullivan: Centennial Edition* (London: Chappell, 1958)

Anderson, Olive, *Suicide in Victorian and Edwardian England* (Oxford: Clarendon, 1987)

Annan, N.G., 'The Intellectual Aristocracy', in *Studies in Social History: A Tribute to G.M. Trevelyan*, ed. Plumb, J.H. (London: Longmans, Green and Co., 1955)

Antosa, Silvia, 'Cannibal London: Racial Discourses, Pornography and Male-Male Desire in Late-Victorian Britain', in Avery, Simon, and Graham, Katherine M., eds, *Sex, Time and Place: Queer Histories of London c.1850 to the Present* (London: Bloomsbury, 2016)

Arnstein, Walter L., *Britain Yesterday and Today: 1830 to the Present* (Lexington, MA: D.C. Heath, 1988/1966)

Assael, Brenda, *The London Restaurant, 1840–1914* (Oxford: Oxford University Press, 2018)

Bailey, Peter, *Popular Culture and Performance in the Victorian City* (Cambridge: Cambridge University Press, 1998)

Baily, Leslie, *The Gilbert & Sullivan Book* (London: Cassell & Co. Ltd, 1952)

Baker, Michael J.N., *The Rise of the Victorian Actor* (London: Croom Helm, 1978)

Beebe, Lucius (illus. Ronald Searle), *The Savoy of London* (USA: Curtis Publishing Company, 1963)

Bennett, Robert J., Smith, Harry, Van Lieshout, Carry, Montebruno, Piero, and Newton, Gill, *The Age of Entrepreneurship: Business Proprietors, Self-Employment and Corporations since 1851* (London: Routledge, 2020)

Booth, Michael R., *Theatre in the Victorian Age* (Cambridge: Cambridge University Press, 1995/1991)

Cannadine, David, 'Gilbert and Sullivan: The Making and Un-making of a British 'Tradition', in Porter, Roy, ed., *Myths of the English* (Cambridge: Polity, 2007/1992)

Cocks, H.G., *Nameless Offences: Homosexual Desire in the Nineteenth Century* (London: I.B. Tauris, 2003)

Collins, Leonora, ed., *London in the Nineties* (London: Saturn Press, 1950)

Davis, Tracy C., *Actresses as Working Women: Their social identity in Victorian culture* (London: Routledge, 1991)

Davis, Tracy C., *The Economics of the British Stage 1800–1914*
(Cambridge: Cambridge University Press, 2000)

Dellamora, Richard, *Masculine Desire: The Sexual Politics of Victorian Aestheticism*
(Chapel Hill: University of North Carolina Press, 1990)

Dyhouse, Carol, *Glamour: Women, History, Feminism.* (London: Zed Books, 2010)

Flanders, Judith, *Consuming Passions: Leisure and Pleasure in Victorian Britain*
(London: Harper Press, 2006)

Gere, Charlotte, *Artistic Circles: Design & Decoration in the Aesthetic Movement*
(London: V&A Publishing, 2010)

Goodman, Andrew, and Hardcastle, Robert, eds, *Gilbert and Sullivan's London*
(London: Faber & Faber, 2000/1998)

Goron, Michael, *Gilbert and Sullivan's 'Respectable Capers': Class, Respectability and the
Savoy Operas 1877–1909* (London: Palgrave Macmillan, 2016)

Goyens, Tom, *Beer and Revolution: The German Anarchist Movement in
New York City, 1880–1914* (Chicago: University of Illinois, 2014)

Hart, Imogen, 'History Painting, Spectacle, and Performance', in
Edwardian Opulence: British Art at the Dawn of the Twentieth Century
(New Haven and London: Yale University Press, 2013), pp. 109–23

Hoare, Stephen *Piccadilly: London's West End and the Pursuit of Pleasure*
(Gloucestershire: The History Press, 2021)

Holcombe, Lee, *Victorian Ladies at Work: Middle-Class Working Women in England and Wales*
(Newton Abbot, Devon: David & Charles, 1973)

Holmes, Colin, *John Bull's Island: Immigration and British Society, 1871–1971*
(Hampshire: Taylor & Francis, 1988)

Homberger, Eric, *Mrs Astor's New York: Money and Social Power in a Gilded Age*
(New Haven: Yale University Press, 2002)

Hyman, Alan, *Sullivan and His Satellites: A Survey of English Operettas*
(London: Chappell, 1978)

Jackson, Stanley, *The Savoy: The Romance of a Great Hotel*
(London: Frederick Muller, 1964)

John, Angela V., ed., *Unequal Opportunities: Women's Employment in England 1800–1918*
(Oxford: Basil Blackwood, 1986)

Johnson, Claudia D., and Johnson, Vernon E., *Nineteenth-Century Theatrical Memoirs* (Westport, Connecticut: Greenwood Press, 1982)

Joseph, Tony, *The D'Oyly Carte Opera Company 1875–1982: an unofficial history* (Bristol: Bunthorne Books, 1994)

Kaplan, Joel H., and Stowell, Sheila, *Theatre & Fashion: Oscar Wilde to the Suffragettes* (Cambridge: Cambridge University Press, 1994)

Kift, Dagmar, *The Victorian Music Hall: Culture, Class and Conflict*, tr. Roy Kift (Cambridge: Cambridge University Press, 1996)

MacKenzie, Compton, *The Savoy of London* (London: George G. Harrap & Co. Ltd., 1953)

Macpherson, Ben, *Cultural Identity in British Musical Theatre, 1890–1939: Knowing One's Place* (London: Palgrave Macmillan, 2018)

Malcolm, Charles A., *The History of the British Linen Bank* (Edinburgh: T. and A. Constable, 1950)

McWilliam, Rohan, *Creating the Pleasure District, 1800–1914: London's West End* (Oxford: Oxford University Press, 2020)

Miller, Derek, *Copyright and the Value of Performance, 1770–1911* (Cambridge: Cambridge University Press, 2018)

Oost, Regina B., *Gilbert and Sullivan: Class and the Savoy Tradition, 1875–1896* (London: Ashgate, 2009)

Pick, John, *The West End: Mismanagement and Snobbery* (London: City Arts, 1983)

Prochaska, Frank, *Royal Bounty: The Making of a Welfare Monarchy* (New Haven & London: Yale University Press, 1995)

Rappaport, Erika Jane, *Shopping for Pleasure: Women in the Making of London's West End* (Princeton and Oxford: Princeton University Press, 2001/2000)

Smith, Andrew F., *Drinking History: Fifteen Turning Points in the Making of American Beverages* (New York: Columbia University Press, 2013)

Smith, Geoffrey, *The Savoy Operas: A New Guide to Gilbert and Sullivan* (London: Robert Hale, 1983)

Stephens, W.B., *Education in Britain, 1750–1914* (London: Macmillan, 1998)

Stokes, John, *In The Nineties* (Hemel Hempstead, University of Chicago Press, 1989)

Taylor, Derek, *Ritzy: British Hotels 1837–1987* (London: The Milman Press, 2003)

Thompson, F.M.L., *The Rise of Respectable Society: A Social History of Victorian Britain, 1830–1900* (London: Fontana, 1988)

Thiel, Liz, Lomax, Elaine, Carrington, Bridget, Sebag-Montefiore, Mary, intro. by Reynolds, Kimberley, *A Victorian Quartet: Four Forgotten Women Writers* (Staffordshire: Pied Piper Publishing, 2008)

Williams, Olivia, *The Secret Life of the Savoy and the D'Oyly Carte Family* (London: Headline, 2020)

Yeandle, Peter, Newey, Katherine, and Richards, Jeffrey, eds, *Politics, Performance and Popular Culture: Theatre and Society in Nineteenth-Century Britain* (Manchester: Manchester University Press, 2016)

Young, Arlene, *From Spinster to Career Woman: Middle-Class Women and Work in Victorian England* (Montreal & Kingston: McGill-Queen's University Press, 2019)

Zakreski, Patricia, *Representing Female Artistic Labour, 1848–1890: Refining Work for the Middle-Class Woman* (Hampshire: Ashgate, 2006)

Acknowledgements

It is always true that historians and researchers stand on the shoulders of giants: the many books, journals, newspapers and other representations of the past are what we rely upon for our work.

I would like to thank the following institutions for extending to me the courtesy of their collections, and for their help when needed: the British Library, the British Library Newspaper Library (Colindale), the J.P. Morgan Library (New York), the Archive at Kew Botanical Gardens, the London Library, the Savoy Hotel Archive (with many thanks to their archivist Susan Scott), the Victoria and Albert Museum (Theatre Collections) and the University of London (Senate House). Jo Fox, Dean of the School of Advanced Study at the University of London, was a terrific support, and kindly read the manuscript and made extremely helpful suggestions. Remaining errors are of course mine. It is a huge privilege to be a Senior Research Fellow at the Institute of Historical Research – I am grateful for the support and encouragement of my colleagues, and for the joy of being surrounded by outstanding scholarship.

The team at Unicorn Publishing was both talented and delightful and I am hugely grateful to Lucy Duckworth, who believed in this project from its beginnings, and encouraged me every step of the way. My thanks also go to Elisabeth Ingles for the splendid editing. Anna Hopwood did a magnificent job with the design, and Katie Greenwood with the picture research. Many thanks to Ramona Lamport for proofreading, Nicola King for the Index and to Lauren Tanner for marketing and publicity.

Having the support of family and friends has been not only welcome but crucial and I am very fortunate in having benefited from their unwavering belief in Helen D'Oyly Carte, and in me. Special thanks are due to my parents, my siblings, and my in-laws, as well as to my beloved pack: Conor, Emily, Alice and Cassian.

This book is for EBA, with love, admiration and gratitude.

Index

Picture Credits

Cover: Walter Richard Sickert, *The Acting Manager*, c.1885-6 (oil on canvas) Bridgeman Images/Christie's Images

Endpapers: Byam Shaw, *Design for the Act Drop at the Coliseum*, Photographer: John Hammond

Alamy/Chronicle 24

Alamy/Lebrecht Music & Arts 189

Art Institute of Chicago 62, 63

Bridgeman Images/Look and Learn 93

British Museum 146

Getty Images/DEA/Biblioteca Ambrosiana 48

Library of Congress 38, 39

National Galleries of Scotland 23

National Library of Australia 17

National Portrait Gallery 26, 27

Victoria and Albert Museum, London 4, 69, 73